D1236679

World Cinema and the Visual Arts

World Cinema and the Visual Arts

Edited by
David Gallagher

ANTHEM PRESS
LONDON · NEW YORK · DELHI

Anthem Press
An imprint of Wimbledon Publishing Company
www.anthempress.com

This edition first published in UK and USA 2012
by ANTHEM PRESS
75-76 Blackfriars Road, London SE1 8HA, UK
or PO Box 9779, London SW19 7ZG, UK
and
244 Madison Ave. #116, New York, NY 10016, USA

British Library Cataloguing-in-Publication Data
A catalogue record for this book is available from the British Library.

Library of Congress Cataloguing-in-Publication Data
World cinema and the visual arts / edited by David Gallagher.
p. cm.
Includes bibliographical references and index.
ISBN 978-0-85728-438-9 (hardback : alk. paper)
1. Motion pictures–Aesthetics. 2. Visual arts. I. Gallagher, David.
PN1995.25.W67 2012
791.4301–dc23
2011050716

ISBN-13: 978 0 85728 438 9 (Hbk)
ISBN-10: 0 85728 438 X (Hbk)

This title is also available as an eBook.

TABLE OF CONTENTS

PREFACE

The annual meeting of the American Comparative Literature Association took place on April 1–4, 2010 in New Orleans, Louisiana attracting over 2,000 scholars from around the world. Using the Hotel Monteleone as its official conference base, seminars were organised across New Orleans at the hotels Astor, Bienville and Monteleone, as well as Arnaud's Restaurant in the French Quarter. A number of the panels focused on the subject of contemporary cinema and the visual arts. The panels from which the papers in this volume were assembled were: 'Being-in-the-World: Chinese Cinema and its Cosmopolitan Perspectives', 'Berlin's Imagined Geographies', 'Just Memory: Utopian Fiction and Abraxian History', 'National Traumas, Diasporic Encounters: Violence, Memory, and Literary/Visual Culture', 'Post/colonial Film: Imaging Identity and Resistance', 'Made in Hong Kong: Language, Literature and Film from a City in Search of Itself', 'Affectivity and Aesthetics of the Postnational across Literature, Cinema, and Theory', 'Comparative Literature: From Practice to Theory', 'Reading Between the Arts: Multi-Media, Aisthesis, and Interart Studies', 'Intermediality after 1900', 'Re-defining art: Artistic genres in literary works', and 'The Hidden Voice: Cross-Cultural Women's Autobiographical Novels'.

Following the conference, and thanks to the assistance of the principal conference organiser, Dr Elizabeth Richmond-Garza, a call for papers was facilitated, from which the editor selected the best abstracts thematically for their relevance to contemporary cinema and the visual arts, and these consisted of the most excellently written and most suitable taking into account principally three criteria: argument, structure and theme. The selection process continued as draft papers were then submitted and reviewed, subjected to a strict judging process before it was decided to accept the papers to be included in the present volume. Contributors were then invited by the editor to spend further months revising, amending and researching their draft papers throughout 2011 with a view to completing them within around six months and submitting their final submissions to the editor in August/September of 2011.

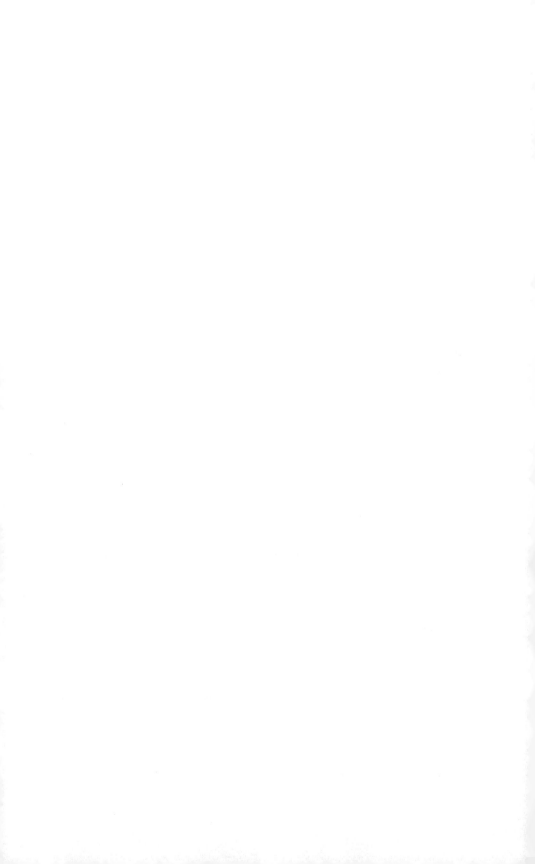

NOTES ON CONTRIBUTORS

Lily Wong is a PhD candidate in comparative literature at the University of California at Santa Barbara, specialising in Chinese and Sinophone popular culture, gender and sexuality, and film and media studies. She has been published in journals including *Pacific Affairs* and *China Review International*. Her current research pays close attention to affective economies, historical writing, and the media formation of trans-pacific Sinophone communities.

Isa Murdock-Hinrichs received her PhD from the University of California, San Diego, where she is currently a lecturer. She has published on the New German Cinema, in particular Fassbinder and Weimar film and culture. Her research interests include film theory and history, as well as theories of space and aesthetics, Weimar cinema, literature and culture.

Shelton Waldrep is professor of English at the University of Southern Maine. He is the author of *The Aesthetics of Self-Invention: Oscar Wilde to David Bowie* (University of Minnesota Press, 2004), the co-author of *Inside the Mouse: Work and Play at Disney World* (Duke University Press, 1995), and the editor of *The Seventies: The Age of Glitter in Popular Culture* (Routledge, 2000). His latest book is entitled *The Dissolution of Place: Architecture after Postmodernism*, and is forthcoming from Ashgate.

Anna Zaluczkowska is a senior lecturer and programme leader for media, writing and production at the University of Bolton, England. She is an award-winning filmmaker and writer and her works have been screened at film festivals throughout the world, on television, in museums and at live events. She started work as an editor working for a number of franchised workshops where she edited documentary and drama projects on video and 16mm film. She went on to produce several educational programmes, short films and documentaries before taking an interest in writing. After taking an MA in writing at Sheffield Hallam University, Anna worked at the Arvon Foundation as a centre director while developing her writing skills. She has

written a number of short films, feature films and theatre pieces, the latest of which are *Amazo-Bra*, a short animation funded by Screen Yorkshire, and *Space Circus*, a children's theatre production for Chol Theatre, which was nominated for the Bryan Way Theatre award.

Jerod Ra'Del Hollyfield is a postdoctoral fellow in the English department at Louisiana State University in Baton Rouge, Louisiana, with research interests in film studies, postcolonial theory, film adaptation and the Victorian novel. He received his PhD from LSU in May 2011 after completing his dissertation, 'Framing Empire: Victorian Literature, Hollywood International, and Postcolonial Film Adaptation'. His work has been published in *Atlantikos*, *CineAction*, and *Film International*. He is the founder of and contributor to *The Noisy Philistine* (www.noisyphilistine.com), a weblog devoted to commentary on the digital revolution and its effects on global film production and distribution.

Howard Y. F. Choy received his PhD in comparative literature from the University of Colorado. Currently an associate professor at Wittenberg University, he has taught at Stanford University and the Georgia Institute of Technology. A journalist and theatre critic from Hong Kong, he is the author of *Remapping the Past: Fictions of History in Deng's China, 1979–1997* (Brill, 2008) and the assistant author of *The Illustrated Encyclopedia of Confucianism* (Rosen Publishing Group, 2005). Currently editing a book of Liu Zaifu's selected essays and a volume on discourses of disease, he has also published a number of articles and translations in major scholarly journals, including *positions*, *American Journal of Chinese Studies* and *Asian Theatre Journal*. His research interests focus on Chinese culture and literature, with the most recent project being a comparative study of political jokes across mainland China, Hong Kong, Taiwan and the United States.

Je Cheol Park is a PhD candidate in the Division of Critical Studies in the School of Cinematic Arts at the University of Southern California. He is finishing his dissertation entitled 'The Emergence of Postnational Affects' that explores the ways in which the affective features of contemporary global East Asian cinemas enable spectators to envision and anticipate new postnational communities. His research and teaching interests include East Asian cinema and media, film and media theory, and aesthetics and politics. He has published essays on contemporary East Asian films, film and media theory, and aesthetics and politics in various US and South Korean journals. His recent essay on Kore-eda Hirokazu's *Distance* and *Air Doll* appeared in *Film Criticism*.

Jane Chin Davidson is an assistant professor of art history and the Mieszkuc Professor of Women's Studies at the University of Houston, Clear Lake. She was formerly an ESRC fellow at the Cultural Theory Institute, University of Manchester (2009). Her research interests include the signification of gender, sexuality and race in contemporary visual culture, global exhibitions, and performance art, and she has had articles published in numerous journals and edited volumes, including 'Displacements of the Desiring Machine' in *Interventions: International Journal of Postcolonial Studies*, forthcoming; 'The Global Artfair and the Dialectical Image' in *Third Text: Critical Perspectives in Contemporary Art* (2010); and 'De-territorializing Bodies: Body Art and the Colonial World Expositions' in *Dead History, Live Art? Spectacle, Subjectivity and Subversion in Visual Culture since the 1960s*, edited by Jonathan Harris (Liverpool University Press, 2007).

Nandini Ramesh Sankar is a lecturer at Ithaca College and is completing her dissertation entitled 'A Poetics of Difficulty' at Cornell University. Her publications include the co-authored 'Snapping the Spectrum Up for Food: Marianne Moore, Artistic Representation, and the Ethics of Use' with *CR: The New Centennial Review 2011* and 'The Architectonics of Imperium and the Synthetic-Analytic in Kant', in *Journal of Contemporary Thought* (2009). She is primarily interested in twentieth-century British and American poetry, modernism, intermediality, literature and philosophy, and has presented papers on Gertrude Stein, John Ashbery, J. H. Prynne, Peter Riley, and L=A=N=G=U=A=G=E poetry.

Before starting at Metropolitan State College of Denver in August 2011, **Ana-María Medina** was a visiting assistant professor of Spanish for two years at the University of Houston Downtown. She holds a PhD in peninsular literature from the University of Houston, an MA in peninsular literature from Saint Louis University and a BA in Hispanic studies from the University of Texas at Austin. Her dissertation, entitled 'Manuel Rivas: A Revolution in Contemporary Galician Literature & Beyond' is a study of narrative and film from the feminist perspective in the context of twentieth and twenty-first century Spain, and delves into the pressing questions of cultural conflict and assimilation, union and disunion, historical memory, feminine space, and trans-cultural and multilingual artistic production in the Peninsula. As a graduate student she taught at the University of Houston and was an Assistant Professor at the University of Belize where she coordinated the language department of the Belize City Campus and was a lead member on the committee to design and implement the bachelor's degree course in Spanish education. In 2007 she was the assistant coordinator to the Summer Abroad Program in Cádiz for the University of Houston, where she was the recipient of the UH Teaching Excellence Award (2007) and the Hispanic Studies Departmental

Teaching Excellence Award (2009). Dr Medina teaches beginner and intermediate language classes, heritage language courses and twentieth and twenty-first century peninsular literature, film and culture courses. She has been published in various media including scholarly journals, collections and magazines and has presented at national conferences. She is a member of the Sigma Delta Kappa Spanish and the Phi Beta Delta honour societies and part of the Delegate Assembly Organizing Committee for the MLA.

Minna Niemi received her PhD in English from the University at Buffalo in 2011. Her doctoral thesis concentrates on representations of history in postmodern African and African American literature. She has published articles on African American literature and an article on J. M. Coetzee's work. Niemi has taken an appointment in the English department at Lebanon Valley College for the academic year 2011–2012.

LIST OF FIGURES

INTRODUCTION

The aim of this collective volume of essays has been to combine some new contemporary analyses of two subjects of current ongoing research in the humanities: the cinema and the visual arts. The early origins of cinema involved the positioning and projection of a number of photographs in sequence by Eadweard Muybridge in *Galloping Horse* (1878) – to prove for a bet that all four hooves of a horse came off the ground when it ran – followed in 1889 by the development of the motion picture camera by Thomas Edison and William Dickson.[1] The first recorded sound was a song recorded in 1860 to accompany the first ever moving picture, which was footage of a horseback rider (1878) followed by the first film ever made, which consisted of a silent film depicting four figures in a courtyard (1888). Ever since the date film was born, it has been an increasingly popular genre and cinema and filmmaking have been sources of admiration, fascination and particularly a rising trend towards critical analysis. The range and breadth of studies that exist in relation to film eras, genres, a nation's cinema, film theory or film culture is truly breathtaking. Many volumes of literary criticism have been written on the general subjects of what constitutes cinema,[2] film theory,[3] how to interpret a film,[4] film narration,[5] psychoanalysis,[6] and many critical editions focus on a particular country's films,[7] or a specific filmmaker,[8] or a specific genre or era, such as censored films,[9] silent films or early cinema.[10]

The massive textual body of film theory and theories as a critical apparatus have led to an increasing rise in the number of courses available at universities, where films from all around the globe in a wide variety of world languages are viewed, analysed and interpreted according to the theories of Eisenstein, Pudovkin, Dziga-Vertov, the Russian Formalists, Bazin, Munsterberg, Deren, Brakhage, Arnheim, Kracauer and Mulvey.

The second area of this book is concerned with the visual arts, which is a term used for a broad category of different types of art. These would encompass the fine arts of drawing, painting, printmaking and sculpture; communication, performance and design arts such as film, television, photography, video, graphic, fashion, product, industrial and interior design disciplines, crafts and

photography, as well as architecture, works of art in ceramics, jewellery, wood, paper and other materials. As has been indicated in recent research, the visual experience is essential and seeing through our eyes is the most direct avenue to the mind. It is by viewing the visual arts that we receive sense impressions from all the various art forms that we can then analyse, interpret and decode to assess the possible purpose and meaning of the art in question.[11]

The present analyses of cinema and the visual arts include papers which were originally given at a number of panels at the ACLA Conference 2010 in New Orleans, Louisiana from 1 to 4 April and from contributors who have expanded and extended their original points of enquiry and carried out further research since then, improving their papers to an excellent standard of academically published literary criticism.

In relation to cinema, the films analysed in this collective volume encompass a wide geographical base of those drawn from the diverse cultural traditions of China, Germany, the United Kingdom, America, Northern Ireland and India. The Chinese connection is evident in those set in the city of Shanghai such as *Shanghai Express* (1932) and *The Goddess* (1934). The first study in this volume analyses these two films, the theme of prostitution and its relevance for the women who portray these roles in terms of gender issues. *Shanghai Express* is a Hollywood examination of Chinese culture, the fourth collaboration of Marlene Dietrich and director Josef von Sternberg. *The Goddess* is a silent film released by the United Photoplay Service, directed by Wu Yonggang and starring Ruan Lingyu as the woman with no name living in Shanghai as a prostitute. The next film analysed comes out of the German Expressionist art movement, Fritz Lang's movie *M* (1931), a film starring Peter Lorre as a child murderer and which ran into initial difficulties with the Nazis over its filming at Staaken Studios due to their misunderstanding of the political repercussions of its original title, *Mörder unter uns* (*Murderer among us*).[12] The James Bond franchise features next with an analysis of Daniel Craig's first outing as the eponymous secret agent 007 in *Casino Royale* (2006). Next, the whole background to films focusing on the 'Troubles' in Northern Ireland is addressed, touching on films such as *A Sense of Loss* (1972), *Hennessey* (1975), *The Crying Game* (1992), *In the Name of the Father* (1993), *The Beast that Sleeps* (2001), *H3* (2001), *Bloody Sunday* (2002), *The Mighty Celt* (2005), *Mickybo and Me* (2004), *Breakfast on Pluto* (2005), *Johnny Was* (2005) and *Peacefire* (2008). The next paper regarding cinema turns to investigate the depiction of the Indian film industry through contemporary Indian writers. The final two papers in this area focus on Hong Kong independent filmmaker Fruit Chan's post-1997 films and East Asian films.

I now turn to examine these papers that concentrate on cinema in more detail as an overview of their contributions as a whole. Often called the

'Paris of the East', imaginations of Shanghai have long conflated Shanghai's cosmopolitanism with 'foreign', 'Western' and 'modern'. Shanghai's cosmopolitanism instead of being merely the result of 'Western impact', as Meng Yue argues, was a product of the meeting of late Qing imperial, early republican and foreign imperialist histories. Cultural production exchanged across the pacific, specifically the large influx of Hollywood films, played a crucial part in promoting this interaction. Hollywood's often orientalist representations of 'yellow peril' arguably aligned Shanghai and Tokyo urban elites, forming a 'cultural nexus' centred on shared anger towards an 'unjust world' under Euro-American imperialism, giving rise to desires for an alternative globality. Hollywood's imagination of Chinese women as prostitutes, for instance, provoked political fervour focused on the perils of 'Chinese women', their degraded representations as proof of a 'fallen' world in need for revolution. Lily Wong zeros in on this process of discursive exchange, looking closely at Hollywood's portrayal of the Chinese prostitute in *Shanghai Express* (1932), followed by a tracking of its reception in Shanghai China. Casting a returned gaze, she then turns to depictions of the 'virtuous whore' in *The Goddess* (1934) produced as part of the national cinema movement of the May Fourth activists. These exchanged representations of the 'Chinese prostitute' mirror that of Shanghai, their marked bodies like the marketed city refracting imaginations of what Yue calls 'a more habitable globe'.

Isa Murdock-Hinrichs next draws our attention to Burton Pike's suggestion in *The Image of the City in Literature* that representations of cities as well as their 'real' models consist of interplays of individual and collective associations/ memories, as well as interpretative and fragmentary perceptions. These incorporate cultural metaphors, such as references to Sodom and Gomorrah, while simultaneously also conveying psychic structures in their representation of diachronic and paradigmatic space and time. However, Pike's analysis focuses primarily on visual and conceptual representation, occluding largely auditory phenomena that contribute to a discursive mapping of the city, particularly early twentieth-century Berlin. Murdock-Hinrichs considers how Fritz Lang's first sound film, *M*, portrays Berlin's social structure while astutely negotiating new technologies of sound. Lang conveys a modern urban experience as comprised of cacophonies of visual and auditory influences. The narrative of Lang's film juxtaposes auditory and visual elements related to modernity and industrialisation with 'songs' and verbal expressions rooted in Romanticism, ultimately communicating inconsistencies and contradictions that signify individual and social transformations of a predominantly rural society into an internationally competitive urban state. While technologies of sound are indicative of modern developments on an extra-diegetic level, Lang strategically employs the new medium to undermine easily decipherable

binaries often foregrounded in cinema that shaped the perception of German national identity. Lang's narratives consist of a series of images and sounds, which render the act of 'following the crime' simultaneously an act of *flânerie*. Her essay analyses the way in which Lang's films depict images of symmetrical urban spaces as well as 'indecipherable' spatial representations and contrasts these with 'sounds' and 'silences', thus establishing visual correlates to the logic of criminal inquiry. The film and the crime of the narrative then become, as Michel de Certeau suggests, a 'manifold story that has neither author nor spectator, shaped out of fragments of trajectories and alterations of spaces'.[13] Murdock-Hinrichs argues in fact, that Lang's images and sounds metaphorically re-present Berlin's simultaneous fascinations with modernity and reluctance to re-invent itself. A reading of Lang's film, in particular in conjunction with E. A. Dupont's *Varieté* (1925), reveals how Berlin's fascination with modernity and different modernisms contributes to a disjunction between the social and spatial environment and the cultural psychological reaction to these sites.

Shelton Waldrep next in 'Bond's Body: *Diamonds Are Forever, Casino Royale* and the Future Anterior' examines the role of sex and sexuality during the years that Sean Connery starred as Bond (1962–1971) in order to track the complicated formula by which Bond is implicated in homosexual and sado-masochistic scenarios that arguably reach their most complex form in *Diamonds Are Forever* (1971). While earlier Bond films frequently dealt with the threat of women's rights – most often in the form of a lesbian character (*From Russia with Love*, 1963, for example) – *Diamonds Are Forever* introduced the notion of gay male desire as a new reality for Bond and his future dealings. It also marked a turning point in the franchise from Cold War spy drama to spectacular melodrama, or from 1960s seriousness to 1970s comedy. The film is a post-mortem on the franchise itself and a prescient examination of the corporeality of film – specifically as a male body that is designed to be observed and examined, but never touched. The film is symptomatic of various anxieties around the male body that result, in part, from the insecurity that propels nation-states to spy on each other, which becomes an excuse for men to look at each other, watch, and ultimately ignore the realities of their own actions. *Casino Royale* takes James Bond (Daniel Craig) back to a time before *Dr. No* in 1962, yet puts him spatially in the present, creating a logical paradox that allows him to function as a fusion of both the past and the present. Bond becomes Bond again by ignoring time and becoming only space itself. The new temporal back story that the film tells is the process of Bond becoming 007, which allows for an emphasis on his vulnerability, both physically and emotionally. In addition to his usual physical challenges and humiliations, Bond suffers an induced heart attack and sexual torture. Waldrep explains

how the materiality of the male body is emphasised throughout the film and made parallel with the emotional damage he suffers in his relationship with Vesper Lynd (Eva Green). In this new version of the Bond myth, the producers and writers posit the idea that by not seeing the past as a collision with the present the franchise will avoid repeating the mistake of the Bond films of the 1970s, 1980s and 1990s by rewriting the matrix of its own identity with an origin story that is itself a simulacrum that acknowledges the impossibility of its own existence. The utopian past of the franchise, the Sean Connery years, is both referenced and superseded as the film manages to exist in two alternate histories at one time in order to suggest a way to re-imagine the future by intertwining the past and the present in such a way as to suggest their inability to escape each other.

Anna Zaluczkowska investigates the current analysis of the films that have been forged by the Troubles in Northern Ireland which tends to emphasise their lack of commercial viability or their inability to deal with complex political situations. She argues that over the last 20 years Northern Irish film, a very new practice, has undergone an important learning process which has given rise to a series of films which are able to inject ambiguity into the popular form and investigate the controversial. Many of these films have been produced through collaborations between filmmakers from Ireland, Northern Ireland, America, Canada and the UK, filmmakers who have gone on to make films about conflicts in other countries. After nearly three decades of development Northern Irish Film is finally beginning to find its voice and the work that it has produced has contributed to a general debate about national cinema and the forms that such a cinema should take. Zaluczkowska argues that if it can do this it can also begin to push the boundaries of what constitutes popular cinema. Through the analysis of the impact of recent key films she will suggest courses that film development needs to take in the region.

Jerod Ra'Del Hollyfield demonstrates how, for postcolonial writers, the increased presence of transnational, corporate imperialism so prominent in the current wave of international film industry co-productions serves as a matrix of assertion and control that complicates resistance to past and present forms of imperialism. Forced to contend with both the lingering impacts of colonialism, such as that embodied by the British Empire's dominance of India and the contemporary corporate influence over particular nations, postcolonial novelists are left to formulate strategies that address imperial endeavours for an increasingly globalised audience. As the literature of India over the past two decades indicates, authors desiring to affirm national and cultural autonomy have appropriated depictions of cinema – a term that includes film and television productions – as a way to combat the influence of the transnational culture industry and to situate their own national

film industries within the representations of their nations. In his chapter, Hollyfield argues that Indian postcolonial writers use depictions of cinema to interrogate the dissemination power of transnational, corporate imperialism and its reliance on mass media to maintain its presence. Discussing Salman Rushdie's *The Satanic Verses* (1988), Arundhati Roy's *The God of Small Things* (1997) and Vikas Swarup's *Q&A* (2005), Hollyfield examines how each author uses a similar strategy to present national film industries as representations of imperial forces: a childhood flashback to the molestation of a primary male character by an elder male in the context of cinema. Through associating cinema production and viewing with molestation, all three authors depict the effects of past and present imperialism on India's culture and population. Fragmenting identities, destroying personal and political bonds, and curtailing individual attempts at autonomy, the film industries represented in these texts exploit the lingering effects of British colonialism on India while installing the transnational corporation as a burgeoning force with which postcolonial authors in the globalised world must engage.

Howard Choy's paper calls our attention to the verbal aspect of film as an essential experience of viewing, particularly the importance of languages in the making of images. Born in Hong Kong and trained in the United States, the author argues that the mix of colloquial Cantonese with British English and Mandarin Chinese has formed a Chinglish language which, though untaught in school, shapes the hybrid identity of Hong Kong people as shown in independent filmmaker Fruit Chan's 1997 trilogy. While the use of English shapes the colonial legacy that is both taken pride in and played on at the same time, Mandarin arises as the new symbol of national identity. To resist the subservient identity imposed by the supremacy of the dominant Western and Eastern languages, however, a form of Chinglish has emerged as a creolised dialect that reveals the identity struggles of the postcolonial citizens, be they native Chinese or foreign expatriates. Consequently, the Hong Kong images cannot be adequately transcribed through Chinese and English subtitles. Nevertheless, the spoken local images of Hong Kong Cantonese have produced alternative meanings in global Chinese cinemas.

Je Cheol Park in 'The Postnational and the Aesthetics of the Spectral: Hou Hsiao-Hsien's *Flight of the Red Balloon*' asserts that in scholarly works on the post–Cold War world cinema, there would be no term that has become more influential than the term transnational. The phrase 'from national to transnational' is now considered one of the best phrases to epitomise the change in the landscape of world cinema over the past two decades. But at this moment when people began to have doubts about the celebratory attitude toward transnationalism in the wake of global recession, we might need to look at the phrase closely again to find if there is any missing link or any

'vanishing mediator' we might have neglected between this shift from national to transnational. This paper proposes the buried term 'postnational' as this vanishing mediator in order to theorise how this term enables us to understand the way in which contemporary world cinemas can engage in the imaginations of new communities characterised by alterity, openness and instability. Given that national community cinema is grounded on homogeneity, stability and exclusion, Park's theorisation allows us to see a new potential of contemporary global cinema irreducible to that of the national cinema. To illustrate the potential of cinema for opening up a way for the imagination of postnational community, this paper also closely examines one recent film *Flight of the Red Balloon* (2007) directed by Hou Hsiao-Hsien, focusing on how the film's aesthetics of the spectral is crucial to such an imagination. It should be noted that the film seems to be characterised as transnational in terms of both its contexts of production, circulation and reception, and its textual elements. But my close reading of the film shows how the transnational approach to the film risks overlooking its other potentials in relation to the imagination of postnational community. The transnational perspective does not fully answer the questions nor fill the voids that the national approach to cinema has left behind. The postnational perspective on cinema Park proposes should be another response to the questions that the crisis of the national cinema has opened up.

The focus of the volume then switches more exclusively to the visual arts with Jane Chin Davidson addressing how the classificatory order for the visual arts and art history has long been rigorous in its demand for juxtapositions and comparisons – notwithstanding the fact that there is really no such thing as comparative visuality – that is, if taking into consideration a disciplinary domain that parallels comparative literature. The genre of still life painting in modernist abstract art is examined next by Nandini Ramesh Sankar with a specific analysis of the importance of Gertrude Stein's still-lifes in *Tender Buttons*. *Mujer en el baño* by Manuel Rivas is a collection of articles whose visual art is embodied in the subject of a female naked portrait which a male figure observes, and in order to analyse Rivas' use of cross-cultural textualisation Ana-María Medina will use the concepts of montage and Benjamin's dialectical image. The final contribution by Minna Niemi focuses on the art of Kara Walker (1969–), a prominent contemporary African American visual artist mostly known for her silhouettes cut from black paper displayed on white walls, and whose art is controversial due to its racial pictography and violent imagery from the past of the US's South.

Jane Chin Davidson elucidates specifically that the endeavour of comparing cultural objects was an Enlightenment practice, originally established by Johann Winckelmann who in 1764 made the case for judging the 'highest beauty' achieved by Classical Greek artists in contrast to the 'arrested growth'

of the artistic development of Egyptian and Persian art. His politic of comparison simply extends the broader notions about cultures from Kantian 'observations', and later, Hegelian philosophies of history. The hierarchies of nationalism remain integral to the practice of comparison in the field – its ossification simply accepted as natural since European art constitutes the hierarchical frame for comparison. Even in the globalised order for art, the system that divides objects according to the West and the non-West cannot be changed until the stakes for the political use of cultural comparisons are acknowledged as having been raised by the ideology of the aesthetic and not only by the politics of display.

Nandini Ramesh Sankar is of the opinion that Gertrude Stein's explicit nod to Cubism in the so-called 'verbal still-lifes' in *Tender Buttons* invites a consideration of the significance of still life painting in Modernist abstract art as well as Stein's text. The apparent giveness and the utter obviousness of still lifes – which explains the scarcity of critical work on the genre – resists interpretation by declaring itself insufficient material for exegesis. This explains its importance in a period of a formal revolution in painting: being emptied of subjective presences and, by the twentieth century, most of its traditional symbolism, the still life becomes a primary context for a 'pure' contemplation of spatial relations in the work of the Post-Impressionists starting with Cézanne. But behind the thematic and imaginative poverty of the still life lurks the disruptive plenitude of the non-human. Sankar argues that Stein's *Tender Buttons* designates the still life as a space for alternative and possible forms of being human, and that her idiosyncratic reading of Picasso's *Three Musicians* supports this claim. Rather than being deliberately nonsensical or opposed to subjectivity as such, *Tender Buttons* remains cognizant of the inevitability of a subject whose every act of interpretation and inscription also constitutes self-interpretation and self-inscription. At the same time, it is also aware of the possibility that the realm of things – rendered objects by the positing of the subject – might in fact offer the most congenial space for the recuperation of what is not yet or no longer human.

Ana-María Medina explains that Manuel Rivas has been traditionally recognised as an important participant in the recuperation of historical memory through his novels and film. The majority of these studies focus on his most famous works; the short story *La lengua de las mariposas* and the novel *El lápiz del carpintero*. The importance of Medina's chapter lies in moving beyond these seminal works toward an analysis of lesser known texts such as *Mujer en el baño*. *Mujer en el baño* is inspired by Roy Lichtenstein's pop art piece with the same name. It is important to note that as a journalistic piece it should hold to some parameters, but as Medina's analysis underlines, Rivas' journalistic works are clearly at an intersection of narrative genres. Moreover, the paper

seek to interrogate how the text and the textualisation of the art pieces have become a tool to subvert patriarchy and analogously served to create symbolic identities with which the postmodernist reader can associate.

Minna Niemi looks next at Kara Walker's art, which has been perceived by many viewers as offensive; her art invokes pictography from a past that many of us would like to forget rather than see these images circulated in the present. More precisely, Walker conjures up historical images in her silhouettes that uncannily mimic the stereotypes characteristic of racist pictography in the antebellum South. In contrast to the criticism her work has received, Niemi maintains that there is a particular, although painful, value in Walker's project to which we need to remain alert. Within the theoretical framework of cultural hybridisation and creolisation, her work participates in what Romberg has referred to as a 'symbolic piracy', as the racist pictography from the nineteenth century is appropriated and turned against its initial purpose. Thus, rather than celebrating degrading visual codes, she re-appropriates and explicitly manipulates these images – 're-signifying' them and bringing them into the present in a way that allows them to retain their threatening element – but turns the threat back on the racist culture that has produced them. Niemi claims that by so doing, her art becomes capable of representing the complexities of the violent past, which needs to be remembered. In her analysis of the haunting nature of Walker's art, she turns to Freud's theorisation of art as a uniquely threatening aspect of life, the notion he elaborates on in his definition of the uncanny as the dreadful element arising from the past and in his essay 'The Moses of Michelangelo'. In the case of Walker's art, such a threat arising from the past and captured in the form of art is particularly related to the pictography of the antebellum South. Her art reminds us that only through the remembrance of past violence can the past be processed and re-evaluated in the present.

Notes

1 *Artforms*, ed. by Duane Preble, Sarah Preble and Patrick Frank, 7th edn (Upper Saddle River, NJ: Prentice Hall, 2002), p. 166.

2 André Bazin, *What is Cinema? Volume 2*, sel. and trans. by Hugh Gray (Berkeley: University of California Press, 1971; repr. 2005).

3 For some general introductions to film theory, see for example Robert Stam, *Film Theory: An Introduction* (Oxford: Blackwell, 2000) and Robert Lapsley, *Film Theory: An Introduction* (Manchester: Manchester University Press, 2006). For two other excellent studies on film theory, see Leo Braudy and Marshall Cohen, *Film Theory & Criticism*, 7th edn (New York and Oxford: Oxford University Press, 2009) and Siegfried Kracauer, *Theory of Film: The Redemption of Physical Reality*, with an introduction by Miriam Bratu Hansen (Princeton, NJ: Princeton University Press, 1997).

4 James Monaco, *How to Read a Film: Movies, Media, Multimedia*, 3rd edn (New York: Oxford University Press, 1977; repr. 2000). Janet Staiger takes a neo-Marxist stance,

emphasising: 'contextual factors rather than textual materials or reader psychologies as most important in illuminating the reading process or interpretation', in *Interpreting Films: Studies in the Historical Reception of American Cinema* (Princeton: Princeton University Press, 1992), p. xi.

5 David Bordwell, *Narration in the Fiction Film* (Madison: University of Wisconsin Press, 1985).

6 Vicky Lebeau, *Psychoanalysis and Cinema: The Play of Shadows* (London and New York: Wallflower, 2001).

7 In *Studying Contemporary American Film: A Guide to Movie Analysis*, Thomas Elsaesser and Warren Buckland include in their study of American film sections on film theory, methods, analysis, classical /post/classical narrative, *mise-en-scène* criticism, statistical style analysis, thematic criticism and deconstructive analysis, cognitive theories of narration as well as realism in the photographic and digital image. Elsaesser and Buckland interestingly are of the opinion that 'Film scholars are experts who develop a passionate interest in "unusual" theories, and ask "strange" and "obscure" questions about films' (p. vii). Other studies of national cinema include: Roy Armes, *African Filmmaking: North and South of the Sahara* (Edinburgh: Edinburgh University Press, 2006); Jonathan Rayner, *Contemporary Australian Cinema: An Introduction* (Manchester and New York: Manchester University Press, 2000); Susan Hayward, *French National Cinema*, 2nd edn (London and New York: Routledge, 2005); *East Asian Cinemas: Exploring Transnational Connections on Film*, ed. by Leon Hunt and Leung Wing-Fai (London and New York: I.B. Tauris, 2008); *Deutsche Spielfilme von den Anfängen bis 1933: Ein Filmführer*, ed. by Günther Dahlke and Günter Karl (Berlin: Henschel Verlag, 1993); Stephen Teo, *Hong Kong Cinema: The Extra Dimensions* (London: British Film Institute, 1997); Peter Bondanella, *Italian Cinema: From Neorealism to the Present*, new exp. edn (North Devon: Roundhouse Publishing, 1983; repr. 1999); Mark Schilling, *Contemporary Japanese Film* (New York and Tokyo: Weatherhill, 1999); Paulo Antonio Paranaguá, *Mexican Cinema*, trans. by Ana M. López (London: British Film Institute, 1995); Barry Jordan and Rikki Morgan-Tamosunas, *Contemporary Spanish Cinema* (Manchester and New York: Manchester University Press, 1998); and *Spanish Cinema: The Auteurist Tradition*, ed. by Peter William Evans (Oxford: Oxford University Press, 1999; repr. 2003).

8 As Tom Gunning does in his study of Fritz Lang: Tom Gunning, *The Films of Fritz Lang: Allegories of Vision and Modernity* (London: British Film Institute, 2000; repr. 2001).

9 James C. Robertson, *The Hidden Cinema: British Film Censorship in Action 1913–1975* (London and New York: Routledge, 1989; repr. 2004).

10 *Early Cinema: Space, Frame, Narrative*, ed. by Thomas Elsaesser (London: BFI, 1990; repr. 1997).

11 *Artforms*, ed. by Duane Preble, Sarah Preble and Patrick Frank, p. 26.

12 This is pointed out by Siegfried Kracauer, who discusses initial political difficulties over filming, describes the plot in detail, and analyses the juxtaposition of scenes with the criminals and then with the police authorities, as well as Lang's effective use of sound techniques in his first talkie: Siegfried Kracauer, *From Caligari to Hitler. A Psychological History of the German Film*, ed. by Leonardo Quaresima (Princeton: Princeton University Press, 1947; repr. 2004), pp. 218–22.

13 Michel de Certeau, 'Walking in the City', in *The Practice of Everyday Life*, trans. by Steven Rendall (Berkeley: University of California Press, 1984), p. 93.

Chapter 1

PROJECTING A MORE HABITABLE GLOBE: HOLLYWOOD'S YELLOW PERIL AND ITS REFRACTION ONTO 1930s SHANGHAI NATIONAL CINEMA

Lily Wong

University of California, Santa Barbara

Word of California's exclusion of overseas Chinese found its way to China's ports through the circulation of cultural production at the end of the nineteenth century. Representations of US hostility and Chinese hardship played a crucial role in provoking a Chinese urban public already enraged by images of an unjust world under Euro-American imperialism, and by a Qing state powerless in the face of such perceived injustice. For many, the aggression of American capitalism was increasingly linked to the weakness of the Qing court. Burgeoning was a frustrated public pushing for hopes of a more equal global exchange. Thus while the Qing court and the US were negotiating a renewal of the Chinese Exclusion Treaty in 1905, American goods were boycotted on the streets of Shanghai by an agitated urban public demanding just treatment of their overseas expatriates turned compatriots.[1] Though failing to make much of an impact on US policies, the boycott more or less succeeded in forming an alliance between a Chinese urban public and the Chinese diasporas, a cross-Pacific coalition tightened, if only temporarily, by desires for a fairer global imaginary.[2]

While debates over Chinese exclusion in mainstream American discourse at the time often revolved around the problem of Chinese labour, what was at stake for the demonstrators in Shanghai, however, was the dignity of their national image and its place in peril within a modernising world built on unequal global exchange.[3] Produced out of this anxiety, as Yong Chen argues, was a 'populist nationalism' which grew out of this gap in between perceptions

of Qing weakness and foreign aggression.[4] That is, a newfound 'nationalistic sentiment' was provoked through the cross-imagination and overlapping perceptions of the Chinese plight across the Pacific. This emerging nationalism broadcasted the urgency to push forth what revolutionaries of the time claimed as 'popular sovereignty': a transnational imagination of sovereignty that was separate from foreign imperialist and Qing imperial powers.[5]

This transnational provocation of popular nationalism, scholars have suggested, played a critical role in gathering reactionary sentiment necessary for the overthrow of the Qing Empire by revolution just six years later in 1911.[6] The transnational Chinese boycott thus became a popular mode of 'civilised protest', which re-emerged throughout the following decades, as seen in, for instance, the anti-Japanese boycott in 1908 and the May Fourth Movement in 1919. As Yong Chen maintains, Chinese American store owners in San Francisco burned Japanese-made cosmetics and embroideries in stock in order to show support of the anti-Japanese protests in China at the time. In Chicago, storeowners also imposed heavy fines on those who violated the boycott.[7]

At the heart of this persisting nationalistic sentiment were continuous cross-Pacific discussions of 'Chinese womanhood' – the mobility, purity and place of Chinese women as modern citizens of the global community was of critical concern. Transnational imaginations of 'Chinese women' played a vital role in China's positioning in the global community. This was made particularly clear by the US's Page Act 1875 under which Chinese female immigrants were equated with prostitutes. As a result, Chinese women were excluded from entering and, by extension, their families were prevented from settling, in the US.[8] Thus, out of the tensions over human labour between the US and China, emerged contested imaginations of one particular group of affective labourers – Chinese prostitutes. While the US's conflation of Chinese women with prostitution continued the persecution of Chinese immigrants into the twentieth century, in Shanghai these depictions of prostitutes as 'yellow peril' further provoked political fervour, with cultural production, specifically film, quickly becoming an ideological battleground through which these competing political, social and cultural tensions were played out across the Pacific.

As Miriam Hansen argues, early American cinema offered something like the first global vernacular to the world market, and this vernacular played a key role in mediating competing cultural discourses on modernity and modernisation.[9] To Hansen, 'cinema was not only part and promoter of technological, industrial-capitalist modernity; it was also the single most inclusive, public horizon in which both the liberating impulses and the pathologies of modernity were reflected, rejected, or disavowed, transmuted or negotiated', and it made this new mass public visible to itself and to society'.[10] Hollywood, producing more than eighty per cent of the films shown in China

up till the 1930s, thus offered a reflexive horizon for Shanghai left-wing intellectuals to mediate and challenge the experiences of global modernity that Hollywood projected.[11]

As Shuqin Cui suggests in *Women through the Lens: Gender and Nation in a Century of Chinese Cinema*, film, perceived as foreign and new in China, functioned as a particularly vital site of social reform. She maintains:

> Widespread social disorder and the dominance of foreign films directly exposed Chinese audiences to the hegemony of foreign power. This dual spectacle, national and visual, showed progressive filmmakers the power of cinema, the visual medium, to expose social problems and construct national discourses.[12]

Cinema served as both the proof of foreign encroachment (or more specifically Hollywood's dominance of market and representation) and also the means to propagate Chinese nationalism. It is perhaps less of a surprise, then, that the golden age of Hollywood, commonly said to be from the late 1920s to 1950s, also marked the transformation of Shanghai's early film production from a mainly commercialised entertainment industry into an increasingly politicised enterprise. As Zhang Zhen stresses, in *An Amorous History of the Silver Screen*, film at the time was 'a complex translation machine and motor for change, generated as a mass mediated social and aesthetic experience…modern science and technology – along with new ideas about class, gender and the body – collided with traditional culture in some ways but were domesticated and productively absorbed in other ways'.[13] In particular, the translating and re-narrating power of cinema that Zhang Zhen alludes to can be seen through refracted representations of 'Chinese prostitutes' across the Pacific. While Hollywood imagined Chinese women as prostitutes with questionable morals, such denigrating representations arguably provoked political fervour in the Shanghai film industry concerned with the perils of 'Chinese women'.[14] Prostitutes, in Shanghai's left-wing cinema, were thus portrayed as virtuous whores oppressed by both patriarchal traditions and foreign encroachment, specifically by the ruthlessness of global capitalism.[15] Thus, while Hollywood's projections of Chinese women as problematic prostitutes illuminate the integrity of the main, often Caucasian characters' visibility within a global imaginary, Shanghai's left-wing film industry represented Chinese prostitutes as 'virtuous whores' who readily answer to escalating calls for personal and, by extension, nationalistic reform. That is, the Chinese prostitute's body, both physical and ideological, becomes a microcosm of the nation – both the US and China – at large and it is through the appropriation of the prostitute's body that these tensions, promoted between the Hollywood and Shanghai industries, manifest themselves.

This chapter, then, zeroes in on this exchange of representation between the two film industries, and looks closely at the relationship between two particular actresses at the core of such representations – the Chinese American actress Anna May Wong, and China's 1930s icon Ruan Lingyu. I trace the two actresses' negotiation between portrayals of the 'Chinese prostitute' on screen and the larger social discourse of 'modern Chinese women' integrated and excluded by both the Hollywood and Shanghai film industries. I ask: what does it mean when desires to perform competing notions of 'modernity' in the face of an imagined global community, are projected on this so-called 'modern Chinese woman' scripted to be simultaneously desired and disdained by her various audiences? Juxtaposing my readings of Anna May Wong with Ruan Lingyu, I show how the actresses, or rather their travelling images, affectively produce perhaps what Walter Benjamin calls a 'productive apparatus' – their 'degenerate' performances functioning as generative sites that produce as they unsettle contending discourses of 'global modernity' as its symbolic economies morph, mediate, and are even disrupted when projected across the Pacific.[16]

By the 1930s, Anna May Wong was already quite visible on the Hollywood screen. She was able to play supporting roles in major films such as *Peter Pan* (1924), *Thief of Bagdad* (1924) and *Piccadilly* (1929), and even took on lead roles in movies such as *Toll of the Sea* (1922). Despite her cinematic visibility, the roles given to her were, many have argued, limited to particular orientalist imaginations of Chinese women – with her scripted as either the innocently available lotus blossom or the morally loose dragon lady. From pregnant woman-in-waiting to Mongolian slave, from murderous prostitute to daughter of villainous gangsters, her roles ranged from the easily degraded to the degrading woman of the Orient. As the first Chinese American actress known worldwide, Wong became the focus of studies investigating US racial stereotyping, and the limits and/or possibilities of resistance through performance.[17] Here, instead of reading her within the boundaries of US politics, I place her within a trans-pacific framework. In so doing, I see the 'nation-state' (be it the US or China) as interdependent with, rather than mere producer of, global exchange. Thus, reading Anna May Wong's image through this trans-pacific framework, I investigate not racialisation or resistance, *per se*, but trans-pacific productions of modernity and discourses of development and nation-building involved with it.

As Wong's performance of 'questionable' Chinese women travelled internationally, it produced a wide range of responses. Commenting on her performance in *Toll of the Sea*, the *New York Times* exclaimed: 'Miss Wong stirs in the spectator all the sympathy her part calls for, and she never repels

one by an excess of theatrical 'feeling'…. Completely unconscious of the camera, with able pantomimic accuracy…she should be seen again and often on the screen.'[18] English journalist P. L. Mannock, acclaimed her to be a 'glamour sensation' in London-based magazine, *Picturegoer*.[19] *Mon Ciné*, a popular French magazine at the time, put Wong on the front cover of their July 1924 issue and included a detailed article reviewing Wong's career.[20] In spite of the praise of the Euro-American press, Wong's increasingly eroticised personas in such films as *Thief of Bagdad* and *Piccadilly* provoked strong critique from urban Chinese intellectuals. Shanghai's *Dianying Zazhi* (Movie Magazine), for instance, criticised Wong as 'not satisfy[ing] Chinese peoples' hopes'.[21] *Dianying Huabao* (The Screen Pictorial), another Shanghai magazine, argued that she failed to 'respect her identity', and urged her to earn the respect of her countrymen.[22] Anna-May Wong herself, along with the wider Chinese American community in California in particular, also vocally expressed their frustrations with Hollywood's depictions either through published articles or self-funded minor film productions.[23] Thus, competing with Hollywood's marketing of Wong's public persona, is arguably the trans-pacifically produced – between the Chinese and Chinese Diasporas – nationalistic rhetoric developing since the 1905 boycott.

Wong's enactment of a 'Chinese prostitute' in *Shanghai Express* (1932), in particular, heightened this cross-pacific contention over representations of 'Chinese women' and, by extension, of the 'modern Chinese nation'. Set in China during a time of civil unrest, *Shanghai Express* portrays the adventures of a group of first class passengers travelling on the Shanghai Express – a train from Beijing to Shanghai. In the film China is painted as an exotic place which by nature proves incompatible with modern development. Before the train even starts, the foreign passengers bet on how late the train will be when it eventually arrives at Shanghai station. As one American passenger asserts, 'we are in China now…where time and life have no value'. At the heart of the narrative is thus the tension caused by this perceived incongruity of time – specifically that between the universal modern time the train is engineered to follow, and the timelessness of China which can affect even modern technology, or in this case, the train to derail from its temporal track. As framed in Figure 1 for instance, Chinese people and livestock wander on the railroad tracks, literally blocking the train from progressing forward.

China is thus portrayed as a place inherently incompatible with modern progress, revealing the chronopolitics of modernity through which non-Western worlds, in this case China, are measured to be always lagging behind in a teleological logic of modern development.[24]

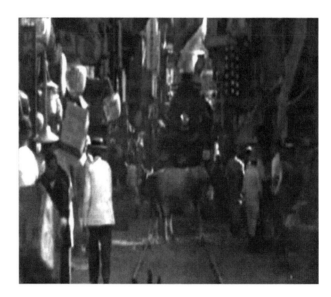

Figure 1. Chinese people and livestock blocking the *Shanghai Express*. © 1932 Paramount Pictures. All rights reserved.

Not only is China depicted as a place temporally out of step with modern progress, it is framed as a site where 'modernity' is easily led astray. This can also be detected through the varied depictions of the film's two heroines. As the tale's main heroine Shanghai Lily (a British escort played by German actress Marlene Dietrich) explains her 'fallen' situation to her former lover Dr Harvey, she states that 'five years in China is a long time', as if implying that it was precisely her prolonged stay in China that turned her into a wandering prostitute. Opposite Shanghai Lily is the Chinese prostitute Hui Fei (played by Anna May Wong). Unlike Shanghai Lily's degraded status, Hui Fei's is apparently in no need of explanation and, thus, granted none in the narrative. Though the film scripts the two women as travel companions and as both women of infamous profession, it goes to great lengths to differentiate them and, by extension, their respective respectability and desirability.

Their difference is shown immediately once they are introduced into the narrative. At the Beijing station, Hui Fei is carried in on a wooden crate, apprehensively looking around and then shown scurrying onto the train. Shanghai Lily, on the other hand, enters the station in an automobile, and then strides proudly onto the platform. Immediately, the two heroines' access to modern mobility and respectability are differentiated in the film. As Anthony Chan observes, 'Shanghai Lily is the intense, modernised, and motorised Western woman. She is the female foil to Hui Fei, who represents China in all its backwardness and traditional decadence, made even more primitive by

her reliance on a human-powered vehicle'.[25] To the first class Euro-American passengers on the train, Shanghai Lily is clearly the more desirable of the two; as an American passenger asserts, 'I thought they were rather good looking, at least Shanghai Lily is.' While a Presbyterian minister laments the sinful presence of these two women in a first class compartment, the British Doctor Harvey proclaims: 'I don't know about the Chinese woman, but for the other lady…she is a friend of mine.' This hierarchy of desirability is again reasserted when the Doctor refuses to recognise Hui Fei when being introduced by Shanghai Lily, stating that he 'reserve[s] the privilege to choos[e] [his] friends'. In response, Shanghai Lily replies, 'she's no friend of mine, I'm only trying to be decent'. Here we again see a scripted distance in the two characters' allowed proximity to modern propriety and even association.

The two heroines' respectability further diverges as the plot progresses. The villain Mr Chen desires first and foremost Shanghai Lily, yet with the protection of Dr Harvey Shanghai Lily is untouched. Frustrated, Mr Chen in turn manages to rape Hui Fei without much difficulty due to her relatively dispensable place in the eyes of the train's first class passengers. Later on when Shanghai Lily is eventually forced to offer herself to Mr Chen in order to save Dr Harvey, Hui Fei mysteriously appears and kills the villain. By killing off the tale's 'yellow menace', Hui Fei saves the integrity of not only Shanghai Lily but also her relationship with the doctor. The tale thus closes with the lovers reunited. Shanghai Lily reforms in order to be forever with her lover. Hui Fei disappears from the tale as the train arrives at Shanghai station, as expected, four hours late. Here, one can draw an analogy between Hui Fei and China, as they both represent the exterior of a respectable modern imaginary, both morally and temporally out of step with their comparable contemporaries. Moreover, Hui Fei's embodiment of a 'timelessly backward oriental woman' highlights, and eventually enables, Shanghai Lily's becoming a 'respectable modern woman'.

Despite being one of the most popular of Anna May Wong's films, *Shanghai Express* attracted the strongest critique from Shanghai's left-wing intellectuals such as Hong Shen. The then screen writer and professor of drama, Hong Shen, led a protest of students from Fudan University to interrupt the opening night screening of *Shanghai Express*.[26] The film was not only eventually banned, but Paramount Picture's license in China was suspended as a result.[27] *Beiyang Huabao* (Pei-Yang Pictorial News) ran the headline 'Paramount Uses Anna May Wong to Embarrass China Again'.[28] Shanghai tabloids went on to deride Wong as 'the female traitor to China'.[29] As the film dominated the box office at a moment when Paramount pictures was attempting to buy out all the Chinese studios, the success of Shanghai Express, despite the Nationalist Government's purported ban, worked as a reminder of the US's hegemony in both economic capital and cultural representation.[30] The film, moreover, came

out in the midst of the Nationalist Party's 'Anti-Spiritual Pollution Movement', a movement to reform the Chinese public into so-called 'new', 'modern' and 'moral' global citizens.[31] *Shanghai Express*' portrayal of the Chinese prostitute and, by extension, China as being timelessly out of step with global modernity was thus one of the first things attacked by both the intellectual activists and the Nationalist government.[32] For Anna May Wong's performance of a Chinese prostitute, as disposable and degradable within the Hollywood imaginary, was perceived as a disgrace and thus arguably a call to action.

A national cinema movement arose in Shanghai around the same time of *Shanghai Express*'s ban, re-narrating Chinese womanhood in reformist films such as *Sange modeng nuxing* (Three Modern Women, 1933), *Xiandai yi nuxing* (A Modern Woman, 1933), *Xin nuxing* (New Women, 1934) and *Liren xing* (Three Beautiful Women, 1949).[33] Moreover, the trope of the 'Chinese prostitute' was on the Shanghai Screen re-narrated as helpless victims oppressed by both patriarchal traditions and global capitalism. In *Shanghai Express*, Hui Fei, raped and denied any respectable association, was given no access into a respectable family structure. Through depictions of Shanghai National Cinema,[34] however, the Chinese prostitute was unambiguously incorporated within the family structure, but not without a reactionary function. These re-narrated 'Chinese prostitutes' were scripted to perform a family in crisis – their precarious place within the family institution scripted to mirror a nation humiliated by foreign invasion and infested by domestic oppression.

Produced by Lianhua studios and popularised on Shanghai's silver screen, *The Goddess* was one of the first of such productions, released just two years after *Shanghai Express*. The film tells the tale of an unnamed prostitute who walks the streets in order to save for her son's education. Originally titled Shennü in Chinese, the title literally connotes both streetwalker in Shanghai dialect if read from one direction and goddess in mandarin if read the other. This Madonna-whore configuration is further developed into the heroine's character, for she is portrayed as attentive mother by day and alluring street walker by night. At the opening of the film, the following description is inscribed upon an image of a naked mother kneeling to nurse her baby:

> struggling in life's turmoil on the streets, she is just a lowly prostitute…but when she picks up her son in her arms, she becomes a loving mother. In the midst of her two lives, she shows her great humanity.

This compassionate juxtaposition of these public (streetwalker) and private roles (virtuous mother) is unique compared to popular discourses of the time which increasingly demoralised prostitution.[35] By embodying the plight of both capitalist exploitation and domestic oppression, the heroine thus demarcates a renewed site of public sympathy and incentive for reform.

When on the streets, the heroine is placed either next to a massive Chinese character for *dang*, advertising a pawn shop (Figure 2), or life-sized mannequins glowing from the store window behind her (Figure 3), signalling her status as an objectified commodity traded and consumed alongside flows of capital.

Walking the streets out of desperation, she is forced, moreover, to evade the police, to succumb to the bullying of local gangsters, and to endure the

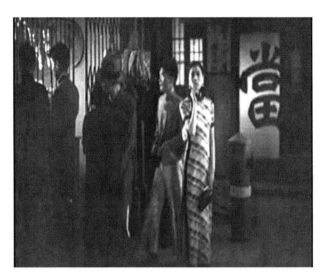

Figure 2. The heroine standing in front of a pawn shop. © 1932 Paramount Pictures. All rights reserved.

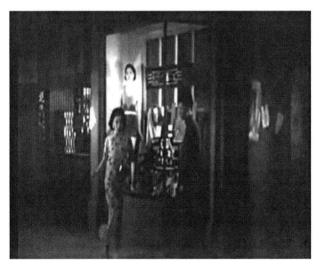

Figure 3. The heroine running past a mannequin placed in store window. © 1932 Paramount Pictures. All rights reserved.

humiliation of common prejudice. In the eyes of the police she is not a citizen worth protecting, in the mind of the gangsters she is to be used as property, and for the commoners around her she is a disgrace.

In addition to viewing her degraded public persona, however, the audience is allowed a panoramic perspective of the heroine as a virtuous mother within her private quarters. Time is the dominant means through which her two personas are demarcated. In Figures 4–7, for instance, the camera cuts from the heroine cleaning up after dinner to a close-up of the

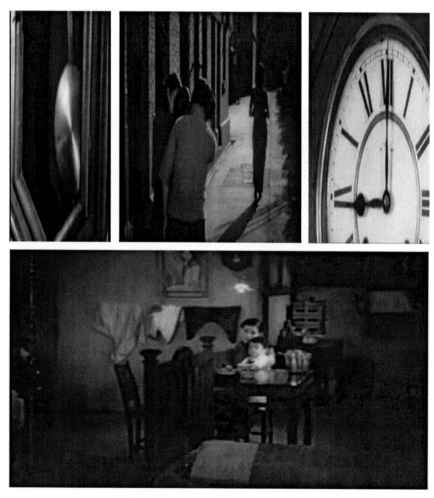

Figures 4–7. The heroine's private labour as mother and public labour as streetwalker being split by modern clock-time. © 1932 Paramount Pictures. All rights reserved.

wall clock. Followed, is a medium-shot of the heroine rocking her son to sleep to the rhythm of the clock's pendulum until the clock points to the Roman numeral nine. Immediately she tucks her son to sleep and heads to the streets. Thus, resting at the centre of the filmic frame, the Western-style wall clock and, by extension, technological and quantified modern time functions as the immaterial force that divides the respective labours of her two personas.

Portrayed as a virtuous whore, the unnamed prostitute's personhood splits and compartmentalises perceptions of public and private womanhood by embodying both virtuous mother by day and scandalous prostitute by night. Here, we see a re-situating of 'public' or more specifically a site of public sympathy, in between the absence of a just state patriarchy (symbolised by the corrupt police and gangsters running the streets), the oppressive residue of Confucian morals (represented through the prejudice of the commoners), and the encroachment of global capital (signified not only through the film's blatant references to commodity culture, but also the heroine's division of labour through regimented modern time). The urgency to mend and restructure the public and private, fragmented by such external forces, is made even more apparent when various male figures enter into the narrative and breach the heroine's private quarters.

The privatised family fantasy is in *The Goddess* openly exposed and abandoned. The story starts with an already ruptured family, one composed of merely the nameless prostitute and her son. The gangster is the first to swing open the heroine's door. After a brief encounter on the streets, the gangster tracks her down and forces his way into her private quarters, forcefully enacting a marriage ceremony with leftover food and cheap wine. Left with no choice, the heroine helplessly succumbs to his forced encroachment, letting him exploit both her public and private labours. As a self-proclaimed husband he takes advantage of her domestic labours, having her cook and share his bed unwillingly; as her self-appointed pimp, he confiscates the money she earns on the streets and gambles it away aimlessly. The son's schoolmaster is the other patriarchal figure that enters, uninvited, into the heroine and son's domestic life. Stepping into their room, he exposes his concern for her questionable occupation, causing the heroine the embarrassment for having to ask the child to step out of the apartment while she and the schoolmaster converse. In so doing, the schoolmaster physically breaches the mother and son's comfortable place behind closed doors. Although the schoolmaster leaves feeling sympathetic for the heroine, his exposure of the heroine's profession to the school board nonetheless ends in the boy's expulsion.

With these two patriarchal interventions, questions over this unnamed prostitute's rights as a human being emerge: 'Even though I am a degenerate woman, don't I have the right as a mother to raise him as a good boy?'

the heroine cries in protest. Moved by the heroine's plea, the schoolmaster argues in front of the school board:

> The problem is not with her, but with our society. She is a human being and has her human rights – so does her son. Particularly her son.

Here, the school master takes issue with society and its future embodied by the son who is helplessly set up to fail. The son, particularly the son, is seen as being unjustly deemed subhuman despite his and his mother's arduous endeavours. The school master maintains:

> It is all because…she [the heroine] wants him to have an education – which she never had. She wants him to have a chance – which she never had. We who consider ourselves educators must make sure he has that chance. We have a moral duty to save him from this toxic environment.

The schoolmaster takes up his 'moral duty' and calls for a re-evaluation of what he sees as unfitting and unjust public understandings of human rights, propriety, and morality in the case of virtuous prostitute and son.

This hail for social reform is, moreover, unambiguously exemplified in the film's conclusion. Expelled by the school and exploited by the gangster, the heroine and her son, as seen in Figure 8, are pushed to the edges. Looking out

Figure 8. The heroine and son glaring at society in and out of the movie screen.

from the windows of their impoverished domestic quarters, they glare straight into the camera, staring at a public (both inside and outside the screen) that leaves them no space for survival.

Disappointed by the cruelty they encounter, the heroine takes action into her own hands and sets out to retrieve her money from the gangster, ending up only to accidentally kill him. Sentenced to twelve years in prison, her labour is consequentially suspended, relieving her from the temporal cycle which divides her private and public labours as mother and prostitute, from dusk till dawn. The regulation of 'modern clock time' which splits the heroine's labour is here substituted by the enforcement of a 'national' time that clocks her moral duty to be of twelve years. That is, we see a substitution of capitalist regimentation for national regulation, from capital's division of labour to the nation's determination of morals.

This substitution is even more pronounced at the end, when the schoolmaster replaces the heroine as surrogate guardian of her child. The schoolmaster visits the heroine in prison and promises to raise and instruct her son as if his own, in turn relinquishing her from her labours as a mother all together. Asking never to be mentioned again, the heroine willingly erases herself from the son's memory once and for all. For 'in the solitary and quiet life of the prison, she finds a new peace in imagining her child's future'. Through her symbolic death behind bars, the heroine not only breaks loose from the temporal shackles of quantified labour but renews her son's future by cutting off his past. In particular, she severs her 'natural' affiliation with him to leave room for a more sustainable surrogate. Her degenerative actions as streetwalker, murderer and unfit mother, in effect, are what generate the possibility for a renewable future for the son and the Chinese society he embodies.

The disgraced prostitute redeems herself as a selfless goddess by succumbing to her own body as a street walker, as forced property to the gangster, as a social problem in need of inspection by the schoolmaster, as a murderer imprisoned behind bars, and finally as a substituted parent erased from her son's memory. She exposes her private body, private quarters and even private relationship with her son for a reconfigured imagination of a better future and bigger message. Her figure heralds an urgency for reform which reflects the Shanghai left-wing cinema's dual function – it projects an external (cultural and economic) resistance against Hollywood's international domination, while internally mythologising nationalistic collectivity.[36] In the case of *The Goddess*, moreover, this nationalistic sentiment is not comfortably aligned with the Nationalist Party, *per se*, but embodied by a heroine damaged by its allowed patriarchal forces (be it the bullying police, the exploitative 'husband', or even the sympathetic schoolmaster). The nameless prostitute elicits nationalistic sentiments re-defined through a site of public sympathy

demarcated by anxieties over both a nation-state led astray and the straying powers of global capital. This left-wing staging of public sympathy, in other words, heralds urgency to redeem the public from increasing degradation by capitalist divisions and domestic oppression.

This reconfiguration of the public and private on the narrative level is arguably both reflected and refracted on the level of filmic form and public spectatorship. Miriam Hansen argues that early cinema provided an alternative social space which was distinct from the domestic and work spheres, where people of similar background and status could find company not necessarily of their own kin.[37] She states that 'it was the interaction between the films on the screen and the 'film in the head of the spectator…that allows individual experience to be articulated and thus organised in a participatory, social and public mode'.[38] Thus, to Hansen, early silent cinema offered an alternative experience of public participation through a re-imagination of one's interior – whether projections of the private sphere, or one's individual experience – shown from the particular vantage point of the alternative public space of the movie theatre.[39] This rings true especially in the case of Shanghai National Cinema, since the majority of films screened were, like *The Goddess*, 'family melodramas'. For, bringing together the nation's most prominent and persistent metaphor, the family, with its most disenfranchised embodiment and the prostitute, *The Goddess*' sensationalised tale about the private (a 'prostituted' family in crisis) is thus staged to move and mobilise alternative means of public participation from its audience, be it reform or revolution.

Tracing Anna May Wong and Ruan Lingyu's performances, we can delineate cross-pacific tensions over definitions of 'modern womanhood' projected through competing filmic representations of the 'Chinese prostitute' – a figure designed to embody the exteriors of 'modern womanhood' and, by extension, the 'modern citizen'. In focusing on the travelling and transmuting representations of the actress, I track the overlapping yet uneven and often conflicting intersections of American racialisation, global capitalism and Chinese nation-building. That is, I read the actresses' varied performances of 'Chinese prostitutes' as sites that produce and unsettle competing discourses of 'being Chinese' in a time haunted by modern development, imperialist threats and nationalistic passions.

Anna May Wong's performance of Hui Fei in *Shanghai Express* on the one hand sustains the developmentalist teleology of Euro-American centric modernity. Enacting an 'objectionable' Chinese prostitute on screen, her problematic image generates a desirable association between whiteness and modern femininity. The same image projected to Shanghai, on the other hand, produces also the urgency for Chinese nationalistic uprising. While Wong's performance serves as historical evidence of US racialisation, it also indexes

a historical shift in Chinese political activism. That is, while Hollywood's stereotyping of Chinese women in *Shanghai Express* arguably highlights the integrity of whiteness and its place as leader of modern development, the Shanghai film industry re-narrates the trope of the Chinese prostitute in *The Goddess*, refracting the fallen image of the prostitute into a rising call for nationalistic advancement. Playing a virtuous whore willing to succumb to her body, more importantly to her own flesh and blood – son – for the betterment of the nation, Ruan Lingyu's performance heralds the need to detach modern development from capitalist regimentation, and to synchronise, instead, ethical advancement with national regulation.

We, thus, see Ruan's performance of the 'Chinese prostitute' overlapping with the travelling image of Anna May Wong. Their cinematic encounters, I stress, make transparent competing chronopolitical discourses of 'modern' progression – in this case, that between a capitalist teleology of modern development and a nationalist time for social-ethical advancement. Thus, by delineating the ways Ruan and Wong's moving images reflect, refract, resist and even rejuvenate contending narratives, we can see how their marked bodies reveal as they affect overlapping regimes in production of meanings to be in the world, on time, on site with 'global modernity'.

Notes

1 For more on the 1905 boycott see Jane Leung Larson, 'The 1905 Anti-American Boycott as a Transnational Chinese Movement', in *Chinese America: History and Perspectives* (Chinese Historical Society, 2007), which focuses specifically on the role the Baohuang Hui played in the overall movement.

2 As Larson shows, the boycott movement reached communities well beyond Shanghai and California; it travelled and affected other diasporic communities in Hong Kong, Yokohama, Singapore, Honolulu, Burma and beyond.

3 For more on mainstream anti-Chinese discourse in the US, see Eric Hayot, *Hypothetical Mandarin: Sympathy, Modernity, and Chinese Pain* (New York; Oxford: Oxford University Press, 2009), chapter 4; and Yong Chen, *Chinese San Francisco 1859–1943* (Stanford, CA: Stanford University Press, 2000), chapter 6.

4 Chen, *Chinese San Francisco 1859–1943*, pp. 148–61.

5 For more on 'popular sovereignty' see Larson, 'The 1905 Anti-American Boycott as a Transnational Chinese Movement', pp. 6–12.

6 See for instance Larson and Chen.

7 Chen, *Chinese San Francisco 1859–1943*, p. 233.

8 For more on the relation of the Page Act and the later, Chinese Exclusion Act in 1882, see George Anthony Peffer, *If They Don't Bring Their Women Here: Chinese Female Immigration before Exclusion* (Urbana: University of Illinois Press, 1999), Elmer Sandmeyer, *The Anti-Chinese Movement in California* (Urbana: University of Illinois Press, 1939) and Karen J. Leong, *The China Mystique: Pearl S. Buck, Anna May Wong, Mayling Soong, and the Transformation of American Orientalism* (Berkeley and Los Angeles: University of California Press, 2005).

9 Miriam Hansen, 'Fallen Women, Rising Stars, New Horizons: Shanghai Silent Film As Vernacular Modernism', *Film Quarterly*, 54.1 (2000), 10–22 (p. 11).

10 Ibid.

11 As Laikwan Pang notes: 'in the year of 1936, among all films shown in China, only 12 per cent of them were local productions, [and] American films comprised more than 80 per cent': *Building a New China in Cinema* (Lanham: Rowman & Littlefield Publishers, 2002), p. 148.

12 Shuqin Cui, *Women through the Lens: Gender and Nation in a Century of Chinese Cinema* (Honolulu, HI: University of Hawai'i Press, 2003), p. 9.

13 Zhang Zhen, *An Amorous History of the Silver Screen: Shanghai Cinema, 1896–1937* (Chicago: University of Chicago Press, 2005), p. xxx.

14 For more about the 'women problem' in early Shanghai Cinema, see Sarah Stevens, 'Figuring Modernity: The New Women and The Modern Girl in Republican China', *NWSA Journal*, 15.3, Gender and Modernism Between the Wars, 1918–1939 (2003), 82–103.

15 The politicised figure of the prostitute can be seen in various films including *The New Women*, *The Goddess* and *Daybreak*. For more about how filmic representations of Chinese prostitutes became key apparatus in China's nation-building process, see Shuqin Cui, *Women Through the Lens: Gender and Nation in a Century of Chinese Cinema* (Honolulu, HI: University of Hawai'i Press, 2003), pp. 15–18.

16 For more on Benjamin's notion of 'productive apparatus' see Walter Benjamin, 'The Author as Producer' in *Reflections: Essays, Aphorisms, Autobiographical Writings*, ed. by Peter Demetz and trans. by Edmund Jephcott (New York: Harcourt Brace Jovanovich, 1978), p. 23.

17 For more analysis on Anna May Wong and her cinematic performances, see Celine Shimizu, 'The Sexual Bonds of Racial Stardom: Asian American Femme Fatales in Hollywood', in *The Hypersexuality of Race: Performing Asian / American Women on Screen and Scene* (Durham, NC: Duke University Press, 2007), and Cynthia W. Liu, 'When Dragon Ladies Die, Do They Come Back As Butterflies?: Re-imagining Anna May Wong' in *Counter Visions: Asian American Film Criticism*, ed. by Darrell Y. Hamamoto and Sandra Liu (Philadelphia: Temple University Press, 2000), pp. 23–39.

18 'The Toll of the Sea', *New York Times*, 27 November 1922, p. 18.

19 *Picturegoer*, 29 November 1924.

20 *Mon Ciné*, July 1924.

21 *Diangying Zazhi*, November 1925.

22 *Diangying Huabao*, May 1925.

23 Anna-May Wong publically denounced unfair representations of her and 'Chinese people' in articles such as 'The Chinese Are Misunderstood', which appeared in *Hua Tzu Jih Pao*, 22 February 1936, and in which she explained her predicament in taking on demeaning roles. As if in a gesture to declare independence from Hollywood, Wong starred in *The Silk Bouquet* (also known as *The Dragon Horse*, 1926) – a film funded by the San Francisco–based Chinese American company Chinese Six Companies and which, as noted in an article on the film in *Mein Film*, 'improved the poor opinion that America has about Chinese people' and 'portrayed Chinese people in a positive light'. See *Mein Film* 10, 1926.

24 For more on chronopolitics of development, see Elizabeth Freeman, 'Time Binds, or, Erotohistoriography', *Social Text*, 23 (2005), 57–68.

25 Anthony B. Chan, *Perpetually Cool: The Many Lives of Anna May Wong (1905–1961)* (Maryland: The Scarecrow Press, 2007), p. 227.

26 For Hong Shen, see Jay Leyda, *Dianying Electric Shadows: An Account of Films and Film Audience in China* (Cambridge, MA: The MIT Press, 1972), p. 82. On students, see Jonathan D. Spence, *The Search for Modern China* (New York: Norton, 1999), p. 283.

27 For more on Paramount Picture's suspended license, see Ruth Vasey, *The World According to Hollywood* (Madison: University of Wisconsin Press, 1997), p. 155. It is important to note here that the banning of films was initiated not by the Nationalist government but by May Fourth intellectuals, thus showing a difference between the 'nationalistic sentiment' promoted here and the Nationalist party in power. For more about the May Fourth intellectuals' uneasy relationship with the Nationalist government in the case of film censorship, see Xiao Zhiwei, 'Anti-Imperialism and Film Censorship During the Nanjing Decade, 1927–1937', in *Transnational Chinese Cinemas: Identity, Nationhood, Gender*, ed. by Sheldon Lu (Honolulu, HI: University of Hawai'i Press, 1997), pp. 35–58.

28 *Pei-Yang Pictorial News*, 5 December 1931.

29 *Radio Movie Daily News*, June 1932.

30 As early as 1931, Paramount Pictures had planned to buy off all Chinese Film Studios with $15 million. For more on this, see Xiao, p. 44.

31 For more on China's 'Anti-Spiritual Pollution Movement's' effect on the Chinese film industry at the time, see Xiao.

32 See Zhang Yinjing, 'Prostitution and Urban Imagination: Negotiating the Public and Private in Chinese Films of the 1930s', in *Cinema and Urban Culture in Shanghai, 1922–1943*, ed. by Yinjing Zhang, (Stanford, CA: Stanford University Press, 1999), pp. 170, 301, n.44.

33 These reactionary narrations, however, were not fully embraced by left-wing intellectuals. For more about the debate see Zhang Zhen, *An Amorous History of the Silver Screen: Shanghai Cinema, 1896–1937* (Chicago: University of Chicago Press, 2005), chapter 7.

34 Here, I refer to this left-wing cinema as 'Shanghai National Cinema' instead of 'Chinese National Cinema' as a way to retain the internal friction between the Shanghai identity and the Chinese national identity that this cinematic movement claimed to simultaneously represent. In so doing, I highlight the particular cultural and political landscape the city of Shanghai provided in order to excite the emergence of this nationalistic cinema, and how its self-avowed national profile not always reflected the overall sentiments of the Chinese nation. For more, see Laikwan Pang, 'Shanghai or Chinese Cinema?', in *Building a New Cinema in China: the Chinese Left-Wing Cinema Movement, 1932–1937* (Lanham: Rowman & Littlefield Publishers, 2002), pp. 165–96.

35 A trend seen not only projected through Hollywood films such as *Shanghai Express*, but also in popular domestic representations. For as Gail Hershatter notes, in *Dangerous Pleasures: Prostitution and Modernity in Twentieth-Century Shanghai* (Berkeley and London: University of California Press, 1997), the 1930s marked a change in representations of prostitution in historical sources, for they were now seen as medical and moral problems, 'represented as the disease-carrying, publicly visible disorderly and victimised "pheasant"' (p. 8).

36 For more on dual function of National Cinemas, see Sheldon Lu, *Transnational Chinese Cinemas: Identity, Nationhood, Gender* (Honolulu, HI: University of Hawai'i Press, 1997), p. 6.

37 Hansen, 'Early Silent Cinema: Whose Public Sphere?', pp. 155–58.

38 Ibid., p. 159.

39 Ibid., pp. 155–58.

Chapter 2

BERLIN – THE CITY OF SOUND AND SENSATION IN FRITZ LANG'S *M* AND E. A. DUPONT'S *VARIETÉ*

Isa Murdock-Hinrichs

University of California, San Diego

London is an old lady in black lace and diamonds who guards her secrets with dignity and to whom one would not tell those secrets of which one was ashamed. Paris is a woman in the prime of life to whom one would only tell those secrets one desires to be repeated. But Berlin is a girl in a pullover, not much powder on her face, Hölderlin in her pocket, thighs like those of Atlanta, an undigested education, a heart that is almost to ready to sympathize, and a breadth of view that charms one's repressions from their poison, and shames one's correctitude. One walks with her among the lights and in the shadows. And after an hour or so one is hand-in-hand.

—Harold Nicolson, 'The Charm of Berlin' (1932)

I am not satisfied with the expression 'street image'; I would prefer to say 'street landscape' or 'cityscape', for what it refers to is the actual landscape total image, which is produced by the arrangement and forming of masses in the same manner as the natural landscape emerges out of the grouping of mountain masses and vegetation.

—Walter Rathenau, 'Die Schönste Stadt der Welt' (1902)

Joe May's *Asphalt* (1929) opens with a scene of several men solidifying the asphalt on newly built streets with large handheld objects. Asphalt as a foundation of the city seems to promise not only swifter movement and a level ground for the passage of horse carriages, cars and pedestrians, but also appears to hint at the way in which the progressive urbanisation shapes German culture and becomes an increasingly prominent aspect of Weimar cinema. The next few scenes focus on the bustling life of the city. May intersperses rapidly moving cars and low angle shots capturing feet of the crowds as they cross streets and push through the traffic with images of people pausing fascinated in

front of store windows, watching live models pulling on stockings. The film contrasts those with shots of the intimate settings of Sergeant Albert Holk's home. These interior spaces resemble Biedermeier idylls, albeit lower class, of family intimacy. Holk's mother knits contentedly to the right of the frame while her husband across the table reads the newspaper and drinks coffee/tea. The bustling movement of the streets clashes strangely with the tableau-like stillness of the domestic scenes. The beginning of *Asphalt* encapsulates Berlin's precarious role as a rapidly growing city in a nation whose culture is still steeped in traditions that seem far removed from the modernity that the social and economic transformation of the Weimar Republic inaugurates.

Asphalt is part of a larger oeuvre of Weimar's films that foreground the urban as a tantalising site of modernity and social transformation. The relatively large number of films, ranging from Karl Grune's *The Street,* Joe May's *Asphalt,* G. W. Pabst's *Joyless Street, Diary of a Lost Girl* and *The Love of Jeanne Ney,* to Fritz Lang's *Dr. Mabuse, The Gambler* and *Spies* (to name a few), exemplifies the popularity of the genre and the fascination of Weimar's population and filmmakers with this particular setting. It is however Fritz Lang's *M* (1931) that transforms the urban environment into one that reflects the rural psyche of Germany's citizens and that critically represents Berlin's unique position as a city that was at once representative of all of Germany and strangely disconnected from it. A reading of Lang's film, in particular in conjunction with E. A. Dupont's *Varieté* (1925), reveals how Berlin's fascination with modernity and different modernisms contributes to a disjunction between the social and spatial environment and the cultural psychological reaction to these sites.

Lang's visual representation of *M*, like Walter Ruttmann's *Berlin Symphony of the Big City*, lacks direct references to Berlin as a city.[1] This includes absence of architectural markers that would identify the setting as Berlin such as portrayals of famous buildings or sequences along well known districts and or streets, i.e. the Kurfürstendamm, the Brandenburg Gate, Unter den Linden and so on. Lang's distinct choice of Berlin as a diegetic setting appears only as an oblique reference on the soundtrack, yet even these mentions are accessible only to German speaking audiences, as the subtitles fail to reveal them. The dialect of the people, in particular the organised crime gangs, can easily be identified as *Berliner*, and inspector Lohmann's arrest of the petty thieves in the bar is accompanied by a reference that they are to be taken to the 'Alex' – meaning the police headquarters at the Alexanderplatz. This direct reference to a social and cultural institution is lacking in the subtitles which merely convey that the criminals be taken to 'the police station'. The omission of these verbal references to Berlin in the subtitles hints at a problematic that Lang explores throughout the film. *M* displays a curious dissonance between the images and the soundtrack. In other words: the soundtrack creates a

portrayal of the city that results in a slippage between the auditory and visual phenomena of the film. As such the soundtrack conveys meanings beyond those revealed through the images. However, the camera similarly identifies the limitations of the soundtrack as medium of narration and interprets the voice over beyond that which the verbal narration of the murder investigation conveys. These slippages suggest that Lang relies on film form to delineate Berlin's socio-spatial environment in the early twentieth century.

Lang curiously represented the film, entirely a studio production, in an interview in 1931 as documentary.[2] This claim seems to confuse the general genre conventions and formal structures associated with documentary and narrative filmmaking. Several interpretations of this fascinating remark and analyses of the film have linked the murder in the film to the case of the 'Vampire of Düsseldorf', the notorious murderer Peter Kürten who was convicted of nine counts of murder and seven counts of attempted murder merely two weeks before the film premiered on 11 May in 1931.[3] These interpretations thus suggest that the film exploited the sensationalism that surrounded the actual apprehension of the murderer and resulting mass hysteria and that it re-staged events and investigative techniques that are related to actual events. Yet Lang's film appears to function as a documentary on yet another level, the film itself seems to convey a way in which the socio-economic conditions and Berlin as a metropolis shape the perception and means of construction of a social and communal space and identity. As such the film bears striking similarities to what Sabine Hake identified as Walter Ruttmann's project in *Berlin, Symphony of the Big City*. Hake suggests that the value of Ruttmann's film lies less in the truthful portrayal of urban life in Berlin than in demonstrating the mechanisms that uphold and constitute such an image and reality.[4] In fact, *M* presents glimpses at historical and cultural events that shaped Weimar Germany but more importantly reveals the elements and interpretations of the individual and collective psyche.

Lang's first experiment with sound as a new technology relies precisely on this new medium to compose and shape the perception and representation of the setting and the city. Whereas silent film often includes extra-diegetic music to accompany the narrative of the film, Lang refrains from use of extra-diegetic music. The pointed absence of and extremely limited use of soundtrack, whether in the form of noise, music, or dialogue, fashions instead his portrayal of early twentieth-century Berlin as strangely devoid of the bustle of urban life. These opening scenes convey Berlin's problematic position as urban focal point and national capital. Despite Berlin's role as Weimar's cultural, political and social centre, Weimar Germany was still a predominantly rural environment. The 1925 census revealed that only 27 per cent of the 63 million people of Germany were living in a city of more than 100,000 inhabitants. However, Berlin was with 4.3 million inhabitants

in the 1930s by far the largest city and about four times the size of the next largest city, Hamburg.[5] These numbers are significant insofar as they provide insight into the discordant cinematic representations of cities and city life.

Lang strangely transforms the bustling city into an image that consists of tenement buildings and small alleys as he opens the film with a black screen and the voice over of the famous children's song:

> Warte, warte nur ein Weilchen
> Bald kommt der schwarze Mann zu Dir
> Mit dem kleinen Hackebeilchen
> Macht er Schabefleisch aus Dir.[6]

Anton Kaes and Tom Gunning have identified the song as the 'Haarmann song', referring to another one of Weimar Germany's famous serial killers, Fritz Haarmann.[7] While this interpretation clearly conveys the effect of the murders and murderers on the popular culture of the Weimar Republic, it also sets the stage for a formal practice that Lang employs throughout the film. The soundtrack of the opening sequence hints at a presence, namely that of the murderer, whereas the image itself denies such a presence. During the film, Lang uses the soundtrack to alternately suggest presences and absences beyond those discernible in the images. In later scenes Lang relies precisely on the same method to convey an absence. When Frau Beckmann begins to worry about the belated absence of her young daughter Elsie and calls out into the hallway of the apartment building, the camera accompanies her voice with images that depict various parts of the house, such as the attic and the stairway as abandoned and isolated spaces.

Figure 9. Fritz Lang's *M.* © 1931 Nero-Film AG. All rights reserved.

As the mother's voice reveals the rising fear and hysteria associated with the absence of her daughter, the static image of the attic, entirely consisting of inanimate objects suggests Elsie's death before the narrative reveals it. The emptiness of the space renders it at once familiar and unfamiliar. The laundry on the clothes line hints at human presences, yet its stark whiteness and geometric shapelessness solidify the absence of it. The nature of a building as a living space and the presence of human remnants, in the form of the clothing, immediately evoke associations of family and domesticity. The stillness of the space, however, resembles what Anthony Vidler identifies as the uncanny spaces often tied to gothic romanticism. Vidler points out that those spaces are 'desolate'; the walls were bland and almost literally 'faceless' and that the walls were marked by 'the discoloration of ages'.[8] These spaces appear uncanny insofar as they initially present ideas of domesticity and family. The marked condition, the disrepair and emptiness of these sites, however, renders them uncanny. In their emptiness they merely hint at human presence yet the striking absence of these elements of family and familiarity, reveal their similarity to crypts and tombs.[9] Like the crypts and tombs that 'house' the bodily remnants of a person, the attic indicates a human presence, only to undermine its existence. The abandoned nature of these spaces in the midst of a bustling city seems all the more uncanny, in particular in early twentieth-century Berlin which counted large numbers of inhabitants in its administrative district and thus made it the third largest city in the world after New York and London.[10] Moreover, Berlin, as a vibrant cultural centre as well as a scene of extreme political conflicts and social and cultural uncertainty signified Germany's social transformation into an urban industrial state. While Berlin became representative of Weimar's transformation, it was in reality 'a city of immigrants and of "outsiders" suddenly promoted to the highest level of the new society [and] by 1922 it was estimated that over 200,000 Russians lived in Berlin'.[11] The progressive movement to Berlin, as already inherent in the numbers that indicate its rapid growth, indicates that Berlin's culture was a conglomeration and perhaps an abstract of a number of local and international ones. The urbanisation of Berlin established 'an odd exoticism of the big city', that metaphorically represented 'the city as big jungle'.[12] However, Lang's portrayal of Berlin transforms the cultural metropolis into a site that is marked by the haunting effects of former presences and distinct absences.

While the de-familiarised space was frequently employed in the interest of avant-garde attempts of estrangement, Adorno points out that the artistic techniques of defamiliarisation have the opposite effect:

There is no denying the antagonistic condition Marx called alienation was powerful leaven for modern art. However modern art was not simply a replica or reproduction of that condition but has denounced it in no uncertain terms,

transposing it into an *imago*. In doing so modern art became the opposite other of an alienated condition. The former was as free as the latter was unfree.[13]

Adorno suggests that the defamiliarisations of modernism had already entered the social sphere to such an extent that they had lost their impact of avant-garde shock in art. Instead the defamilarisation in art merely transposed and re-established a form of objectification and alienation. Lang's transformation of urban spaces into uncanny ones can thus not be read as a modernist technique, but as a critical engagement with Weimar's collective psyche.

Moreover, Lang's depiction of deserted spaces, whose stillness seems to be tied to Gothic-Romantic concepts, reveals the peculiarity of the collective psyche and imagination of Weimar Germany. Lang's Berlin conveys a striking absence of busy streets and signs of modernity and urbanisation. Instead, his film presents an image of Berlin that consists of back alleys, barely occupied streets and little vendors and shops, suggesting a small town rather than a metropolitan environment of Berlin's dimensions. Whereas the restricted gaze of Lang's camera communicates the inability to perceive the city in its entirety, it simultaneously conveys a Berlin radically different from the image of modernity and progress that it evokes. Lang's intent focus on a specific area is briefly contrasted with short images of maps that represent the totality of the city. As such this representation can be read as a general commentary of urban perception. The vision of the city itself is, according to Burton Pike, always a fragmentary image as it is physically and psychologically impossible to apprehend and comprehend multiple spaces simultaneously. As soon as we try to encompass and represent the entirety of an urban environment, such a representation is reduced to an abstraction, i.e. a map.[14]

Figures 10–11. The police investigation of the murders (*M*). © 1931 Nero-Film AG. All rights reserved.

Figure 12. Investigation of private homes (*M*). © 1931 Nero-Film AG. All rights reserved.

Contrary to the barely peopled spaces of the city street the interiors of the police headquarters and Beckert's residence appear as cluttered spaces whose residue of Biedermeier domesticity seem simultaneously to mock German organisation and represents Weimar's political and economic struggles.

Capturing the image of German interiority, the camera assumes a gaze that resembles those of early anthropological and ethnographical documentary filmmaking and exhibitions of ethnographic and anthropological artefacts in the 1910s. These exhibitions often assembled a variety of objects without any discernible principle of organisation. In deciphering these cluttered displays, the viewer was to mimic the anthropologists' gaze.[15] The striking similarities between Beckert's home and the police headquarters suggest an inherent connection that exposes both to the same analytical gaze – both the deranged murderer and those entities that embody the structures of social organisation and values reveal residual elements that are comparable. The foundational similarities appear striking in terms of their implications. After the strange emphasis on empty spaces in Frau Beckmann's apartment building, Lang creates and maintains a contrast between the curiously unoccupied streets and the cluttered or busy interiors throughout the film.

Moreover, Lang establishes not only a correlation between Beckert and an ideal of German domesticity, but associates Beckert with objects and elements of nature.[16]

Whereas all other diegetic interactants are firmly anchored within the urban environment and at times even display notions of cosmopolitanism, Beckert's ties to 'nature' appear as hauntingly deranged. After clues to the murder of Elsie Beckmann have been found in a park or *Schrebergartenkolonie*,

Figure 13. Beckert behind the fruit cart (*M*). © 1931 Nero-Film AG.

linking the empty candy bag to Beckert's penchant for 'sweets' and his method of gaining the children's confidence, Lang depicts Beckert behind a fruit cart. While the fruit cart occupies the foreground of the film, Beckert's round face is barely visible behind the wares (which are strangely enough 'exotic fruits') as he selects and eats apples. The metaphor of the apple may be heavy handed, but hints at Beckert's haunting admission of the inability to escape his crimes when he reveals the nature of his actions to the assembled criminal tribunal. Beckert laments his predicament in the final sequence of the film:

> aber ich kann nicht anders, hab' ich denn nicht dieses verfluchte Ding in mir, das Feuer, die Stimme, die Qual. Immer, immer muss ich durch Strassen gehen, und immer spüre ich das ist jemand hinter mir her; das bin ich selber; und verfolgt mich…und mit mir rennen die Gespenster von Müttern, von Kindern, die gehen nie mehr weg, die sind immer da…. Nur nicht wenn ich's tue…dann kann ich mich an nichts mehr erinnern, dann stehe ich vor einem Plakat und lese was ich getan habe und lese und lese…das habe ich getan? – Aber ich weiss doch von gar nichts.[17]

Beckert himself continuously alternates between self-awareness and ignorance of his actions. The bite of the apple, at a moment at which Beckert is not killing someone hints at his torment to understand his role in the recent events that haunt Berlin. However, this awareness increases the need for oblivion and thus reproduces the cycle of killing. As the film progresses Beckert becomes more and more intertwined with the motifs of nature until he eventually sits in a garden café and his face appears surrounded by vines that simultaneously obliterate his body. The progressive development of the motif of nature seems to reveal

the object of Lang's narrative as psychological. He had initially intended to produce the film with the title *The Murderer Among Us*, yet altered it to *M* when the fascist elements, who were at this point gaining significantly in strength, objected to the title. While the Nazis obviously interpreted the title as referring to their activities within the country, Thea von Harbou's significant role in the script and the production process suggest otherwise.[18] It seems instead that Lang was ultimately interested in the Peter Kürtens and Fritz Haarmanns that may be present in all of us. The fact that such a psychoanalytical portrait was ultimately also about the Nazis and the questions that have puzzled scholars for generations, namely how were the atrocities of the Nazis possible, how they could mobilise large segments of the populations and keep others from speaking up, seems retrospectively almost ironic.

Even though Lang reveals that Berlin is dominated by a certain sensationalist sensibility of modernity, it is this form of modernity that disrupts the 'tranquillity' of Lang's Berlin in *M* and destabilises the elements of the collective environment. The sensationalism that dominates the production of news media also shapes the private lives of the people, as Frau Beckmann, Elsie's mother, purchases her regular subscription of a murder mystery by a door-to-door salesman while she awaits the return of her daughter from school. The representation of the murders in the newspapers, however, seems to unravel the elements and organisation of the collective community. When the newspaper boys, relying on the horror associated with and terrifying effect of the murders, exclaim the headlines to increase their sales, they repeatedly alter the dynamics of the people on the streets. Lang depicts a newspaper boy running through the street and advertising the murders twice. When the headlines are verbally imparted to the people, each announcement seems to produce an uncontrollable frenzy of suspicion. These sensationalist interpretations of the murders seem to take hold of the imagination of Berlin's citizens as the vague descriptions of the crime and murderer lead to a series of misinterpretations and accusations, giving way to a number of 'crime narratives' that circulate in the city.

Whereas the soundtrack lends narrative coherence to the separate and contingent elements of the film, the camera destabilises those.[19] Contrary to the soundtrack the camera in Lang's *M* seems more difficult to define. While the soundtrack conveys elements of the narrative and the collective German imagination/psyche beyond those that are represented in the images, the camera presents a multiplicity of narratives that are less connected than the narrative warrants. In fact, Tom Gunning points out how the camera seems to occupy multiple shifting positions and thus communicates a sense of 'an observing presence outside of the consciousness of any character'.[20] Gunning refers to the strangely disembodied shots at the beginning of the

film that cannot be attributed to a character's point of view and seem to linger on the balcony of the apartment building long after the character has disappeared from the frame. The streets are frequently presented from an ominous overhead shot and the camera captures empty stairways and parts of buildings in a manner that defies the idea of an objective narrator.[21] While this 'observing camera' dominates most of the film, point of view shots, such as Frau Beckmann's anxious glances up and down the stairway, the criminal's view out of the window, and others interrupt the pattern of the 'disembodied camera'. Lang hints at the simultaneity of disparate stories and events that constitute the urban environment. The larger narrative is subdivided and relegated to point of view shots to reveal individual impressions and anxieties. He thus replicates the multiplicity of perspectives and independent (and perhaps contingent) narratives that form the basis of Alfred Döblin's *Berlin Alexanderplatz*. Lang's camera technique ultimately articulates the elements of the experience of modernity as a cacophony of stimuli and suggests that the urban environment, and hence its representation, consists of a simultaneity of existences and experiences. Moreover, the lack of an identifiable point of reference seems to establish a portrait of the city as an element in which a number of 'stories' and 'narratives' coexist.

It is, however, not merely the point of view, which Gunning's analysis seems to suggest consists of a strangely disembodied third person point of view, but Lang's emphasis on and deconstruction of the frame that points to a sort of 'randomness' to the narrative. Lang's film appears to play with the constituents of cinematic narratives. *M* emphasises the elements of the shot as individual images and their integration within the larger structure of the diegesis. The film repeatedly calls attention to the confines of the frame and in fact seems to identify them as restricting the narrative. The entry of characters from off-screen spaces as well as repeated glances into areas that are not visible within the frame, hint at an extension of the narrative beyond the confines of the frame. For example, her heavy breathing precedes the washerwoman's walk up the stairway. She is audible before she enters the screen from the bottom of the frame.[22] Similarly, Frau Beckmann exits the frame to the left of the screen to gather the money to pay the magazine salesman. The formal strategies continuously extend the narrative beyond the margins of the frame and point to those elements that impact the narrative and by extension the urban life of Weimar Germany, yet remain outside of the immediate focus.

If indeed, as Brigitte Peucker suggests, early film images of the body evoked an anxiety about the human body and its dismemberment by means of the camera, then the obvious fragmentation of cinematic and architectural space in *M* recreates this anxiety about the physical body and violently re-defines

ideas of spatial perception.[23] Peucker points out that early camera techniques, such as close-ups of body parts, created an anxiety about the severance of the body parts that mirrors the anxiety that Freud associates with E. T. A. Hoffmann's 'The Sandman' in his essay 'The Uncanny'.[24] Cinematic representation itself thus becomes a source of uncanny representation of the human body. Anthony Vidler proposes, in addition, that architecture in its early stages relied on the human body as measurement and representative image. Hence, the architectural structures served as extensions and representations of the body itself. In fact, Vidler's writing conveys that architecture progressively represented and served as an externalisation of the human psyche, ultimately connecting the appearance of spatial anxieties, such as claustrophobia and agoraphobia, to this transformation associated with the perception of the external and architectural space.[25]

In *M* the visual perception of urban space reveals an increasing fragmentation and contrast between external and internal space. This fragmentation, formally conveyed by the repeated emphasis on the frame and its limitations, as well as the abstract shots of or from parts of the city that suggest impossible points of view, endow the film with an uncanny element that is solely structurally derived. If we consider, moreover, Burton Pike's analysis that points to similarities between psychic structures and the city, the relationship between the internal spaces that are devoid of human interaction and contact and the external spaces that depict elements of small town life can easily be interpreted as a visual representation of the psyche of Berlin. Aside from the empty attic, these internal spaces are cluttered with inanimate materials and objects that seem to signify an historical connection. Yet their random assortment and their ornamental fashion seem to signify their inapplicability to the urban environment and hence modernity. In fact, the striking absence of diegetic noises, soundtrack, and/or the limitations of the narrative and the frame reveal how incomplete and ill-equipped Weimar consciousness is to apprehend modernity and urbanisation. Essentially Lang creates a cinematic text that signifies modernism's reluctance to subscribe to and perpetuate the 'Enlightenment dream of rational and transparent space', and renders the urban at once as fragment and as collage/montage.[26] Perception rests on a mediated gaze that reads the urban both through spatial and temporal phenomena.

Contrary to Lang's representation of Berlin as a space devoid of the modernity associated with it, E. A. Dupont's *Varieté* emphasises Berlin's role as a social and cultural metropolis. In fact, the export conditions and censorship associated with the screenings of many of Weimar's films in foreign locations provide additional insight into the social climate that shaped and constituted Berlin. The version of E. A. Dupont's *Varieté* that was exported and screened

in the United States exhibits important differences from the film that was shown in Germany.[27] Whereas the German film was significantly longer, the dynamics of the love triangle and subsequent question of murder and guilt were also shaped by the premise that Boss Huller (Emil Jannings) was not married to Lya de Putti's character (Bertha-Marie), but left his wife for her. American censorship was unwilling to allow for the 'amorality' inherent in such relationships and only agreed to distribute the film if those scenes were cut and Lya de Putti was transformed into Huller's wife.[28] The fact that *The Blue Angel* was banned in Paris, but 'considered tame in Berlin' provides a similar example and reveals how Weimar culture was shaped by a particular imagination that translated into a 'culture of excess'. Alexandra Richie points out these were not restricted to the cinematic medium but permeated Berlin's artistic culture as in the 'smart new journal *Weltbühne* sexual freedom and pacifism were exalted and middle-class values savaged'.[29] Berlin's particular fascination with topics that challenged the bourgeoisie norms points to its extraordinary embrace of modernity and attempt to transform the cultural remnants of Imperial Germany. The striking difference in the established relationships between the characters in Dupont's film leads to significant alterations in the portrayal of private and public life, as well as the representation of Berlin's urban environment during the Weimar Republic.

The film's narrative opens to images of the fairground in Berlin that emphasise the spectacle and spectacular nature of the environment. Karl Freund's mobile camera formally stresses the vitality and modernity of the city as it superimposes shots and foregrounds movements. It not only seems to trace the attractions of the fairground as movement, but also appears to indicate an excess of visual and aural stimulation as its abrupt movements and rapidly shifting perspectives represent a multiplicity of points of view rather than one that serves as guiding principle for the audience. Placed on the Ferris wheel the camera emulates the movement of the carnival attractions and presents impossible viewpoints that establish the camera's role as participating autonomously of Boss and other characters in the entertainment and the narrative. The distinct camera movements communicate a 'visual pleasure' independent of that of the narrative as a significant component of the film.[30] While the camera discovers and translates the entertainment and spectacle of the fairground as distinctly 'exhibitionist', in terms of Sabine Hake's analysis of early *variétés*, it also presents them in relation to the *Wintergarten* opening in the next sequences as almost provincial.

As in *M*, Boss' and Bertha-Marie's private space similarly evokes notions of provincial domesticity that seems oddly displaced in Berlin. When towards the end of the fairground sequence the camera comes to rest on a couple of trapeze artists descending the ladder from the trapeze, the film follows them at

the obvious end of their performance and into their carnival wagon. Contrary to the *Wintergarten* sequences the film does not depict their performance, but lingers on the transformation of their relationship from public spectacle to reveal a private intimacy that is surprising. The exterior of their 'mobile home' already hints at the discrepancy between the two as it is lacks all cosmopolitan sophistication and modernity associated with Berlin. Instead it appears like a rural home complete with flower boxes under the windows and chequered curtains. Dupont captures Berlin's train stations as performers and visitors arrive for the opening of the *Wintergarten* from distant locations. The camera lingers repeatedly on the signs of the train to establish Berlin as centrally located on important train routes, ranging from Paris to Moscow – of course, via Berlin.

Berlin, as a capital and moreover as a metropolis with aspirations of becoming a *Weltstadt*, exerted a fascination that affected both its inhabitants and visitors. Dupont's film captures Berlin's allure in the *Wintergarten* performances. The film transforms these entertainment acts into spectacles of light and scopophilia. When Boss, Bertha-Marie and Artinelli engage in their trapeze act in the *Wintergarten*, the camera focuses on the exchange of gazes and emphasises the act of looking as foundational to Weimar's 'surface culture'. The performance is accompanied by bright spotlights that highlight the performance as spectacle itself and reproduce the animation of Berlin's nightlife, which distinguishes itself as a 'culture of light'. While the camera repeatedly captures the marvellous stunts of the trapeze act, it similarly reverses the – point of view and apprehends the rapt audience from the perspective of the artists and reveals their uninhibited gawking and open-mouthed enthralment. The alternate depiction of glances simultaneously conveys the act of looking as one of being looked at. The scopophila of the performance, and ultimately of the city, conveys a 'new sense of urbanism rooted in imagination and desire'.[31]

Although the film was clearly the product of a time of relative economic stability during the Weimar Republic since Germany was able to draw on loans from the United States as part of the Dawes plan, Germany and particularly Berlin were socially and culturally far from stable.[32] The perception of *The Blue Angel* as a relatively tame film as well as the large number of Weimar films openly addressing sexuality are indicative of Berlin's public experimentation with gender and sexuality.[33] By the late 1920s sex in Berlin had become just another commodity and the almost standard incorporation of nudity in variety theatres was received with a sense of 'boredom and predictability'.[34]

Moreover, the film appears as a projection of a fetishism that celebrates modern technology. *Variete*'s performances at the *Wintergarten* extol modernity and Americanism in a visual conflation of physical human body and technology. The camera repeatedly captures, for example, the movements of a group of

dancers, resembling the Tiller girls, who are 'distinguished by their identical bodies, their generic costumes, and their automated movements'.[35] These scenes contrast the earlier fascination with the mobility of the camera in the fairground sequences insofar as the camera at the fairground foregrounded its enchantment with the movement of inanimate objects, such as the ferris wheel. The *Wintergarten* performances clearly convey a reproduction of technological influences of modernity by means of the human body. Kracauer reveals such mimetic reproduction of technology as an integral part of the variety theatres of the Weimar Republic in his description of the Schumann Theater. He suggests that

> 'Das Lebendige wird dem Mechanischen angenähert, das Mechanische gebärdet sich lebendig; auf dieser Fusion von Menschen und Dingen beruht das Varieté… ein mechanisches Wunder, l'homme de machine, der menschliche Automat…ein Homunculus, empfehlenswert für Ford'.[36]

The cynical comment that those performances of the variety theatres would serve as a 'recommendation' for Ford divulges his distaste for an 'aesthetic of the assembly line' that ultimately supports a transformation of the social sphere based on economic models. Moreover, Kracauer's series of definitions for this phenomenon maps a progression towards the monstrous and fantastic. He initially refers to these performances as 'mechanical wonder', ultimately arriving at the term 'homunculus'. The idea of wonder and fascination has given way to the horrific models of fantastic literature that emphasise the manufactured and inanimate nature of the monstrous object. Dupont's film similarly seems to indicate that the increased integration of technology, especially in the entertainment industry, shapes the social and human sphere, rendering it more and more abstract.

Yet Dupont's cinematic representation of a popular entertainment functions not merely as a 'critical documentary', albeit with a fictional plot since *Varieté* exemplifies the marriage of variety show and film in a unique and celebratory way, so that it 'represented film as a variety act, and simultaneously, the variety act as cinematic in its construction'.[37] In order to present the fluidity and spectacular quality of the trapeze performance Karl Freund strapped the camera to a trapeze and swung it along the actual acts and subjected it to the jumps and saltos of the artists. Freund and Dupont even ventured to drop the camera to adequately capture a fall.[38] Hence, the camera's movement not only mirrors a trapeze act but it actually performs it. The trapeze act itself becomes a construction of camera performance, editing and lighting. The film represents the act not only by means of an extremely mobile camera, but also indicates shifting points of view and abrupt glances by means of the editing.

While the *Wintergarten* sequences are characterised by intense mobility, flashing lights and rapid movements, these scenes are punctuated by those parts of the narrative that are devoted to the development of the romantic relationships, the deception and murder. Contrary to the movement inherent in the performances the scenes that actually carry narrative weight exhibit very little movement within the frame. The Weimar film critic Balthasar observes the uneven distribution of the narrative in his review in the 1920s. He points out that:

> With due admiration for the text, but also with (perhaps) too much compliance, from time to time the director shatters the manuscript. [Freund and Dupont] represent, for example, the *Wintergarten* program as a magnificent performance, and yet they also let the action drag. They split up the events into extremely artistic and charming images. However, consequently they hinder their flow of the film again and again their filming shows self-purpose, as they fiddle with, improve upon, and repeat the process.[39]

Balthasar's reading of the film observes the fragmentation of the narrative and its staccato movements. The story of love, betrayal and subsequent murder is interrupted with a series of images that do not serve any narrative purpose, but represent a visual spectacle in and of themselves. Whereas Balthasar's assessment suggests that the effect of the *Wintergarten* scenes disturbs the cinematic melodrama, I would like to venture that the incorporation of those images and the subsequent fragmentation of the narrative are characteristic of Weimar and urban culture and represent as Sabine Hake suggests 'contradictory needs: the illusion of control and the yearning for surrender… the preoccupation with meaning and the total disregard for it'.[40] Dupont's film expresses thus not merely Berlin's fascination with the visual spectacles of modernity but also reveals and addresses the antithetical desires of the urban psyche in the structural representation of the narrative.

However Dupont represents mobility not merely as a significant aspect of the camera work, but also addresses social mobility as an inherent promise of the Weimar Republic. Boss Huller's rise from carnival performer to *Wintergarten* artist seems a fulfilment of restructuring of the social strata with a potential of social mobility. Similarly, Artinelli is able to lure Bertha-Marie into his hotel room by indicating that he may have opportunities of employment in America. Bertha-Marie has convinced Boss to leave the carnival and take the job that holds more promise, yet her reaction to Artinelli's con reveals the extent of her desires to transcend the limitations of social class since America simultaneously represents an ideal classless society and the promises of capitalism. But how are we to interpret the ending if the film seems to advocate

the transformation of society? After a friend of Boss enlightens him about the true nature of Artinelli's and Bertha's relationship, Boss waits in Artinelli's room, confronts and kills him. Immediately following the murder he leaves the hotel and confesses his crime to the police. While the murder explains the reason for Boss' imprisonment in the opening sequence, it generates a more critical reading of the promise of upward mobility.

The film ends after Boss has narrated the events leading to his imprisonment to the prison warden, with a shot of a large gate opening to reveal a few trees swaying in the wind and bathed in light. The light streams in through the opening doors of the gate and suggests not only freedom for Huller in the form of parole, but also forgiveness beyond that of the social institution. It seems that the closing shot of the work presents a 'demonization of the sensationalised transgressions throughout the film'.[41] Considering the ending, it appears that Dupont's film condemns modernity and the social and economic aspirations that it may generate. Moreover, the German film version's opening sequences, which emphasise Boss' family ties, seem to point to the nuclear family as social foundation and thus to advocate an awareness of one's social role and position within the social order.[42] While those readings clearly point to a narrative coherence, the final images of the film are cinematically strangely out of place. The redemptive ending appears to prefigure Douglas Sirk's melodramatic productions in Hollywood. Prompted by studios and writers to equip his films with a digestible ending, Sirk, who hated 'happy endings', developed conclusions to his 'women's weepies' that seemed artificial and contrived. Boss Huller's return to the safety of the family appears similarly out of place. Whether the ending was indeed, as in many of Sirk's films, a demand of the studio (Ufa in this case), or whether Dupont trusted his viewers to decipher the ending for what it was, is not clear. The artificiality of the ending does, however, demonstrate that Dupont was aware of a certain ideological and narrative inscription in the urban environment and Weimar culture and suggests that he communicated this awareness 'tongue in cheek'.[43]

In fact, the illusion of cinema, particularly in Berlin, was one that transcended the cinematic screen and translated the filmic reality into the urban space. The opening of *Varieté* was accompanied by a performance that extended the spectacle of the screen beyond the confines of the frame. The program description reveals that:

First of all, while the curtain rose in faint light, one saw uncertain glowing lights and heard fairground music from the organ. Gradually, it became light and one saw that the entire surface of the biggest of the showbooths carried the word 'Varieté'. Artists came and produced various tricks, girls danced, jugglers worked, until the darkness sank in again and one saw the shadows of the working

artists. Only the torchlight of the jugglers and the ornamental lamps of the showbooths glowed, similar to the word 'Varieté'. A gauze curtain fell unnoticed, and immediately the fairground film appeared. This film mixed with the fading image of the stage until the 'white wall' came down. This and all the original prologues lasted fifteen to twenty minutes, just enough time for the spectator to prepare for the coming film.[44]

The opening of *Varieté* consciously integrated and extended elements of the narrative beyond the cinematic screen and hence transformed the urban reality into one that is infused with and permeated by facets of illusion and fiction. In fact, the opening of Dupont's film does not present a singular case in which the filmic constituents are translated into the cityscape. The opening of Fritz Lang's *Metropolis* was accompanied by an alteration of the exterior of the movie theatre, the Ufa Palast at the Nollendorfplatz, in order to create a façade and an environment that would mirror those of the film. The movie theatre thus functions as an 'extension of the film set'.[45] The integration of cinematic elements into the everyday of urban reality reveals not only the transformative agency of the 'movies' but also the ways in which German reality was a conglomerate of fictions, of factory work and aspirations to establish a democratic state.

Whereas visitors to Berlin were drawn to its modernity, its animation and cultural excesses of its nightlife, Berlin represented, as I already indicated in the introduction, a very different picture during the day.[46] It appeared as 'an oppressive gray, crude, and unlovely place. Its old architecture was massive and without distinction, while new buildings appeared frighteningly new, the anticipation of some steel, concrete, and glass metropolis of the future'.[47] The contrast between Berlin's fluid movements at night and its drab austerity during the day reflects the problematic inherent in the distinction between 'Weimar' as a signifier of the site where the constitution was ratified and Berlin as the republic's capital.[48] Berlin as representative of a national or German identity was inherently difficult since its modernity and urban transformation were not characteristic of Germany as a whole. The city of Weimar, associated with important German thinkers and writers, exemplifies this correlation between Berlin's rise to spectacular dimensions and the cultural and intellectual stasis of the rest of Germany. Anton Kaes points out that 'the underlying dichotomy of country vs. city which characterises such pronouncements is a product of related historical phenomena: on the one hand, Germany's sudden development from agrarian state to a mass industrial society, and, on the other hand, the lagging intellectual and emotional grasp of this new technical and cosmopolitan reality'.[49] Berlin in cinema seems to embody this particular problem associated with the rapid modernisation of Germany that Kaes identifies, and particularly *Varieté*.

The contrasting moods and settings in *M* and *Variété* hint at the 'ambivalence' associated with the city itself.[50] Berlin was at once 'unique – distinct, different from the rest of Germany'[51] and simultaneously representative of Germany's national transformation. Moreover, Berlin's contradictory position was apparent within the city itself, as at night then Berlin conveyed a tremendous sense of animation when modern lighting, traffic lights and modern traffic transformed the city. By day it was rather different, 'appearing an oppressive, gray, crude and unlovely place. Its old architecture was massive and without distinction, while its new buildings appeared frighteningly new, the anticipation of some steel, glass and concrete metropolis of the future'.[52] The descriptions and depictions of Berlin's urban environment rest on oppositions and contrasts. Berlin's architecture, its conflation of different architectural styles and periods, seems to reveal not only a distinct historical presence but also an uncanny fragmentation. Similarly Weimar depicts at times the city and its residents as the most decadent, cosmopolitan, or spectacular and at other times (or perhaps in the same breath) as the most lawless, diseased and corrupt. Weimar cinema, at once representative of German modernity and simultaneously representing Berliner metropolitanism, reveals how Berlin has come to be imagined as a site of utopian progress and a space of internal contradiction. It conveys the varying and blurred notions of exclusion and inclusion, experiences of longing and belonging, and social transformation as represented in cinematic and social space.

Notes

1 Tom Gunning, *The Films of Fritz Lang: Allegories of Vision and Modernity* (London: BFI Publishing, 2000).

2 Anton Kaes refers to Lang's commentary on his film in *Die Filmwoche* in 1931. See Anton Kaes, *M* (London: BFI Publishing, 1999).

3 See Todd Herzog's chapter 'Fritz Lang's *M* (1931): An Open Case. Weimar Cinema', in *An Essential Guide to Films of the Era*, ed. by Noah Isenberg (New York: Columbia University Press, 2009), pp. 291–310.

4 Sabine Hake, 'Urban Spectacle in Walter Ruttmann's *Berlin Symphony of the Big City*', in *Dancing on the Volcano: Essays on the Culture of the Weimar Republic*, ed. by Thomas W. Kniesche and Stephen Brockmann (Columbia, SC: Camden House, 1994), pp. 127–42.

5 See 'Berlin and the Countryside' in *The Weimar Republic Sourcebook*, ed. by Anton Kaes, Martin Jay and Edward Dimendberg (Berkeley: University of California Press, 1994), p. 412.

6 The translated rendered in the subtitles is: 'Wait, wait just a little while; soon the black man will come to you; with this little chopper; he will chop you up.'

7 Kaes, *M*, p. 10.

8 Anthony Vidler, *The Architectural Uncanny* (Cambridge, MA and London: MIT Press, 1992), p. 18.

9 Anthony Vidler provides a detailed analysis of houses as structures that can simultaneously appear as sites of domesticity and death, such as in the case of the ruins of Pompeii.

10 Detlev J. K. Peukert, *The Weimar Republic*, trans. by Richard Deveson (New York: Hill and Wang, 1989), p. 181.

11 Alexandra Richie, *Faust's Metropolis: A History of Berlin* (New York: Carroll & Graf Publishers, Inc., 1998), p. 332, p. 334.

12 Anton Kaes, 'The Debate about Cinema: Charting a Controversy (1909–1929)', *New German Critique*, no. 40, Special Issue on Weimar Film Theory (1987), 7–33.

13 Theodor Adorno, *Aesthetic Theory*, trans. by C. Lenhardt (London and New York: Routledge and Kegan Paul, 1984), p. 369.

14 Burton Pike, *The Image of the City in Literature* (Princeton: Princeton University Press, 1981), p. 9.

15 See Assenka Oksiloff, *Picturing the Primitive: Visual Culture, Ethnography and Early German Cinema* (New York: Palgrave, 2001).

16 Patrice Petro reveals that the Hinterhöfe that the opening of the film reveals are generally 'associated with women's activities in the Weimar years': *Joyless Streets: Women and Melodramatic Representations in Weimar Germany* (Princeton: Princeton University Press, 1989), p. 21.

17 It has been translated in the subtitles as 'but I can't help myself, I have this evil thing in me, the fire, the voices, the torment! It's there all the time driving me to wander the streets, following me, silently, but I can feel it there…. It's me, pursuing myself…. And I'm pursued by ghosts of mothers and those of children, they never leave me. They are always there, always, except when I do it. Then I can't remember anything. And afterwards I see those posters and read what I've done. Did I do that? But I can't remember anything about it'.

18 It is a well-known fact that Thea von Harbou continued to work in the film industry after Lang had left Germany and that she also worked under the Nazi Regime. In order to hold such a position, it seems obvious that she had to have sympathised with the Nazis.

19 Stephen Heath, 'Narrative Space', in *Questions of Cinema* (Bloomington: Indiana University Press, 1981), pp. 19–75.

20 Tom Gunning, *The Films of Fritz Lang: Allegories of Vision and Modernity* (London: BFI Publishing, 2000), p. 166.

21 Edward Dimendberg suggests that the overhead shots of the barely peopled streets point to a surveillance culture that begins to dominate German modernity in 'From Berlin to Bunker Hill: Urban Space, Late Modernity and Film Noir in Fritz Lang's and Joseph Losey's *M*', *Wide Angle*, 19.4 (1997), 62–93.

22 Gunning, *The Films of Fritz Lang*, p. 167.

23 Brigitte Peucker, *Incorporating Images* (Princeton: Princeton University Press, 1995), p. 19.

24 Freud's analysis of E. T. A. Hoffmann's 'The Sandman' connects Coppelius' rolling eyeballs, which become a source of fear for Nathaniel, with the fear of castration. This act in itself seems to resemble that of the camera's physical dismemberment of the human body.

25 Vidler, *Warped Space*.

26 Vidler, *Warped Space*, see also Marin Jay, 'The Scopic Regimes of Modernity', in *Modernity and Identity*, ed. by Scott Lash and Jonathan Friedmann (Cambridge, MA: Blackwell, 1992), pp. 178–95; and David Harvey, *The Condition of Postmodernity: An Enquiry into the Origins of Cultural Change* (Cambridge, MA: Blackwell, 1990).

27 This is the version that is now commercially available and has been restored to some extent. The German version is unfortunately lost.

28 *New York Times* film review, 30 June 1926.

29 Alexandra Richie, *Faust's Metropolis: A History of Berlin* (New York: Carroll & Graf Publishers, Inc. 1998).

30 See Sabine Hake, 'Urban Spectacle in Walter Ruttmann's *Berlin Symphony of the Big City*', in *Dancing on the Volcano: Essays on the culture of the Weimar Republic*, ed. by Thomas W. Kniesche and Stephen Brockmann (Columbia, SC: Camden House, 1994), 127–42 (p. 30).

31 Ibid.

32 'Between 1924 and 1931 Germany received 33 billion marks in (mostly American) short-term loans and it was for this reason that in the 1920s Berlin was characterized by a surge of apparent prosperity, growth, easy money and optimism.... Germany was now second only to the United States in world exports, and indeed exported more finished products than any country in the world': Richie, *Faust's Metropolis: A History of Berlin*, p. 329.

33 Alex de Jonge points out that there was a point in the Weimar Republic when homosexuality was clearly fashionable: *Weimar Culture*, p. 139.

34 Richie, *Faust's Metropolis*, p. 355.

35 Frances Guerin, 'Dazzled by the Light: Technological Entertainment and Its Social Impact in *Variete*', *Cinema Journal*, 42.4 (2003), 98–115.

36 Siegfried Kracauer 'Schumann-Theater', in *Frankfurter Turmhäuser Ausgewählte Feuilletons 1906–1930*, ed. by Andreas Volk (Zurich: Edition Epoca, 1997), pp. 95–166. This can be roughly translated as: 'Those things alive will be nearing the mechanical, the mechanical acts alive; the Variete consists of this fusion of human beings and things...a mechanical wonder, l'homme de machine, the human automaton, a homunculus, recommendable for Ford.'

37 Frances Guerin, 'Dazzled by the Light', p. 105.

38 Michael Esser, 'Der Sprung über den großen Teich: E.A. Dupont's *Variete*', in *Das Ufa Buch: Kunst und Krisen, Stars und Regisseure, Wirtschaft und Politik*, ed. by Hans-Michael Bock and Michael Töteberg in cooperation with CineGraph-Hamburgisches Zentrum fuer Filmforschung e.V. (Frankfurt on Main: Zweitausendeins, 1992), p. 165.

39 Ernst Günther, *Geschichte des Varietés* (Berlin: Henschelverlag, 1981), p. 142.

40 Hake, 'Urban Spectacle in Walter Ruttmann's *Berlin Symphony of the Big City*', p. 130.

41 Richard McCormick, *Gender and Sexuality in Weimar Modernity* (New York: Palgrave, 2001), p. 86.

42 See Frances Guerin who examines the role of the family in the film in detail: 'Dazzled by Light', p. 109.

43 Elsaesser points out in his extensive analysis of Weimar cinema that some filmmakers 'play with certain concepts and ideas' and hence reveal a deeper understanding of the workings of the Weimar Republic: Thomas Elsaesser, *Weimar Cinema and After: Germany's Historical Imaginary* (New York: Routledge, 2000).

44 Quoted in Frances Guerin, 'Dazzled by Light', p. 109.

45 See Anton Kaes 'Metropolis: City, Cinema, Modernity', in *Expressionist Utopias: Paradise, Metropolis, Architectual Fantasy*, ed. by Timothy O. Benson (Los Angeles: Los Angeles County Museum of Art, 1993), p. 148. David Frisby, Anton Kaes and Janet Ward all, independently of each other, comment on the spectacular event that accompanied the opening of *Metropolis*.

46 Alex de Jonge, *The Weimar Chronicle: Prelude to Hitler* (New York: A Meridian Book, 1978), p. 126.

47 Ibid.

48 It is perhaps interesting to note that the reason that the constitution was signed and ratified in Weimar, home of Goethe, Schiller and Herder, was because Berlin was considered too dangerous after the 1918 revolutions.

49 Anton Kaes, 'The Cold Gaze: Notes on Mobilization and Modernity', *New German Critique*, 59, Special Issue on Ernst Junger (1993), 105–17.

50 Burton Pike, 'The Image of the City in Literature', in *The Image of the City in Modern Literature* (Princeton: Princeton University Press, 1981), p. 26.

51 See Alex de Jonge, 'Berlin', in *The Weimar Chronicle: Prelude to Hitler*, p. 129.

52 Ibid., p. 126.

Chapter 3

BOND'S BODY: *DIAMONDS ARE FOREVER, CASINO ROYALE* AND THE FUTURE ANTERIOR

Shelton Waldrep

University of Southern Maine

'It was a window into a queer world and into a queer business.'
—Ian Fleming, *Live and Let Die*

A part of the formula of the Bond film franchise is that the hero has always made his way in the world by romancing beautiful women and defeating corrupt villains. Yet Bond's nominal heterosexual identity must always function in relation to the villain's 'perversity'. Bond depends, that is, upon the villain's sexuality as a sort of negative definition of his own. Indeed, Bond's subjectivity is tainted both by his intimacy with the villain and his frequent cruelty to the 'Bond girl'. This essay will examine the role of sex and sexuality during the years that Sean Connery starred as Bond (1962–1971) in order to track the complicated formula by which Bond is implicated in homosexual and sado-masochistic scenarios that arguably reach their most complex form in *Diamonds Are Forever* (1971). Connery's last film with EON Productions, *Diamonds*, is unique in the Bond oeuvre by having as its villains, a gay male couple. The film is the first in the Bond franchise to deal directly with the threat to Bond's sexuality brought about by the Stonewall riots and the rise of a burgeoning gay-rights movement. While earlier Bond films frequently dealt with the threat of women's rights – most often in the form of a lesbian character (*From Russia with Love*, 1963, for example) – *Diamonds Are Forever* introduced the notion of gay male desire as a new reality for Bond and his future dealings. It also marked a turning point in the franchise from Cold War spy drama to spectacular melodrama, or from 1960s seriousness to 1970s comedy. The film is a post-mortem on the franchise itself and a prescient examination

of the corporeality of film – specifically as a male body that is designed to be observed and examined, but never touched. The film is symptomatic of various anxieties around the male body that result, in part, from the insecurity that propels nation-states to spy on each other, which becomes an excuse for men to look at each other, watch, and ultimately ignore the realities of their own actions.

The strange mixture of comedy and nastiness that characterises the film begins in the opening teaser, the pre-credit sequence that is by the time of the film a part of the franchise formula. We hear Sean Connery's voice, but do not see his face, while he beats up two men, one in Japan and one in Cairo, Connery emerging, finally, by the pool to confront a woman named 'Marie'. Connery as Bond grabs the top part of the woman's bikini and wraps it around her neck, choking her and threatening her with death unless she tells him the location of Ernst Blofeld, his frequent enemy and his nemesis once again in this film. The sequence ends with Bond confronting Blofeld in Mexico where he has apparently gone to oversee the construction of three duplicates of himself – men changed through plastic surgery to resemble him.[1] Bond dispenses with one man while he sits in a bed of moulding plastic poured from a sphincter-like vat and then apparently kills Blofeld after a knife fight by dumping him into a Dantesque pit of sulphur.[2] 'Welcome to Hell, Blofeld,' quips Bond.

This particular sequence sets up at least three themes that will function throughout the movie: (1) the cruelty associated with Connery's version of Bond, made famous later in an interview with Barbara Walters in which Connery argued for the necessity of hitting women in order to teach them a lesson, finally crosses over into misogyny on the screen; (2) the use of the double (or of multiple versions of the same person) is emphasised and will be picked up as a trope of the film connected especially to the notion of male homosexuality in the form of the villain as a split subject position, two gay men, Mr Wint and Mr Kidd, who literally and figuratively project a new instability within male sexuality; and (3) the beginning of the use of the metaphor of refuse, of excrement and anal expulsion that will become the final metaphor of the film.

The return of Connery in the role of Bond comes after the visible emergence of women's rights and the dawning realisation that there would be a political element to the visibility of gay and lesbian rights. The film seems to react to both of these realities while at the same time looking backward to the era of the Connery franchise. The film immediately preceding *Diamonds* was the only Bond film not starring Connery, *On Her Majesty's Secret Service*. Released in 1969, it was the last Bond film of the sixties – the decade still most associated with the Bond phenomenon. It was not considered a success

by the producers, Harry Saltzman and Albert R. Broccoli, mainly because of Lazenby's presumed limitations as an actor. With hindsight, however, the film has grown in stature, often considered by many as a superior film *qua* film, if not, perhaps, a great Bond film. Much of this judgment is based upon the casting of Diana Rigg as the primary 'Bond girl'. Rigg not only brings to the role a great deal of subtlety and intelligence, but Lazenby, whether consciously or not, gives Bond a certain amount of complementary vulnerability. The film ends first with a climactic scene in which Rigg as Tracy gets to show off her fighting abilities – *à la* the Avengers – and then dies in an attack by Blofeld after just getting married to Bond. The film shows that this Bond girl has some substance, is not, in other words, just another girl. At the same time, it shows that Bond has grown, has developed a weak spot precisely by allowing someone into his life. By ending the film on a down note, the producers feared that they had let down the public rather than assuming that their attempt to grow the character had produced a superior artistic achievement. *Diamonds* was, then, a reaction to this perceived misstep, an attempt to pretend that *On Her Majesty's Secret Service* had never happened. Nowhere in *Diamonds* does Bond ever mention having once had a wife, though his search for Blofeld in the pre-credits sequence is supposed to suggest his ruthless desire for revenge and, to some extent, link the two films thematically, if not tonally.

In looking back to a moment before *On Her Majesty's Secret Service* the creators of the Bond franchise looked to what was considered by many critics and fans as the high-water mark of the franchise, 1964's *Goldfinger*. This film seemed to be the place where the Bond formula came most completely together – Gert Fröbe as the laser-wielding Auric Goldfinger; Oddjob and his equally castrating bowler hat; the nude gold-laced Bond girl; the Aston Martin, and so on. The franchise even began to develop a sense of humour about itself in this film, a sense that it could relax and perhaps did not have anything to prove since it had finally become a phenomenon in its own right. What people perhaps fail to remember about this film is that it is also uncomfortably misogynistic. From Bond's dismissal of the soon-to-be gold plated character with a pat on the butt when he is talking with his FBI friend Felix Leiter ('Men's work', he says) to the conversion of Pussy Galore from Amazonian lesbian private pilot and henchwoman to lover and loyal defender of the West after a roll in the hay with Bond, the film treats the sexuality of women as not only childlike, but totally malleable in the presence of Bond. While other films during the Connery years have less objectionable, or at least somewhat neutral, portrayals of women, *Goldfinger* stands out as not having aged very well. *Diamonds* was originally supposed to be a retelling of that film – one that was reconceived by Cubby Broccoli at some point after he had the inspiration to meld the story with the myth of Howard Hughes. In the final form of the film, the plot is muddled and the yoking of the Hughes idea

to the basic retelling of *Goldfinger* causes the film to drag down – or, perhaps, to make the plot somewhat beside the point. What remains of the *Goldfinger* idea seems to be in the attitude toward women, one that definitely hearkens back to the early sixties, when the Bond films were born. The connections to *Goldfinger* also show up in the soundtrack, the title song is sung once again by Shirley Bassey, but also in the extensive use of American settings. In *Goldfinger*, Kentucky figured prominently. Here, Las Vegas, thanks in part to the Hughes character, Willard Whyte, represents America's interest in the sparkle of both real and fake diamonds, of a sort of egalitarian spectacle of consumption, showmanship and technology. Interestingly, nothing seems to be real here: Bond crashes onto the set of astronauts using a moon buggy; Bond's hotel suite in the Whyte House is clearly a movie set that looks about as real as a room in an Astaire-Rodgers picture. All of the American locales are contrasted to the European ones – Bond meeting with 'M' in London; Bond killing Peter Franks in Amsterdam. The US seems as fake as the neon billboards on Fremont Street. The few glimpses we have of a real US, such as a scene set in a service station, emphasise its basic ugliness – exposed power lines, cheap paving, fat and/or ugly inhabitants.

The basic reality of Vegas is that it is not what it claims to be, or what it seems. Bond spends much of his screen time in elevators, tunnels, behind the scenes. The sense of Las Vegas as a duplicitous place is further underlined by the two main gay characters, who are related somehow to this same grotesquery. Wint and Kidd, as played by Bruce Glover (father of Crispin Glover) and Putter Smith, are contrasted in their physical attributes, but must function together as the villain. They are not only lovers, but also a team. We never see them apart. They complete each other's sentences. The physical malformation of the villain is replaced with the notion of homosexuality – as something missing that even doubling cannot replace. Homosexuality becomes an endless signifier, much like the three copies of Blofeld (mirrored in the fact that he has more than one fluffy white cat to stroke). Duplicating men is never the same thing as creating one good man – i.e., Bond, i.e., Connery. Lazenby cannot take his place, no one can; he is the origin and the only real thing in the desert.

The problem with this formulation, of course, is that it is not true. Connery made it quite clear before he agreed to appear in the film that this was going to be his last time out as Bond, a fact that proved true as far as Eon Productions was concerned. Connery received over 1.2 million dollars to star in the film – the highest at the time – and then donated it all to charity. The producers knew, in other words, that though the film attempted to hearken back to the early sixties, that the death of the original Bond was imminent. The extent to which Connery and Bond were one and the same thing created a problem for the film, one that resulted in anxiety about the very definition of maleness,

of what might be considered real. What is Bond? More specifically, what is he to men? To the British or American males of a certain age Bond internalised central aspects of male identity: do you want to be Bond, or to become him? Do you want to be like him, or to have him? To what extent does the sameness of Bond – his chromosomal male sex – get confused with his gender – his cultural re-definition of maleness as a mixture of British-ness, toughness, consumption, coldness, professionalism, loyalty and self-awareness? How can you be him and be like him at the same time? The film's answer, that Bond is Connery, clearly splits the film apart. The gay male couple is at most an attempt to split the difference. Similarity of sex does not create similarity of gender. Bond feels pity for Wint and Kidd, but not sympathy. Connery walks through the film comfortably, but also never works up a sweat, never takes anything too seriously. The gay male presence in the film is displaced onto the plot of the film as the threat from the villain, while the actual threat to identity appears everywhere else. For a film series that emphasises sex, Bond's relationship with the one Bond girl on display, Miss Tiffany Case, Jill St. John, is particularly lacking in sexual sparks. While their initial meeting in Amsterdam is hopefully full of sexual innuendo ('That's quite a nice little nothing you're almost wearing'), by the time Bond sleeps with her, he hangs up his dinner jacket before getting into bed. The supposedly real villain of the film, Blofeld, is given a surprisingly strange treatment by talented character actor Charles Gray, who portrays him as effeminate, supposedly jealous of Bond's relationship with Tiffany, but also appearing to her at one point in a disguise that consists of a dress and wig.

The gender markers are clearly confused, but also do not just include anxiety about men. When Bond closes in on the prison in which the millionaire Willard Whyte has been kept, the final threat that Bond must overcome appears in the

Figure 14. Thumper and Bambi move in for the kill (*Diamonds are Forever*). © 1971 Eon Productions. All rights reserved.

form of two lesbian body guards, who come closer than anyone else to keeping Bond from his appointed rounds.

That Bond finally defeats them through sheer brute force – and not one, but two – are part of the film's intended *mythos* – in the form of Connery, Bond is now larger than life. The twinning throughout the film – from the two sisters in Amsterdam who built a bridge so that they could visit with each other to the scientist that Bond impersonates at the rocket facility – the film employs the idea that Bond exists in two places at once – in the past and in the present, but not in the future. He is limited only by the temporal, only by the notion of futurity. The franchise will go on, but no one knows how. Things will change, but no one knows if it will be for the better. Bond's pre-Lazenby past is the version of the future that the producers hope for – a form of conservatism to triumph over women, gay men, change itself.

The negative attitude that the film ultimately has for the necessity of change is seen throughout in the form of the film's last trope, that of its anal references. Bond slips the cassette tape that controls Blofeld's satellite system into Tiffany's bikini bottom; Bond ties the bomb that Wint and Kidd intend to kill him with to Wint's coattails. The pleasure of the anal as well as the attempt to put it in its place exists throughout the film in much the same way that women do – to be both admired and feared, used and avoided. While the bottoms of Vegas chorus girls are admired longingly in the film, the reduction of male–male desire to the same thing ultimately takes over. Upon landing at LAX with the body of the drug smuggler Peter Franks, Bond's American friend Felix Leiter asks him where he has concealed the diamonds on the body, to which Bond replies, 'Alimentary, Dr Leiter'. The body is promptly burned so that the refuse it leaves behind will be precious. Bond himself almost gets incinerated at the same funeral parlour. Death as waste lingers everywhere. Bond is knocked unconscious only to wake up in a rat-infested metal pipe far out in the desert.[3] He breaks into Willard Whyte's penthouse by way of the bathroom – the room Whyte uses to monitor his gaming empire.[4] Bond finds himself everywhere confronted by the spectacle of shame, of an American way of life that is, like Vegas itself, based on the needless multiplication of consumption, on the idea of too much.

The film is unusual in placing most of its principal action in an American setting – in and around the city of Las Vegas, Nevada. The American landscape functions, at times, as a sort of anaesthetised subject – a blank slate that resists meaning or deflects it back onto the viewer.[5] The desert is contrasted with the urban Vegas dreamscape, which more properly generates meaning as a newly 'family' entertainment destination – a fact emphasised by placing a long scene in the then new Circus Circus casino.[6] True to the reality of Vegas and the *mythos* of Bond, however, the film ultimately gives

in to a series of adult desires – showgirls, off-colour comedians, gambling at craps. Vegas is made, in some American way, parallel to the Bond universe. By placing Bond in an American setting in the early 1970s, Vegas becomes symptomatic of the anxieties percolating through the body politic. Most early 1970s pop films set in contemporary American society felt compelled to deal with the social upheavals of the time either literally (*The Andromeda Strain*, 1971) or metaphorically (*Westworld*, 1973). While functioning as a seemingly utopian space for its male spectators, *Diamonds* enacts revenge literally and physically on the bodies of the two gay men as the feminine is replaced by the supposed effeminacy of male homosexuality. The film as a complex reaction to the new visibility of the queer body, which, in finally being shown, is, like the desert, presumed to be but never understood.

If Ian Fleming created the original Bond as an answer to the anxieties of the MI6 scandals involving gay figures like Kim Philby, then Bond represents by the early 1970s how complex the attempt to stabilise Bond had become.[7] If Bond is a figure who could exist to counteract the lingering notion of Oscar Wilde, of the British male as somehow an 'other' of male sexuality, then Bond's anodyne did not last all that long.[8] The one way out producers seemed almost to stumble upon was to have recourse to humour. Bond's way of dealing with difference, with the coming of change, was not to take anything too seriously. The result of this was to send the franchise into a period of popularity, the Roger Moore years, in which the importance of Bond seemed to resonate precisely in how topical it could become. *Live and Let Die* (1973), the first of the Moore films, referenced black-action films; *The Man with the Golden Gun* (1974) was in part about martial arts films; *Moonraker* (1979), possibly the nadir of the entire franchise, was Bond meets *Star Wars* (1977). The more the Bond films seemed to avoid the real present and take recourse to the genre of film itself, the more the franchise seemed to go away from those elements that made it important in the first place – the seriousness with which it took its themes of death and redemption, of a new kind of twentieth-century identity. Only with the latest Bond film, *Casino Royale* (2006), does the EON franchise seem to return to the pre–*Diamonds Are Forever* era to re-establish what may have been important about Bond in the beginning. This now classic reboot of the franchise once establishes Bond's credibility by completely rewriting the formula and creating one of the rarely successful prequels for a major series of movies. In this version of the Bond *mythos*, less is more and there is some hope that by not seeing the past as a collision with the present that the franchise will avoid repeating the mistake of *Diamonds Are Forever*. *Casino Royale* takes Bond back to a time before *Dr. No* in 1962, yet puts him spatially in the present, creating a logical paradox that yet allows him to function as a fusion of the best of both worlds. While hardly an answer to the problem of the body

and of sexuality that is presented in most Bond films, the approach in this film is at least a potentially promising new beginning that complicates the divide between normative and non-normative forms of gender and sexuality. Bond becomes Bond again, by ignoring time and becoming only space itself. While it is too early to see where this new start might lead, it is at least a promising possibility that Bond may finally catch up with himself.

The new version of the Bond film *Casino Royale* opens in Prague where the cinematography treats the viewer to a careful black-and-white exterior of modernist architecture redolent of post–World War II corporate manufacture, a veritable icon of periodicity. The scene switches to the interior of a small office, one whose look sums up many of the characteristics of famed set designer Ken Adam's aesthetic for the series from the first film onwards, one that championed total design: every wall, floor, staircase, lamp, object and person seemed to fit into an overall pattern of futurity, function and knowingness – a marker for the Bond films at their best and, subsequently, of the Connery years of the 1960s. The visual style of the scene we are about to enter, in other words, suggests the film series' past, the sleek, black-and-silver world of the bachelor: masculine, hard-edged and hyper-modern. By opening the film in this way the director and producers seem to signal that the look of the original Bond films now constitutes not only a style but a retro-style, an era, an acknowledgement of a past. The very surface of the film suggests a new type of self-consciousness for the Bond formula about its structure, style, and function. And indeed, this film does seem on one level to resist or even arrest its own history, to place it within a spatial construct much like a Möbius strip in which the end of the film twists slightly to become its own beginning. Running counter to this spatial structure is the overall relationship that the film has to the timeline of the series: its events take place before the events of the other films, but after this brief pre-title sequence set in Prague, it takes on the look of a contemporary movie, switching from black-and-white to colour and to characters that act, more or less, like they are coterminous with the present. Time, in other words, enters the film only to be confused and undone by the spatial tropes that the film attempts to establish as part of the deconstruction of the Bond franchise's elements.

The audience does not realise the extent of the re-imagining taking place in the film until it arrives at the final moments of this scene. It begins with Bond talking with an MI6 agent gone bad, Dryden, about his undercover contact, Fisher. At one point, Dryden asks, 'How did he die?' to which Bond responds, 'Your contact?' 'Yes', Dryden answers. 'Not well', says Bond. 'Made you feel it, did he?' asks Dryden, drily and somewhat wistfully. This exchange is significant in two ways. First, Bond responds to his question with an interrogative, suggesting just a note of insecurity or naiveté. Perhaps he is willing to have a real human

Figure 15. Bond and Fisher, round one (*Casino Royale*). © 2006 Eon Productions.

conversation or perhaps eager to talk to someone about his first kill. Bond, in other words, is not fully formed and the rest of the film will be a treatise on his origins, on his hardening into what he will become. Second, the question elicits an honest response from Bond, 'Not well.' We might think that Bond has the usual upper-hand here, as in, it was an ugly death, too bad for your compatriot, and hence, you as well. Bond's interlocutor, however, immediately turns the situation on its head, 'Made you feel it, did he?' The wiser older man – Bond in some number of years – knows that death is a two-way street and that Bond is being schooled in the link between the body and the soul. Intercut with this conversation is a flashback to the job itself, Bond battling brutally with a villain in a black-and-white tiled bathroom: chequered floors and white basin splattered with the dark water and blood of the environment of public privacy. Bond gets roughed up, though not as badly as his adversary, who refuses to die easily. The style of the photography assumes a slightly grainy feel, the opposite of the sensual slickness of the Prague interior.

The images from the beating come in primitive bursts of memory, almost like images Bond is already trying to suppress, but cannot quite – at least not yet. Dryden had begun their conversation with the confident statement, 'If M was so sure I was bent, she'd have sent a Double-O.' With this flashback we now realise that Bond is 'James' but not yet '007'. The man in the bathroom was his first kill, but he needs another. Dryden continues, 'Well, no worries, the second is....' 'Yes. Considerably,' says Bond, as he completes the thought and shoots Dryden dispassionately in the head. A straight, simple nearly silent kill – the sort of elegant murder we associate with Bond and his professionalism. What we are witnessing is the birth of a Double-O – a transition that occurs between Fisher and Dryden, the birth pangs of the first kill and the hard-won knowledge immediately assimilated into the second. Bond turns the tables

back on the fellow spy and makes him his second victim, the badge that earns him his identity. The Bond we thought we knew is gone. In his place is a creature that embodies the Bond we know and also something else – a Bond we have never known, cinematically or otherwise.

This pre-credits sequence ends with our moving back to the flashback where Fisher, having seemingly faked his drowning in the bathroom, rises again. The last image we see is of Bond grabbing his gun and shooting Fisher and, by extension, the audience as the shot becomes the iconic image of Bond shooting into the viewer of a gun that is aimed at him as the screen slowly bleeds red. Bond becomes 007, but the process has only just begun and the rest of the film will tease out the elements that go into the other aspects of the transformation. By the time we get to the end, Bond will have triumphed over not only his nemesis, Le Chiffre, but also arrested the notorious Mr White by knee-capping him and reducing him to crawling at his feet. 'Who is this?' Mr White asks on the phone. Bond answers by uttering his most famous line – 'Bond, James, Bond' – as he steps out of the shadows dressed in a blue version of the three-piece suit that Sean Connery wore at the end of *Goldfinger*. Bond smirks noticeably before we cut to black and roll to the credits and finally hear the iconic strains of the original Monty Norman surf guitar theme song. The director, Martin Campbell, and the writer, Paul Haggis, seem to suggest that the 1960s begin now, only after Bond has gone through the events shown in the film we have just seen.

Those events are ones that take Bond on an odyssey that tests him not only physically but emotionally. The clever conceit of the film is that we are getting to see Bond again, for the first time, as though we did not know him, as indeed we do not. The film works against our sense that the character on the screen is one that we have grown up with and that we think we know well. Just as we begin to fall into a scene or situation that seems familiar, even traditional for the Bond genre, we are reminded that we are, in a sense, seeing everything anew. This same conceit also allows for a simultaneous updating of the Bond character so that he seems more like a Bond for the present, mainly, a Bond with a body, the most physical Bond that we have had since Connery, if not ever.[9] Bond's body gets to register everything for the first time and the film, rather than being merely another episode of the ongoing seriality of the franchise, gets to pack together Bond's life as an *ingénue*, as someone who is vulnerable for the last time before he becomes the cold professional that we know.

The emphasis throughout the film on Bond's body begins for many viewers before they see the movie. The fact that actor Daniel Craig is blond and not in the tall, dark and handsome mould of Sean Connery or Pierce Brosnan drove some fans to set up sites that lambasted him even before the film appeared.

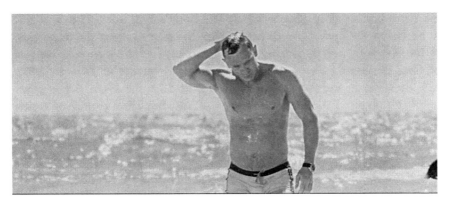

Figure 16. Bond arises from the waves (*Casino Royale*). © 2006 Eon Productions. All rights reserved.

His body, in other words, was an object of extreme attention even prior to the narrative that contained it. The creators of *Casino Royale* met the critics of the casting of Craig head on by allowing him his own emergence from the waves to echo the arrival of the first Bond girl, Ursula Andress, in *Dr. No*. While this trope had already been used in the last Brosnan film, *Die Another Day* (2002), with Halle Berry playing the Andress role, the switch of gendered view in *Casino Royale* also suggests the movement of Bond from subject to object. While Bond's emergence on the beach is to some extent contained within the narrative of the film as he is spied for the first time both by Solange, the first Bond 'girl' of the film, as well as her husband Dimitrios, we as viewers are asked to examine him as well.[10] In a sense, his subjectivity is not formed yet and his body, like his identity, is the object of a certain amount of self-conscious scrutiny both on the screen and off and becomes one of many self-conscious winks to the audience.

The body of Bond is on display in a way that consciously activates what Tony Bennett and Janet Woollacott call 'a license to look', or as they write, 'the novelty of the Bond tales, and that of mass-produced pornography generally, is its place in the new organisation of sexuality in consumer capitalism'.[11] The disruption of British society, the injection of women into the work force, the swift rise of postcolonialism, the shift within the country toward something like a meritocracy, allow for the rise of a character like Bond. His very modernity is tied to the transcoding of all discourses to the sexuality of advertising and branding, which opens up a space for men to look, but also women. At the beginning of the first Bond film, Sylvia Trench invites herself over to Bond's flat in London after meeting him at the same place we do, at the Chemin de Fer table at the club Le Cercle. When he gets home, she is already there wearing one of his shirts – and nothing else. While

the series has certainly always emphasised Bond's right not only to look but to represent the male viewer's prerogative in order to enact the male gaze of the film audience, by placing such an emphasis on the scopohilic aspects of film, the Bond movies, like a mass-produced version of *Persona* (1966), call attention to the physicality of the gaze. Like the films, the original novels emphasised the physical aspects of sex, but often contained much more graphic and hard-edged endings than do the films making it clear that the consummation of the novel itself is in the extreme satisfaction that Bond takes in his final sexual conquest of the lead female character and love interest. While the films are more liable to represent these moments through quips and indirection, Connery does get the forceful aspects of Bond's sexuality right, if anything often overplaying the sadistic edge, especially in a film like *Goldfinger*.

In *Casino Royale* we finally get a version of Bond that makes him seem genuinely vulnerable and he is given, in the character of Vesper Lynd (Eva Green), a lover who is equal to him in terms of mental toughness and agility. In her mixture of French, Swedish and English backgrounds Green echoes the sort of complex identity that Bond himself is supposed to have as the son of a Scots father and a Swiss mother. Likewise, Bond and Lynd's banter, especially upon their first meeting, suggests their compatibility and similarities. For perhaps the first time since Diana Rigg played Tracy di Vicenzo in *On Her Majesty's Secret Service* (1969), Bond seems to have a serious female counterpart, one who could even be his wife. When it later emerges that she is a counter agent who has betrayed him (but sacrificed her own life for that reason, at least in the novel), it is clear that the main event that shapes Bond into the hardened version that we know is this emotional situation, for which the various physical manifestations are perhaps secondary.

Those physical aspects, however, are far from superficial and open up the film to the other aspect of sexuality in the franchise generally, the threat of the villain, which is at least in part the threat of homoerotic association. The villain must be damaged in some way physically that represents not only his sexual dysfunction (whether homosexual, asexual, or sadistic) but his disjointed view of the world as well, his megalomania or desire for chaos. Bond may well be, as Dr No accuses him, a 'blunt instrument', but he is supposed to have the correct desires on his side: protect the free world and bed the girl. Part of the complexity of this formula is its triangulation. The Bond girl is frequently associated with the villain by being herself the victim of some kind of violent sexual past such as Honeychile Ryder in *Dr. No* or Pussy Galore in *Goldfinger*. Kingsley Amis notes, the women in the novels often have some type of physical defect as well: 'Honeychile…has a broken nose and Domino Vitali limps because one of her legs is an inch shorter than

the other'.[12] Her sexuality if not her identity itself has to be realigned by Bond and made whole again. This process can include making her sexuality heteronormative, although in some ways that is shown to be a side effect of the rescuing of the heroine from her past. By getting so close to the girl, Bond gets close also to the villain and becomes associated with both of them in equal measure. The villain's obsession with Bond, his ability to allow him into his confidence and into his lair, is emblematic of his desire for an equal, a confidante, a partner in knowledge. By discounting the girl as either beneath his gaze or much less interesting than Bond himself, the villain forges a homosocial bond with Bond that is frequently the strongest nexus of desire in the film.

In *Casino Royale* the villain Le Chiffre is given a facial scar that weeps blood and, for good measure, an inhaler, but otherwise is devoid of conspicuous monstrosity. In the film as well as in the book he mainly functions as a go-between, someone who aids and abets evil-doers and who has found himself owing a lot of money to the wrong people. As his name suggests, he is a sum, or a number, to some extent an abstraction. While accused by some viewers of the film of coldness, even of homosexuality, because of his lack of response when his girlfriend is threatened with an amputated arm by a gang of African henchmen, his main role is as a torturer of Bond in a scene that not only echoes images from Abu Grab but that in the original novel consciously confuses sexuality and pain. Bond is tortured by being stripped naked and placed on a hollowed-out cane chair. Le Chiffre, played by Danish actor Mads Mikkelsen, swings a knotted rope at Bond's genitals and back side.[13]

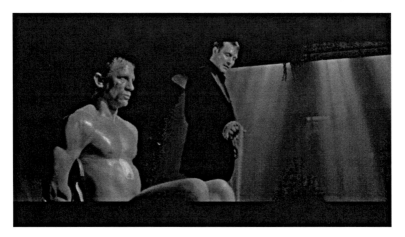

Figure 17. Bond's torture by Le Chiffre (*Casino Royale*). © 2006 Eon Productions.

As Fleming notes, after a point Bond feels 'a wonderful period of warmth and languor leading into a sort of sexual twilight where pain turned to pleasure and where hatred and fear of the torturers turned to a masochistic infatuation'.[14] The mixture of pain and sex, the very definition of Bond's identity, is here controlled by his arch enemy, who, like Goldfinger and his remarkably large laser, threatens Bond with castration. When Bond fails to give him the information that he wants, Le Chiffre knocks Bond and his chair over, draws a knife, and says, 'I am going to cut this short. And feed you what you seem not to value.' Bond's torture is relieved only by the arrival of Mr White who kills Le Chiffre in the name of 'our organisation' the same way that Bond had killed Dryden, with a bullet to the forehead. Scarred and bloody, Bond is sent to Lake Como for an extended convalescence; the implication is that he is damaged almost beyond the point of repair.

This slower, statelier section of the film switches tone and tempo as Bond is shown to go through several stages of recovery that take place over a very long time. The final stage involves the arrival of Vesper and the cementing of what Bond thinks is their romantic relationship. Even here, however, Bond's brush with physical incompleteness is referenced several times as Vesper and he play a game of openness and deception in which they both have secrets that they do not share. As the one left most vulnerable, Bond eventually lets his guard down with Vesper, though mainly because he is falling in love with her. At one key point she accuses him of putting his armour back on, to which he replies, 'I have no armour left. You stripped it off and tossed it away. Whatever is left of me… Whatever is left…whatever I am, I am yours…' Whatever is left of Bond seems to reference, among other things, whatever is left of his manhood, his genitalia and his ability to resist the complications of marriage. Earlier in the film, as he bedded Solange, she asked him, 'Why do I think you've been in this position before? You like married women, don't you, James?' 'It keeps things simple', he replies. The idea that he would now be the married one complicates his sense of identity in a way that is radical for the formula. Bond eventually defines his incompleteness in a different way: 'You do what I do for too long and there won't be any soul left to salvage. I'm leaving with what little is left of mine. Is it enough for you?' His bodily metaphors having eventually become spiritual or mental ones, what he fails to understand throughout this section of the movie, though it is first hinted at when Bond and Vesper have a celebratory dinner in Montenegro, is that Vesper is not who she seems to be. 'I fear I am a complicated woman', she tells him, and indeed, in addition to being in love with a French Algerian, she is also in league with the organisation that is blackmailing her and her lover as well. Bond's coming to awareness is one of a double double-cross in which he, the spy and the one who should be a master of identities, is taken in by trusting his own heart. The defibrillator

that Vesper repairs in an earlier scene outside the Casino Royale that allows his heart to start beating once again after he is poisoned at the table is soon to be broken by Vesper's betrayal. The ability no longer to have a heart is what Bond must learn in order finally to become 007, a nameless number like Le Chiffre himself, a function within an organisation.

In Bond's final debriefing with M. before his visit to Mr White and transformation into the James Bond that we have always known, M. says to him, 'You don't trust anyone, do you James?' 'No', he replies. 'Then you've learned your lesson.' M. goes on to suggest that Bond may need more time off, to which Bond replies, 'The bitch is dead' – the same line that ends the novel. Fleming, like the producers of the Bond franchise today, knew that Bond could be Bond only with the steely attitude that reminds the audience of the sacrifices that he has to make to create a seamless and impregnable outer surface – the performative aspect of Bond. He is always playing the part, like Judith Butler's theory of gender or heterosexuality, because there is no definitive script, there is no natural reality to which masculinity corresponds. One must, therefore, constantly invent it and iterate it in order to create a never-ending chain of signifiers that posit an identity, a subjectivity that others may see and understand and to which institutions and governments might grant rights and responsibilities. In an early version of the script the section after their conversation reads, 'M. replaces the phone, knowing that she has sacrificed a man to create a spy, and for the briefest of moments, is not happy with herself.'

In the main title sequence of *Casino Royale* we see playing cards come to life as the central metaphor of the film is the notion of the game – Baccarat in the novel, poker in the film – especially games that are about lying convincingly. The hearts on the playing cards become bullets and then actual hearts. Though one might think that the blood that has been spouted is that of the villains, it may well be Bond's blood. Early on in the film we see Bond chase a bomb maker through Madagascar seemingly as a way to demonstrate the athleticism of the new Bond, which quickly eclipses that of any previous star in the role and eventually comes to resemble the mixture of acrobatics and running that is 'Parkour' and which had recently been featured in Luc Besson's *Banlieue 13* (*District B13*, 2004).[15] We feel every bit of Bond's body's weight as he jumps onto a crane or down from a rafter. This new physicality is carried over into a sequence in Miami involving a prototype aircraft that Bond is trying to prevent from being blown up. Upon first arriving in Miami, Bond attempts to thwart a drop off for the enemy that is occurring at the 'Body Worlds' exhibit – the naked flaying of flesh that is the signature of these controversial pseudo-scientific events becomes a metaphor for the film's emphasis on the body, on Bond himself as exhibit, posed naturally, but with his interior forever exposed.

The new *Casino Royale* allows the audience a glimpse into the creation of Bond, a rare and privileged spot to behold. *Casino Royale* was the first Bond novel in 1953 and the first Bond filmic version as well in 1954 on the CBS network show *Climax!* It was never available to Eon Productions because of a dispute between MGM and Sony that was finally settled when MGM agreed to exchange the rights to *Casino Royale* for the rights to *Spider-Man*. Finally given the opportunity to film the story for the first time, the producers (which included Barbara Broccoli, the daughter of the co-founder of Eon Productions, Albert R. Broccoli) wisely chose to revisit the origins of the Bond franchise. In doing so, the producers of the franchise could restart the original without in fact having to worry about the difficulty of making a period film or even of providing a background that would necessarily have to be referenced in subsequent films. As Broccoli argued at the time of the film's release, 'But it's not a prequel or a period piece or anything like that – it's set today, right now.'[16] Like the last season of the television show *Lost*, one might argue that the Bond franchise has created an alternative universe in which Bond is, and is not, given a back story. Whether it is a prequel or something else, the film emerged in 2006 at the time of the intersection of several attempts at audacious prequels: *Batman Begins* in 2005 and the conclusion to the trilogy of Star Wars prequels that ends the same year. *Casino Royale* is quite different from the bloated, high-tech films of the Brosnan 1990s and seems much more in alignment with the Bourne films of the twenty-first century, maybe especially the *Bourne Supremacy* from 2005, which itself seemed to reference *From Russia with Love* from 1963. In both of those films there is a return to the physicality of Bond and to the dangers and vicissitudes of his body, which remind us that he is human, a man not just an archetype. But while there have periodically been tweaks and changes in the series' formula throughout the years – *For Your Eyes Only*, *The Living Daylights* and even *GoldenEye* might all be films that were supposed to suggest a turning back to the 1960s or to the novels' original intentions – only *Casino Royale* returns us to something prior to that formula, perhaps even prior to Fleming himself, and by inventing a layer of Bond we never had before gives us Bond back again to enjoy as we probably have not since 1969 or earlier.

At this time, *Casino Royale* has grossed 595 million dollars worldwide. The film that followed *Casino Royale*, *Quantum of Solace* (2008) also did well, though without quite the same critical support. *Solace* functions as a sequel that immediately picks up on the action and delivers a short, action-packed film. The villain is even less marked as evil or abnormal than is Le Chiffre. The Bond girl is even more independent, even disdainful of Bond. It is difficult to know where the Bond films will go from here as they barrel through their alternate timeline forever attempting to outrun a history that is a trap,

a burden, and a much-needed fantasy realm. Rumour has it that the films will continue to provide some origin stories, for M and for Q, for example, which would suggest that the franchise will continue to be both in the present and somewhere in the past as well.

Notes

1 In one version of the script for *On Her Majesty's Secret Service* (1969), Blofeld is supposed to have received plastic surgery since he and Bond met in *You Only Live Twice* (1967). The fact that this is dropped from the film created an error in continuity. 'On Her Majesty's Secret Service (1969)', *The Internet Movie Database*, 12 March 2009 <http://www.imdb.com/title/tt0064757/> [accessed 25 August 2011].

2 In the novel version of *Dr. No*, the villain's base of operations is disguised as a guano-manufacturing facility.

3 Rats are also connected to Mr Wint, whose cologne Bond refers to as smelling 'like a tart's handkerchief'. The odour later identifies Wint to Bond, who concludes that it is 'strong enough to bury anything'; 'And I've smelt that aftershave before, and both times I've smelt a rat.'

4 Played by American sausage king Jimmy Dean, Whyte makes frequent references to his bathroom office and, when finally rescued by Bond, is seen emerging from the bathroom. The first line uttered in the film comes from Blofeld: 'Making mud pies, 007?' One of his last lines is delivered to Tiffany Case: '...my dear, we're showing a bit more cheek than usual, aren't we?'

5 At the funeral parlour, the character of the director, Morten Slumber (David Bauer), bears a striking resemblance to Cary Grant, a denizen of Palm Springs, a desert locale also referenced in the use of architect John Lautner's *Elrod House* (1968) later in the film.

6 Distortion is referenced throughout the film – from the fun-house mirror that Tiffany Case looks into at Circus Circus to the children's freak show she stumbles into that features 'Zambora – strangest girl ever born to live' in which an African American woman is turned into a 'ferocious 450-pound gorilla'. Race and sexuality sit side by side as uncomfortable nodes.

7 See for example John Cork and Bruce Scivally, *James Bond* (New York: Henry N. Abrams, 2002), p. 13.

8 As many critics note, Bond is to a large degree modelled on Fleming himself, especially his 'fussy particularity', which goes well beyond how his martinis are made: Simon Winder, *The Man Who Saved Britain: A Personal Journey into the Disturbing World of James Bond* (New York: Farrar, Straus, and Giroux, 2006), p. 113. Throughout most of *Diamonds Are Forever*, Bond wears a tuxedo, with button hole, or a suit and references on at least one occasion the moment in *Goldfinger* where he pulls off his wet suit to reveal a dinner jacket. The dandy side of Bond is perhaps heightened within the American landscape of the film.

9 Cubby Broccoli put it this way: 'To be candid, all the British actors I had interviewed, while very talented, lacked the degree of masculinity Bond demanded. To put it in the vernacular of our profession: Sean had the balls for the part.' Albert R. Broccoli and Donald Zec, *When the Snow Melts: The Autobiography of Cubby Broccoli* (London: Boxtree, 1998), pp. 165–66. Connery as Bond is itself a complicated matter. Though he is widely seen now as the best of the actors who played Bond, his physique and

manner are off-putting to some. It may be just as important not to associate Connery with Bond if we are to analyse the use made of masculinity in the films. As Richard Rambuss notes, 'Male masculinity sometimes sustains misogyny, but I don't think that it is reducible or has any necessary relation to it. Virility…need not be coextensive with a patriarchy that enjoins a political gendered inequality.' 'After Male Sex', *South Atlantic Quarterly*, 106.3 (2007), 577–88 (p. 585).

10 At one point Solange tells Bond, 'I'm also afraid you slept with me in order to get to him.'

11 Quoted in Michael Denning, 'Licensed to Look: James Bond and the Heroism of Consumption', *The James Bond Phenomenon: A Critical Reader*, ed. by Christoph Linder (Manchester: Manchester University Press, 2003), p. 73.

12 Kingsley Amis, *The James Bond Dossier* (New York: The New American Library, 1965), p. 46.

13 Le Chiffre begins by telling Bond, 'You've taken good care of your body. Such a waste.'

14 Quoted in Toby Miller, 'James Bond's Penis', *The James Bond Phenomenon: A Critical Reader*, ed. by Christoph Linder (New York: Manchester University Press, 2003), p. 236.

15 This sequence was suggested by a similar roof-top scene filmed for *On Her Majesty's Secret Service* but later deleted. 'Plot summary for *Casino Royale* (2006)', *The Internet Movie Data Base*, 19 March 2008 <http://imdb.com/title/tt0381061/plotsummary>[accessed 25 August 2011].

16 Quoted in Benjamin Svetkey, 'He's Bond. He's Blond. Get Used to It!', *Entertainment Weekly*, 31 March 2006, 11–13 (p. 13).

Chapter 4

WHATEVER YOU SAY, SAY NOTHING

Anna Zaluczkowska

University of Bolton

1975: 'Whatever You Say, Say Nothing'[1]

Heaney talks of a Northern Ireland that is parochial and divided – a place of silence and fear where it is safer to keep quiet than to say the wrong thing. Heaney's poem speaks of a provincial people hemmed in by the past and silenced by the conflict. This was certainly reflected in the limited film culture of 1970s Northern Ireland and in my own experiences of the times. I was brought up in Northern Ireland during the worst period of these Troubles – a teenager in the 1970s. Although technically an outsider, my Polish background ensured I was subsumed into the Catholic Nationalist community even though I lived in a predominantly Protestant area. It was a time when people were forced to take sides to line up with one point of view or another.

2011: Now I am asking is Northern Irish Film finally, after nearly three decades of development, beginning to find its voice? I am going to argue here that it has come of age because of its ability to accommodate the demands of the cinematic popular form while investigating the controversial. I believe that this new confidence has been achieved over the past thirty years through the creation of a whole series of interesting if not always commercially viable feature film experiments.

To understand why I am being so optimistic it is first necessary to set out some of the history and filmmaking practice that has led Northern Ireland Screen in 2009 to suggest: 'The screen agency's profile is at an all time high amongst the global filmmaking community.'[2] Filmmaking is new to Northern Ireland as Jon Hill has detailed in his comprehensive account of its development in his book, entitled *Cinema and Northern Ireland*,[3] and I do not propose to repeat his account here but it is worth mentioning a few highlights. He suggests that the unionist government first identified the propaganda possibilities of film in the 1920–30s and any production that was undertaken was used to promote 'Ulster' as a distinct cultural entity. This failed, he suggests, due to the

all-pervading, already well-established notions of what constituted Irishness, but is also due to the unionist government trying to control and shape the image that was projected to others through its filmmaking activities.

The situation was further complicated by the censorship of films in Northern Ireland due to what was perceived as its damaging effects by unionist leaders. They were not alone in thinking this at this time, but their views led to the banning of films in Northern Ireland that could be shown in England and Eire. The arrival of TV to Northern Ireland in the 1950s ensured that this concern was shifted to the development of programmes for broadcast and the relationship between film and TV has been fairly close since then.[4]

It is not until the 1960s that there is any state policy concerned with the cultural and economic aspects of film and its production and at that point there was no funding with which to develop it. This in turn coincided with the emergence of the unrest that was to become known as the 'Troubles'. Northern Ireland's film production is therefore very caught up with the imagery of these 'Troubles'.

Despite the continued lack of funding available, films were made in the 1970s and 1980s. Many of these used experimental methods of filmmaking, taken from Western or Eastern European cinema. I am referring here to filmmakers such as Pat Murphy, Bob Quinn, Alan Clarke[5] and to some extent the early films of Neil Jordan. These filmmakers maintained that the ideas that they wanted to express would not easily fit into what would be described as the conventional Hollywood commercial film structure. They argued that the oblique and metaphoric, poetic language of experimental film was more able to express the conflicting and sometimes contradictory nature of the material they wanted to explore.[6] With things being as polarised as they were in 1970s Northern Ireland it would have been difficult, if not impossible to make a popular film about the situation at the time.[7]

Therefore, no matter how innovative and intelligent these films were, whatever was being said at this time was being said to a particularly small and already well-informed audience. In fact Neil Jordan, himself initially a novelist, suggested at the time that coming from a literary culture, making a film was like tackling a whole new language. Both the form and the way the form was realised were new to the Irish experience.[8]

If you add to this that many films were banned or censored at this time then you can see that the environment was not conducive to self-expression in a popular format. The BBC chose not to broadcast their own commission of Max Ophul's documentary *A Sense of Loss* in 1972; *Hennessey* (1975), a feature film, was not screened by the ABC and Odeon cinemas because they felt it to be inflammatory effectively banning it from the UK.

As a writer and filmmaker and as part of the developments, which took place in the 1990s to find new writers with interesting stories to tell, I found writing about Northern Ireland difficult because I was always concerned to offer a balanced and non-partisan view of the situation. I was worried and uncertain about my political views. As a result none of my efforts ever really succeeded in offering anything new to the debate.

Ronan Bennett (writer of a number of TV plays about Northern Ireland) suggests that the lack of success in the 1970s, 1980s and some of the films of the 1990s was in part due to screenwriters using the same conventions as those engaged in media reporting. These views were that the 'Troubles' were an irrational slaughter, that both sides were to blame and were driven by psychopathic instincts, that sensitive people did not get involved and that there was no alternative to British rule. Caught in a polarised position, Northern Irish screenwriters felt the need to tread carefully across boundaries, weaving events and imaginings together with the heavy responsibility to remain true to their political commitments, while producing a positive explanation that would be intelligible to a wider audience that perhaps does not share these concerns.[9] So I agree with Seamus Deane whose novel *Reading in the Dark* is currently being developed into a film in Northern Ireland by writer Ronan Bennett. Dean suggests that 'It's impossible to be measured in Northern Ireland, perhaps one shouldn't bother.'[10] Many of those early films about Northern Ireland did indeed wear their colours clearly on their sleeves and I would argue worked much better for it.

Given that Northern Ireland was being ruled directly by Britain, the launch of Channel 4 was a significant development. In line with its remit to seek out new and interesting voices and 'represent the alternative and oppositional voice',[11] the Department of Independent Film and Video formed a number of franchised not-for-profit workshops including Derry Film and Video.

These workshops began to make films and the result of all this activity was the formation of the Northern Ireland Film Council, whose job it would be to promote local film and video production and culture. The increased activity of BBC Northern Ireland's drama output, the availability of lottery funding and the establishment of the Irish Film Board also contributed to increased film production. As a result commercial filmmaking in Northern Ireland was born in the 1990s.

It is also important to remember that in 1988 Douglas Hurd (the then Secretary of State for Foreign Affairs) imposed restrictions on broadcasters prohibiting them from transmitting 'any words spoken' where 'the person speaking the words represents or purports to represent' a proscribed organisation. This affected everyone in Northern Ireland and not just politicians. No one could express 'personal opinions' in broadcasts in support of Republicanism

even if they had nothing to do with the IRA or any other similar organisation. These restrictions were brought in because of the Thames TV documentary *Death on the Rock* (1988) that suggested that the SAS were responsible for the killing of three IRA suspects rather than apprehending them. It therefore became difficult to get documentaries commissioned on controversial subjects. These restrictions were not lifted until 1994. Many filmmakers who made their films in the early 1990s would have been aware of these restrictions and would have decided to make docudramas and fictional stories instead.

Another compelling reason for the growth in commercial filmmaking was the fact that the political and economic background was changing. After many years of violence both loyalist and nationalist groups called a ceasefire in 1994. This was to lay the basis for what was to become the peace process that would eventually result in the Good Friday Agreement.

All these developments resulted in a small amount of money being made available to make films and the beginnings of a climate in which it was possible to examine the past and so Northern Irish cinema began the process of re-imagining post-conflict Northern Ireland. It was a time to say something and many writers and directors from England, Ireland and America set about making a range of popular films.

Neil Jordan made *The Crying Game* (1992) and Jim Sheridan made *In the Name of the Father* (1993). Both were very popular and commercially successful films, which interrogated stereotypes and began to signal a changing political mood, one of peaceful resistance. Both were made with a large injection of money from Hollywood and are probably still the most commercially successful films made about the 'Troubles'. Both films received a host of awards but were greeted with controversy and criticism for different reasons. As Neil Jordan said, 'In Ireland I was accused of misusing public funds, portraying the Irish as irrational and prone to atavistic violence, reinforcing colonial stereotypes etc.'[12]

Jim Sheridan's film tells the story of how the Guildford Four became wrongly imprisoned in British jails. Much was made of the factual inaccuracies of his film, but Sheridan makes it very clear that his intention was not to elucidate the facts of the situation but to hold up a mirror to Britain in an attempt to show that a mistake had been made. 'If you can't say that then the whole thing really does come tumbling down', he maintains in a TV programme called *Ourselves Alone* made by Channel 4 in 1995. At around the same time Margo Harkins' low-budget *Hush a Bye Baby* (1990) was also screened on Channel 4 and received the highest ratings for its slot. Again there were protests from Derry, but suddenly the Irish question was on the big screen and attracting large audiences as well as controversy.

Some 18 feature films were made along with 7 television dramas in the 1990s. These films were often a response to media reporting of the situation in Northern Ireland and sought to use popular film to voice an alternative to the reports and images of violence – an attempt to put a human face to the events. Jon Hill was critical of these developments and characterised Neil Jordan's films as British and 'unequal to the challenge of their subject matter and as a result have obscured as much as they have illuminated the issues with which they have dealt'.[13]

It is true that some films at the time were limited in their political complexity, perhaps allowing the popular form to constrain their development, but I do not think Jordan's was among these. As Ronan Bennett stated at the time about Neil Jordan's work:

> There is a very real and a very important sense of ambiguity around Jordan. It is the ambiguity central to artistic endeavour. Ambiguity here is not neutrality but the recognition that doubt, dilemma, crisis and confusion – personal, moral, political – play a crucial part in creating a point of view in the work. Jordan's critics are polemicists. To them certainty, right and absolute truth are things apparently easily grasped, clearly defined and spurned only by the wilfully degenerate. No self-respecting filmmaker can put such fixity of purpose and belief in his work.[14]

Martin McLoone on the other hand saw these 1990s films as the development of an indigenous cinema, which he said 'demonstrated a critical engagement with the legacy of Irish cultural nationalism'.[15] The failings that he sees in these films, such as the lack of a developed loyalist dimension, are due to the conventions of mainstream cinema rather than a nationalist filmmaking conspiracy.

These mainstream conventions demand a hero – a main character who is clearly drawn and who is opposed by an identifiable villain. The hero travels from a position of equilibrium through various disruptions to emerge at a new place with new knowledge. Such conventions that favour stories of the underdog and the nationalist community in Northern Ireland have often seen themselves, and been seen by others, as aligned with the underdog. McLoone does not feel that this form is particularly conducive to the 'contradictory, historical and multilayered complexities of politics'.[16] And that is something that Ruth Barton agrees with in her book *Irish National Cinema*, maintaining that mainstream filmmaking practices are unable to analyse political issues in any depth.[17] But I tend to agree with Lance Pettitt who maintains that 'its better screenplays have engaged critically with its fractured past and the disparate elements of modern Irish life'.[18] It is

certainly true that many films presented representations of Irish and British nationalism in the North, but they were also able to offer a critique of that nationalism to global audiences. Far from being pro-Republican, much of the ground covered in these films not only struggles to come to terms with nationalism but also actively challenges previous notions of Irish identity. As Martin McLoone points out in *Border Crossings* (1994), many of these films interrogate rural mythology, detail the urban experience, concern themselves with social and political failures, challenge religion and women's roles and deal with political violence and disrupted notions of identity which form the crux of the conflict.

In opposition to these analyses, Brian McIlroy in his book *Shooting to Kill: Filmmaking and the Troubles in N. Ireland* argues that these 1990s films were dominated by Irish Nationalist and Republican ideology saying that these visions by Jordan, Sheridan, George, Comerford and O'Connor are problematic in that they concentrate on the Catholic community: 'The representation of the majority Protestant community is so perfunctory in these films that the viewer could be blamed for thinking that the British government is entirely at fault for the violence and instability.'[19]

It is true that Protestants have not been featured very widely in these 1990s films. There were films made about the Protestant experience, but *December Bride*, *Nothing Personal* and *Resurrection Man* were all limited commercial successes and thus not broadly received at the time.

It was not until Colin Bateman emerged into the film production world in the late 1990s that a 'Unionist Thriller' *Divorcing Jack* (1998) was developed. A number of his other stories were subsequently produced, but none really ever found a large audience despite being very funny. Bateman's films were probably ahead of their time, predicting a Northern Ireland in which comedy could be applied to politics. This has something to do with the fact that not many in the Protestant community decided to engage with this form of expression. Richard Williams, chief executive of Northern Ireland Screen, has said:

> There isn't a pile of projects in our office that we're somehow rejecting. That sort of material is rarely written. Interestingly, writers from a Protestant background have a tendency to just shift away from here and ply their trade elsewhere. But even when they do stay here they've a tendency not to write about this sort of thing.[20]

But these arguments essentially miss the point. All these films were made within 10 years of each other – a short time in the feature film business. It was a time when film organisations in the North were finding their feet and looking for the talent of the future. The decade reflected an important engagement

with issues of Northern Ireland for a varied range of English, American and Irish filmmakers.

They tried to inject ambiguity into the popular form at the same time as offering a more partisan view. They did not always succeed, but this public adoption of a 'position' involved a struggle between moral and artistic integrity and necessity. It was played out in the heat of a very public criticism that, due to the popular form that the films adopted, took place in the larger environment of a worldwide debate. The public wanted to hear about what had happened as much as filmmakers wanted to talk about what had happened from their own perspectives. The films of the 1990s also show a more optimistic approach towards the violence suggesting that peaceful resistance is more effective.

By the end of the 1990s more funding became available due to the changing nature of the economy of Northern Ireland. Reflecting New Labour's desire to promote and strengthen the creative industries, the state engaged in a rush to develop the commercial bedrock of the filmmaking culture. Strangely, during the 1990s the commercial success of these films began to diminish while at the same time the peace process was stalling. Audiences were perhaps beginning to tire of the endless talks and the lack of a resolution. This may have explained the drive to invest in material without such a political content.

By 1997 Northern Ireland Screen had placed a high importance on the commercial viability of the product. The subsequent productions, *Mad about Mambo* (2000), *The Most Fertile Man in Ireland* (2000) and *With or Without You* (1999), reflected the general revival of interest in romantic comedies, as seen in the success of films such as *Sliding Doors* (1998) and *Notting Hill* (1999). I would suggest that at this time the filmmaking community in Northern Ireland was keen to put the past behind them to show that it was engaged with global filmmaking practice and trends. However, just like for England or other European countries, this was never going to be a simple task.

Having begun the dialogue of how to talk about the controversial political and cultural issues facing Northern Ireland, it appeared that we were in danger of throwing it all away in order to placate an international marketplace that had had enough of us. This is understandable if you have hitched your cart to the film-as-economic-development horse. So Northern Irish filmmaking in the late 1990s and early 2000s tended to demonstrate the downside of engaging with the popular form.

Its ability to compete in an international market place around matters of global concern was limited given its track record in production. Nonetheless a number of films that attempted to deal with the aftermath of the 'Troubles' were produced – *H3* (2001), *The Beast that Sleeps* (2002), *Mickybo and Me* (2004)

and *The Mighty Celt* (2005) – although none of these really achieved any renown. Hill rather depressingly concludes in 2006 that:

> ...while troubles drama may often have settled into conventional patterns, the integration of troubles subject matter into popular cinematic formats has proved problematic. This has remained so despite the announcement of the ceasefires. For while the prospect of peace may have spurred a new cycle of 'upbeat' films aimed at the popular audience, they none the less remain haunted by the realities of continuing social division.[21]

Martin McLoone writing about Ireland in general rather than Northern Ireland in particular very clearly points out that Irish emigration to England and America has resulted in a very special interplay between the cultures, and this is reflected in the filmmaking that has resulted. 'The Ireland of the new millennium [he suggests] is caught between its nationalist past, its European future and its American imagination.'[22]

This is specifically important for Northern Ireland, which still maintains its constitutional links to England while at the same time working closely with Eire through the European Union. Filmmaking in Northern Ireland by necessity has therefore been dependent on support from Britain and Eire. America, given its central role in feature film production, has also contributed to this mix often through its provision of funds but also through the production of a number of films in the 1990s – *Patriot Games* (1992), *Blown Away* (1994) and *The Devil's Own* (1997).

For this reason when I am investigating Northern Irish film I am looking at a broad range of films which feature the issues and concerns of the North of Ireland, but not necessarily at films that have been exclusively funded or made in Northern Ireland by local personnel. So the voice or voices of Northern Ireland film are not necessarily all Northern Irish.

Indeed due to the conflict that has raged over the last 40 years there is, as yet, no sense of shared identity in Northern Ireland. It is impossible to talk of these films, which explore the politics of partition and the region's identity, in a national context when any sense of national identity is disputed. The concept of Northern Irish film remains fluid and relates to any film which has a significant relationship to Northern Ireland. I want to argue that this can be strength rather than a problem for its cinema.

Then suddenly along came Paul Greengrass who made *Bloody Sunday* (2002). Greengrass suggests that he:

> ...was very lucky. I made that film at the height of optimism. That definitely put wind in the sails of the project. We thought let's take the one event – Bloody

Sunday – for which there is definitely no shared narrative. Let's try and persuade a large number of people from Derry who were either on that march or whose family members were on the march, and a large number of soldiers who had served in Northern Ireland, and see if we can take the known facts and together shape a shared narrative cinematically. Then when it is all done, we can all as a group say it must have been a bit like that.[23]

Oddly enough his film did not provoke a shared experience in Northern Ireland where there was much protest over its release. Unionist politicians in Northern Ireland attacked it for its pro-Republican bias. But the film was a success both critically and financially and had a much wider draw than the British and Irish audiences that had been estimated. Andrew Reid, head of production at Northern Ireland Screen, suggests that this is linked to the fact that Bloody Sunday is an international event in the history of Northern Ireland – an event that everyone has heard of and understands the context. It was made at the same time as another British film, *Sunday* (2002) written by Jimmy McGovern, which coincided with the renewed investigation into the events that led up to Bloody Sunday as part of the Saville enquiry, which has only just delivered its findings in 2010. But I also think its popularity has something to do with our shared experiences relating to 9/11. Films about the Northern Ireland experience had developed a new resonance – they were helping to answer our questions about why these terrible things were happening in our world.

Many of the writers and directors from the 1990s were able to go on to write about conflict in other countries and contribute to a range of popular films that continue to engage audiences in these issues. Ronan Bennett, a northern Irish screenwriter and novelist, wrote *Hamburg Cell* (2004); Neil Jordan, Irish writer/director, subsequently engaged in a number of different genres and is probably Ireland's most famous filmmaker to date; Paul Greengrass, an English writer/director, made *Omagh* (2004) and then went on to make his name in action films; Terry George, Irish writer and director of *Some Mother's Son*, has gone on to make other award-winning films such as *Hotel Rwanda* (2004); and Colin Bateman has gone on to contribute an Irish perspective to British television through his creation *Murphy's Law* (2003).

Their contribution to what has become known as Northern Irish cinema and TV is significant. The issues raised by their films have contributed to general debate about both national cinema and the forms that such a cinema should take. No small achievement for an industry that has only been in serious operation for 20 years – a pretty good strike record.

These writers, producers and directors helped give that small area called Northern Ireland a global voice, a voice that is offering new insights into urban conflicts, which continue to feature in our modern world. Their

success supports my hypothesis that it was an important endeavour to engage in filmmaking ventures that are popular in form, when discussing Northern Ireland's past.

So what of the future? From speaking to Andrew Neil at Northern Ireland Screen I am aware that although they are still making films that deal with Northern Ireland's conflict, such as *Breakfast on Pluto* (2005), *Johnny Was* (2006) and *Peacefire* (2008), they are increasingly working with a new generation of writers and filmmakers for whom the 'Troubles' are less of a concern.

These new writers are keen to explore genre films that do not always relate directly to their experiences of living in the north – films such as the thriller *Wilderness* (2006), the modern-day Western *Middletown* (2006), the slasher *Shrooms* (2007) or more recently the horror *Red Mist* (2008) that are fuelled by global issues and trends.

So why is it that Steve McQueen's *Hunger* (2008) won the Camera d'Or for best First Film at Cannes, *Five Minutes of Heaven* (2009) won the screenwriting and directing prizes at the Sundance Festival, and *Fifty Dead Men Walking* (2008) by Kari Skogland – although less feted on its release – was popular at the box office? These are all films that deal with Northern Ireland's difficult political past. It is my contention that 1990s popular cinema experiments have paved the way for these new takes on the past, as much as they have been due to the resolution of the conflict in the region. Of course they have not been made exclusively by indigenous filmmakers, but they have been made in Northern Ireland with the cooperation of Northern Irish personnel and as such have had to engage fully in the subject. The production team for *Hunger* stress in their promotional material that the film was made with an entirely Irish and Northern Irish crew.[24]

The first two of these films have adopted new ways to express their ideas and tell their stories. In particular McQueen's film *Hunger* has been described as an art film by many and a 'work that is characterised by its poetic tone and slow cumulative power' by Sean O'Hagan (2008) in his *Observer* article in particular.[25] McQueen was quick to dispute this assertion in his interview in this article. Art or not, McQueen's film depicts the role that the body played in the prison protests from 1976 to 1981. The unusual construction of the film, which shows the point of view and violence of the prison guards before setting the protest in a political context in the long midsection of the film – a conversation between Bobby Sands and Father Moran – shows us that once again filmmakers are opening the door to new ways of filmmaking:

I'm not Irish, I'm British – part of our history – you know very much part of our history. So for me there was no sort of exoticism in it. It was a real, how can I say; situation which was our history, one like I said was swept under the carpet

for the last 27 years. Even on its 25th anniversary there was hardly anything in the newspaper – hardly anything. And in fact I think it's the most important piece of history in the last 27 years – more important than the Falklands war and more important than the miners strike because its something which is actually still continuing in one way, shape or form or the other.[26]

Although Emilie Pine, in her book *The Politics of Irish Memory* (2011), disputes that his film has addressed the wrongs of the past effectively, instead suggesting that:

McQueen, however, also reduces the political and paramilitary struggle to 'nonsense' and as a result he – along with all the other storytellers – fails to represent the symbolic meaning and import of all the political status protests between 1976 and 1981.[27]

She argues for a remembrance culture which lays the past to rest and which brings justice through 'cathartic articulation of personal grievances'. Although she does not talk of the film *Five Minutes of Heaven* in her book, I would suggest that it more fully attempts to lay the past to rest through its subject matter. The film tells the story of Alistair and Joe – how Alistair, a fledgling member of the Ulster Volunteer force, murders a Catholic in 1975 and how he is brought together with Joe, the brother of the murdered young man, many years later. The story is based on real people and some real events but imagines what would have happened if they had met in later life. 'The film is about the complex psychological relationship that exists between the perpetrator of a crime and the victim', says producer Stephen Wright from BBC Northern Ireland. 'It is not about truth and reconciliation. It is not about finding easy answers.'

Andrew Neil (head of production at Northern Ireland Screen) is open to such production, but does not want Northern Ireland film culture to be dominated by these visions of the past. Ideas which have great scripts and which throw new light on old issues will always be welcome as will ideas with great scripts which reflect new visions of Northern Irish culture. But he feels that Northern Ireland screen is still waiting for that film – the one that draws large audiences, which originated in Northern Ireland and which offers international resonance around a local issue – its own *Full Monty* or *Slumdog Millionaire*.[28] It remains to be seen if Northern Ireland can produce such a film. But I would maintain that due to the developments that have taken place this moment cannot be far off, especially if Northern Irish filmmakers utilise the connections and collaboration they have already developed with other filmmakers. *Hunger* has not made large profits although it has been able to

return on its investment, and it has won many awards but is not seen as an indigenous Northern Irish film.

Perhaps instead of searching for that illusive and I would argue counterproductive national film culture for Northern Ireland, we should be looking at collaborations between English, American, Irish and any other nationality of filmmakers who want to engage in the filmmaking and discussion that is so essential to the re-imagining of Northern Ireland.

Notes

1 The title of a poem by Seamus Heaney, *North* (London: Faber & Faber, 1975), p. 52.
2 This optimistic quote was found at Northern Ireland Screen <http://www.northernirelandscreen.co.uk/newspage.asp?id=100&storyID=2184> [accessed 7 August 2009].
3 John Hill, *Cinema and Northern Ireland* (London: BFI, 2006).
4 Ibid., see chapter 6.
5 Pat Murphy made *Maeve* (1981) and *Anne Devlin* (1984), Bob Quinn made *Lament for Art O' Leary* (1975), Alan Clarke made *Contact* (1985) and *Elephant* (1989), and Neil Jordan made *Angel* (1982).
6 This is clearly described in Kevin Rocket, Luke Gibbons and John Hill, *Cinema and Ireland* (London: Routledge, 1988).
7 *Hennessy* was made in 1975 but see below for screening problems; and *The Long Good Friday* (1979) was a gangster film based in London featuring IRA gunrunning but was not really a film 'about' the conflict.
8 Neil Jordan has mentioned this in his diaries: Neil Jordan, *Michael Collins: Screenplay & Film Diary* (London: Vintage, 1996), and on *The South Bank Show*, ITV, 1996.
9 Ronan Bennett, 'Telling the Truth About Ireland', *Vertigo*, 1.4 (1994), 24–29.
10 Seamus Deane quoted in an article by Nick Fraser, 'A Kind of Life Sentence', *Guardian*, 28 October 1996, p. 9.
11 Alan Fountain, quoted in A.I.P. & Co. no 51, 1984, p.18. Quoted in John Hill, *Cinema and Northern Ireland* (London: British Film Institute, 2006).
12 Jordan, *Michael Collins: Screenplay & Film Diary*, p. 1.
13 Rocket, Gibbons, Hill, *Cinema and Ireland*, p. 85.
14 Ronan Bennett, 'Hidden Agenda', *Independent*, Thursday 31 October 1996.
15 Martin McLoone, *Film, Media and Popular Culture in Ireland* (Dublin: Irish Academic Press 2008), p. 165.
16 Ibid., p. 196.
17 Ruth Barton, *Irish National Cinema* (London: Routledge, 2004).
18 Lance Pettitt, *Screening Ireland* (Manchester: Manchester University Press, 2000), p. 45.
19 Brian McIlroy, *'Shooting to Kill': Filmmaking and the Troubles in Northern Ireland* (Trowbridge: Flicks Books, 2000), p. 9.
20 David McKittrick, 'Why are all the Troubles' films about republicans?', *Belfast Telegraph*, 31 October 2008.
21 Hill, *Cinema and Northern Ireland*, p. 242.
22 McLoone, *Film, Media and Popular Culture in Ireland*, p. 6.

23 Geoffrey Macnab, 'Classic films with the Troubles in mind', *Independent*, 14 March 2008.
24 Steve McQueen speaking in interviews with Laura Hastings-Smith and Robin Gutch, DVD extras, *Hunger* (2009).
25 Sean O'Hagan, 'McQueen and Country', *Observer*, 12 October 2008.
26 Steve McQueen speaking in an interview with Jason Solomons, DVD extras, *Hunger* (2009).
27 Emilie Pine, *The Politics of Irish Memory* (Basingstoke: Palgrave Macmillan, 2011), p. 126.
28 Interview with Andrew O'Neill recorded in March 2010 at Northern Ireland Screen.

Chapter 5

IMPERIAL GAZES, HOLLYWOOD PREDATORS: A CINEMA OF MOLESTATION IN POSTCOLONIAL INDIAN LITERATURE

Jerod Ra'Del Hollyfield

Louisiana State University

In the work of the authors under consideration here, cinematic depictions and allusions are not the result of what Robert Stam calls 'dichotomous thinking', a presumed bitter rivalry between literature and film in which both forms are presented in their rival media as the lesser opponent in a Darwinian death struggle.[1] Likewise, the authors operate under a clear distinction between national film industries and national cinema, a differentiation, according to Jigna Desai, in which 'the latter is thought to represent the nation, which increasingly is seen as threatened from the inside (minorities) and from the outside by the hegemony of Hollywood…' and 'the former may be considered a commercial, profit-seeking enterprise that often is protected as a national industry against other international producers of similar commodities'.[2] As a result of their goals for commercial appeal and international dissemination, national film industries echo Michael Hardt and Antonio Negri's discussion of the communications infrastructure that produces the conditions and terms of government for the entity they deem the empire of corporate imperialism. As Hardt and Negri write:

> …there is already under way a massive centralization of control through the
> (de facto or de jure) unification of the major elements of the information and
> communication power structure: Hollywood, Microsoft, IBM, AT&T and so
> forth. The new communication technologies, which hold out the promise of a new
> democracy and a new social equality, have in fact created new lines of inequality
> and exclusion, both within the dominant countries and especially outside them.[3]

With national film industries such as India's Bollywood operating under similar mechanisms as Hollywood, the potential exists not only for empire to commodify national cultures but also for it to curtail dissent from international artists. As a result, criticisms of both Hollywood and national film industries become potent strategies for postcolonial writers to contend with empire. In light of such clarifications, the authors I discuss seek neither to assert the value of the novel form over cinema nor to use a particular film industry as a scapegoat for the enduring problems of British imperialism or empire's hegemony. Instead, they employ representations of the cinema and the film industry through strategies as varied as allusion, metaphor, setting and narrative as ways to engage with the legacy of colonialism while contending with the ramifications of empire that currently exert influence over their respective nations.

In this paper, I argue that Indian postcolonial writers use depictions of cinema to interrogate the dissemination power of transnational, corporate imperialism and its reliance on mass media to maintain its presence. Discussing Salman Rushdie's *The Satanic Verses* (1988), Ameena Meer's *Bombay Talkie* (1994), Arundhati Roy's *The God of Small Things* (1997) and Vikas Swarup's *Q&A* (2005), I examine how each author uses a similar strategy to present national film industries as representations of imperial forces: a childhood flashback to the molestation of protagonists by an elder male in the contexts of cinema production, viewing and discussion.

For India, such depictions of molestation go far beyond what Kadiatu Kanneh deems, 'the familiar discourse of rape between colonizer, and colonized country' that was integral to the formation and execution of colonial powers over feminised territories.[4] In the wake of partition, the newly formed Indian government had to quickly contend with the epidemic of abductions and sexual violence directed against women by displaced members of other religious communities, which led to the passage of the Abducted Persons (Recovery and Restoration) Act in 1949.[5] As a result, the discourses of rape and molestation transitioned from direct assertions of colonial ideology to forms of intercultural violence indicative of a nation negotiating colonial influence and its own natal national identity. Despite India's development into a global economic hub poised to become a twenty-first century superpower, sexual abuse continues to remain a persistent problem in the nation most prevalent as the molestation of children so central to the work of the authors in this study. In *Bitter Chocolate: Child Sexual Abuse in India*, the first book-length study of the problem, Pinki Virani estimates that realistically fifty per cent of girls and thirty per cent of boys in India have been molested by the age of sixteen.[6] In what she refers to as 'the most damning indictment of the entire ostensible "upper" social structure', Virani concludes that these instances of molestation

occur with the same frequency regardless of class position usually at the hands of family members and acquaintances within the home.[7]

Though molestation has remained a trope in postcolonial Indian literature that authors employ to allegorically cope with the British colonial legacy – rape and molestation feature prominently in much partition literature such as Raj Gill's *The Rape* (1974) and Bapsi Sidhwa's *Cracking India* (1991) – the frequency of scenes involving child molestation such as those discussed here serve the distinct purpose of revising the molestation trope to contend with the forces of empire that Hardt and Negri discuss. Similar to the influence of transnational media entities such as Hollywood, the influx of non-governmental organisations (NGOs) in India over the past fifty years has led to a transfer of responsibility from the local to transnational organisations that often unwittingly assume the role and rhetoric of last century's colonial powers, especially for issues as contentious as child sexual abuse.[8] Echoing this positioning of NGO's as non-profit examples of empire, David Harvey writes, 'They frequently conceal their agendas, and prefer direct negotiation with or influence over state and class power. They typically control their clientele rather than represent it.'[9]

While linking NGO intervention and Hollywood influence appears tenuous at best, both entities indicate the subtle cultural shifts in postcolonial India that have re-appropriated colonial mechanisms of control for use by transnational entities in the nation's globalised present. Within this context, the authors I discuss associate cinema production and viewing with molestation to depict the effects of past and present imperialism on India's culture and population. Fragmenting identities, destroying personal and political bonds, and curtailing individual attempts at autonomy, the film industries represented in these texts expose the lingering effects of British colonialism on India while installing the transnational corporation as a burgeoning force with which postcolonial authors in the globalised world must engage.

Rushdie, Roy, Swarup and Meer's novels may each examine India during different time periods over the last three decades, but the four texts share distinct modes of representing cinema. Rather than frame Hollywood and Bollywood cinema as examples of the unifying cultural force that Hardt and Negri see as central to empire's mechanisms of control, the authors use it as a catalyst to enact what Homi K. Bhabha refers to as 'the struggle of identifications'. As Bhabha writes:

> …as I see it, the work of hegemony is itself the process of iteration and differentiation. It depends on the production of alternative or antagonistic images that are always produced side by side and in competition with each other. It is this side-by-side nature, this partial presence, or metonymy of antagonism,

and its effective significations, that give meaning (quite literally) to a politics
of struggle *as the struggle of identifications* and the war of positions. It is therefore
problematic to think of it as sublated into an image of the collective will.[10]

For Bhabha, opposition to hegemonic forces lies in rupturing the seamlessness
of mechanisms of control, locating the spaces subtly exposed by an endless
series of reiterations and productions. Not only do Rushdie, Roy, Swarup and
Meer reflect Bhabha's claims in their fiction, but also the four authors employ
their molestation flashbacks to rupture the imperial metanarrative.

As both one of the most infamous works of postcolonial fiction for its
depiction of Islam and a novel central to Bhabha's discussions of hybridity
and the struggle of identifications, Rushdie's *The Satanic Verses* is also a
text fundamentally concerned with how the legacy of colonialism and the
dissemination power of empire employ mass media to maintain control.
According to Bhabha: 'Rushdie seems to suggest that it is only through the
process of *dissemination* – of meaning, time, peoples, cultural boundaries and
historical traditions – that the radical alterity of the national culture will create
new forms of living and writing.'[11]

Bhabha focuses much of his attention on Rushdie's use of the novel form
to address the sacredness of poetry as a means of censure in Islam, positing
that 'Rushdie violates the poetic license granted to critics of the Islamic
establishment.'[12] Yet, while Bhabha's contention is certainly correct, Rushdie's
representations of Bollywood and globalised mass media as mechanisms
of control that fragment his central characters' identities occupies as much
narrative space in the novel as his engagements with Islam. In examining
Rushdie's palimpsest of myth, Islamic tradition, the violent legacy of British
imperialism, Thatcher era immigration policy, and a host of other issues,
one must not overlook that Rushdie's complex sociopolitical web unfolds
within the context of the film industries that employ his two protagonists who
survive the mid-air explosion of a plane taken over by terrorists: 'Two actors,
prancing Gibreel and buttony, pursed Mr. Saladin Chamcha...'[13] Throughout
The Satanic Verses, Chamcha serves as the character most mired in internal
conflict over the tensions between his Indian heritage and his job as both a
voice-over actor and star of *The Aliens Show* – a children's television program
and clear commentary on Chamcha's migrant status in which Chamcha and
his Jewish co-star Mimi Mamoulian play characters who:

> ...changed their voices along with their clothes, to say nothing of their hair,
> which could go from purple to vermillion between shots, which could stand
> diagonally three feet up from their heads or vanish altogether; or their features
> and limbs, because they were capable of changing all of them, switching legs,

arms, noses, ears, eyes, and every switch conjured up a different accent from their legendary, protean gullets.[14]

Establishing Chamcha as a figure prone to self-loathing and proclamations of hatred for Indians early in the novel, Rushdie literalises Chamcha's anxiety and inchoate immigrant status through his literal transformation into a goat: 'His thighs had grown uncommonly wide and powerful, as well as hairy. Below the knee the hairiness came to a halt, and his legs narrowed into tough, bony, almost fleshless calves, terminating in a pair of shiny, cloven hoofs, such as one might find on a billy-goat.'[15] Similar to the half-human, half-goat satyr figures in Greek mythology, the formerly unassuming Chamcha becomes a hybridised 'other,' markedly different from his fellow Londoners and a physical manifestation of white England's immigrant fears. While critics such as Bhabha view the transformation as highlighting the problem for postcolonial migrants of 'whether the crossing of cultural frontiers permits freedom from the essence of the self…or whether, like wax, migration only changes the surface of the soul, preserving identity under its protean forms', Rushdie's parallels between Chamcha's constant transformations on *The Aliens Show* and his actual transformation into a satyr-like creature call into question the potential for the crossing of cultural frontiers.[16] Instead, Rushdie presents empire's dissemination power through cinema as an impasse to cultural crossing, an impenetrable barrier to the liberating *dissemiNation* power that Bhabha sees as central to Rushdie's work. For Chamcha, a career in acting has made transformation the foundation of his identity to such an extent that when he grows hoofs and begins to resemble a goat, the police officers who find him after the explosion and interrogate him for not carrying papers see his mutated appearance as 'if it were the most banal and familiar matter they could imagine', merely the end result of a natural progression of the migrant's innate danger.[17] In order to fully understand why Chamcha would migrate to England and embrace a career in the culture industry that propagates empire's agency, one must take into account the pivotal event in Chamcha's life that Rushdie reveals early in the novel: the thirteen-year-old Chamcha's molestation at Scandal Point in Bombay. Finally old enough to play on the rocks by the bay at Scandal Point without adult supervision, Chamcha's eyes drift toward an older stranger near the rock pools:

> When Salahuddin came down the other grasped him, put a hand around his mouth and forced his young hand between old and fleshless legs, to feel the fleshbone there. The dhoti open to the winds. Salahuddin had never known how to fight, he did what he was forced to do, and then simply turned away from him and let him

go. After that Salahuddin never went to the rocks at Scandal Point.... It seemed to him that everything loathsome, everything he had come to revile about his home town, had come together in that stranger's bony embrace, and now that he had escaped that evil skeleton he must also escape Bombay, or die.[18]

Chamcha's sexual encounter with the old man on the rocks ignites his formerly latent distaste for his homeland, initiating him into an identity defined by migrancy and transformations that he hopes will mask his Indian heritage and form an identity ideal for an acting career that allows him to undertake an endless series of characters and evade ties to a singular nation. Rather than attempt to cross cultural frontiers, Chamcha becomes consumed by a role in empire's cultural metanarrative, content to live out a liminal existence within the framework of a new colonising force that subjugates his homeland in a similar manner as the British Empire that leads to the violence and fragmentation embodied in the elder's act of molestation. The effects of Chamcha's molestation on his occupation as an actor for a broadcasting corporation are the elements of Rushdie's novel central to my argument. However, his depictions of Bollywood actor Gibreel's interaction with the globalised film industry are also integral to Rushdie's critique of the culture industry in the age of empire. Though Gibreel was one of Bollywood's top stars before the terrorist attack, his survival ignites the industry's desire to produce a series of comeback films for the actor:

> All parties further recognized that Gibreel's return from the dead was an item of a commercial value greater than any of the defunct films; the question was how to utilize it best, to the advantage of all concerned. His landing up in London also suggested the possibility of an international connection, maybe overseas funding, use of non-Indian locations, participation of stars 'from foreign', etc.: in short, it was time for Gibreel to emerge from retirement and face the cameras again.[19]

Compounding Gibreel's post-survival delusions that he is the angel Gibreel, the series of proposed films feature Gibreel playing the angel and are 'both historical and contemporary, each concentrating on one incident from the angel's long and illustrious career: a trilogy, at least'.[20] Yet, in spite of the opportunity the international co-productions provide, they only exacerbate Gibreel's descent into madness, destroying his relationship with mountain climber Allie Cone, ending his career when they fail at the box office, and ultimately leading to his suicide at the end of the novel. Unlike Chamcha who became fully integrated into the culture industry before his physical changes ended his career, Gibreel is unable to occupy a consistent transformative state. Not undergoing a similar, identity-shattering traumatic event early in life as

Chamcha did, Gibreel becomes an unfortunate victim of empire's attempts to consume himself, his persona, and his nation's cinema – Rushdie's prescient commentary on the burgeoning globalisation of the industry during the time of the novel's publication.

While much more direct in its associations between molestation and the film industry than *The Satanic Verses*, Roy's depiction of Estha's molestation in *The God of Small Things* focuses its attention on the cultural hegemony of Hollywood's relationship to the political climate of postcolonial India. At Abhilash Talkies, 'the first cinema hall in Kerala with a 70mm CineScope screen', Estha and his twin sister Rahel watch *The Sound of Music* with their mother Ammu and grandaunt Baby Kochamma.[21] As the film begins when 'The camera soared up in the sky blue (car-coloured) Austrian sky with the clear, sad sounds of church bells,' Estha ignites the fury of the audience by singing along with the film: 'There was a voice from outside the picture. It was clear and true, cutting through the fan-whirring, peanut-crunching darkness.'[22] After asking to go sing outside because 'the song came back, and Estha couldn't stop it', Estha enters the lobby, alone except for the Orangedrink Lemondrink Man behind the concessions counter. Luring Estha behind the counter with the promise of the drink, the Orangedrink Lemondrink Man proceeds to molest him:

> 'Now if you'll kindly hold this for me,' the Orangedrink Lemondrink Man said, handing Estha his penis through his soft white muslin dhoti, I'll get you your drink. Orange? Lemon?
>
> Estha held it because he had to.
>
> 'Orange? Lemon?' The Man said. 'Lemonorange?'
>
> 'Lemon, please,' Estha said politely.
>
> He got a cold bottle and a straw. So he held a bottle in one hand and a penis in the other. Hard, hot, veiny. Not a moonbeam.
>
> The Orangedrink Lemondrink Man's hand closed over Estha's. His thumbnail was long like a woman's. He moved Estha's hand up and down. First slowly. Then fastly.[23]

While Estha's molestation is clearly not a direct effect of Hollywood film, Roy positions it as an act of corruption caused by the complex infrastructure of Hollywood's popularity and Indian film exhibition that will serve as the fulcrum for the disintegration of Rahel and Estha's family and their individual identities. Enraptured by the movie going experience of *The Sound of Music*'s spectacle at a state-of-the-art movie house, Estha's family is too distracted by, as Roy writes, 'A magical *Sound of Music* smell that Rahel remembered and treasured' to protect Estha from potential predatory action.[24]

Now violated by the corruption and perversion that manifested under the seemingly innocuous structure of movie going, Estha re-enters the theatre, allowing Roy to contrast the horror of Estha's molestation with the manufactured purity of the film before Ammu and the family leave the theatre to care for the now-sick Estha: 'Baron von Trapp's seven peppermint children had their peppermint baths, and were standing in a peppermint line with their hair slicked down, singing in obedient peppermint voices to the woman the Baron nearly married. The blonde Baroness who shone like a diamond.'[25] In accenting the perfection of the Von Trapp household in a household that will easily thwart Nazis and the impending violence of World War II to unite into a nuclear family by film's end, Roy creates a stark contrast between the clean Hollywood narrative and the tragedy that begins with Estha's molestation and will destroy Estha and Rahel's family through a descent that involves the accidental drowning of their ten-year-old cousin, Ammu's affair with an untouchable Marxist worker, and the twins' incestuous relationship in adulthood. Unlike the Von Trapp family's conflict with Nazism, the scramble for political control in post-Independence India and the corruption of innocence as a precipitate of empire's influence will prove too much for Estha and Rahel's family. Yet, in exposing the exploitative potential of the culture industry's political control in the novel, Roy provides her own examination of the hegemonic mechanisms that continue to maintain their presence in Indian culture.

Published eight years after Roy's novel and in the wake of a wave of diasporic Indian films such as Mira Nair's *Monsoon Wedding* (2001) and Gurinder Chadha's *Bend it Like Beckham* (2002), Swarup's *Q&A* is a hybrid text that investigates the cultural commodities of British imperialism and transnational corporate empire.[26] Structured both as a Victorian novel complete with a Faginesque con artist and a Dickensian twist-ending, and as a novel-length episode of a television quiz show, *Q&A* positions Ram Mohammad Thomas – a character whose name directly addresses the hybrid nature of India – as a passive spectator relating stories of individuals destroyed by the intersections of India's colonial legacy and empire's mass media influence as he attempts to justify his grand-prize winnings on *Who Will Win a Billion?* While Swarup's direct and detailed meditations on mass media's circuitry differ from Roy's use of Hollywood cinema exhibition as a catalyst to examine the postcolonial Indian family, both authors employ scenes of molestation in conjunction with cinema viewing early in their work, exposing their characters to a microcosm of past and present imperial violation. However, as a result of his concern with globalised media's reach on individual nations, Swarup's use of molestation engages with the Bollywood film industry so vital to India's international cultural prominence and economic viability.

Though the first chapter of *Q&A* features a molestation associated with cinema watching, Ram is not the victim, acting instead as a figure who frames the novel's subsequent criticisms of Bollywood around this early event. As the first chapter begins, Ram and his best friend Salim ready themselves to watch the latest film starring Armaan Ali at a movie palace, an activity that Ram speaks of with a near reverence:

> The third bell has sounded. The purple velvet curtain is about to be raised. The lights are progressively dimming, till only the red signs showing EXIT remain, glowing like embers in a darkened hall. Popcorn sellers and cold-drinks vendors begin to leave. Salim and I settle down in our seats.[27]

Introducing Salim as both his best friend and 'crazy about Hindi films. But not all Hindi films. Just the ones featuring Armaan Ali', Ram proceeds to recount the moments when the screen flickers to life:

> First we have advertisements. Four sponsored by private companies and one by the government. We are told how to come first at school and become champions in cricket by eating cornflakes for breakfast. How to drive fast cars and win gorgeous girls by using Spice cologne. ("That's the perfume used by Armaan," exclaims Salim). How to get a promotion and have shiny white clothes by using Roma soap. How to live life like a king by drinking Red & White whiskey. And how to die of lung cancer by smoking cigarettes.[28]

While Ram relates his pre-film experience in a rote manner, the passage allows Swarup to examine both the underlying controlling potential of the culture industry and empire's ability to consolidate the power of various institutions. The advertisements may be an amalgamation of public service announcements, celebrity endorsements, and international corporate upward mobility claims, but, as presented by Swarup, all entities morph into each other and into the theatrical experience, embodying Hardt and Negri's depiction of empire as 'a global concert under the direction of a single conductor, a unitary power that maintains the social peace and produces its ethical truths'.[29]

Unspooling this seamless narrative of empire, Swarup proceeds to use an older patron's molestation of Salim in the theatre to expose the fissures in mass media dissemination. As the boys watch the film, a bearded man sits next to Salim, intermittently brushing his leg against the boy. However, Ram notices that the older man's advances soon become more direct: 'I see that the bearded man's left hand has moved. It is now placed in Salim's lap and rests there gently. Salim is so engrossed in the death scene that he doesn't register it. The old man is emboldened. He rubs his palm against Salim's jeans. As Armaan

takes his last breaths, the man increases pressure on Salim's crotch, till he is almost gripping it'.[30] When Salim attacks the man and pulls off his fake beard, he escapes into the darkness of the theatre, leaving Salim in shock:

> ...in that split second Salim and I have seen a flash of hazel-green eyes. A chiseled nose. A cleft chin. As the credits begin to roll over the screen, Salim is left holding a mass of tangled gray hair smelling vaguely of cologne and spirit gum. This time he does not see the names of the publicity designer and the PRO, the light men and the spot boys, the fight director and the cameraman. He is weeping. Armaan Ali, his hero, has died.[31]

Through his presentation of Armaan's molestation of Salim in the context of a movie going experience featuring not only the star's film but also a commercial for one of his endorsements, Swarup explodes the myth of the culture industry's unity, indicating how its corruption taints the lives of the icons so central to its function as well as those who passively consume it. As the novel's first engagement with Bollywood cinema, the molestation scene establishes Swarup's opposition to the totality of the culture industry that will eventually consume all of his characters.

Despite their harrowing theatre experience, both Salim and Ram eventually become firmly rooted in the film industry. Salim never shakes his 'celluloid dreams of life in Mumbai' and works as a day player until Ram uses his quiz show winnings to launch Salim's acting career.[32] Ram works as a servant for fading Bollywood icon Neelima Kumari, witnessing her desperation, physically abusive sexual relationship with future *Who Will Win a Billion?* host Prem Kumar, and eventual suicide while clutching her 'National Award for Best Actress. Awarded to Ms. Neelima Kumari for her role in *Mumtaz, Mahal* (1985)' trophy.[33] Integrating Bollywood into his narrative in this context, Swarup undercuts his seemingly neo-Victorian happy ending, positing that regardless of Ram's newfound wealth and opportunity for Salim, he and his friend remain mired in the network of empire's cultural dissemination prowess that they first encountered during childhood in the darkness of the movie palace.

Though all three texts employ the national problem of child sexual abuse within the context of cinema as a strategy to formulate identity in postcolonial, transnational India, what perhaps is most striking about the texts is that the scenes of molestation do not conform to the reality of the problem. Given Chamcha and Estha's middle to upper-class standing, the texts may transcend stereotypes of rampant child sexual abuse among the lower classes. Even the lower-class Salim's molestation occurs in a contrived, albeit atypical, scenario in which Bollywood royalty assumes the role of predator, alluding to the prevalence of abuse in Indian society's upper echelons. However, as Virani

discusses, the majority of molestation incidents occur at the child's home with family or friends as the perpetrators, not shifty strangers at the beach or movie palace. For Virani, the problem of child sexual abuse is so rampant within the home because 'the family structure in India does not encourage individualism', rendering the need to admit to and cope with instances of abuse subservient to the preservation of family status and structure.[34]

One can extend such criticism to Rushdie, Roy and Swarup and their attempts to indict the effects of imperialisms on their national culture. For such critiques of hegemony to succeed, the authors must position transgressions such as abuse as stemming from British colonialism and transnational empire's influence, not from within the structure of Indian nationalism. If Chamcha's father served as his abuser rather than his eventual source of self-discovery, the novel's critique would become as diluted as a version of *The God of Small Things* in which the dissolution of Estha and Rahel's family could not serve as the primary symbol of postcolonial conflict, or a *Q&A* that could no longer rely on the creation of a makeshift family of imperialism's victims at its resolution. There is no room for 'individualism' when an author seeks to represent a nation contending with imperial legacies. What results is a need to conform to some semblance of nationalistic ideology in order to effectively engage with the influence of past and present imperialism, a need that recalls Spivak's assessment of postcolonial critique: 'One cannot "choose" to step out of ideology. The most responsible "choice" seems to be to know it as best one can, recognise it as best one can, and, through one's necessarily inadequate interpretation, to work to change it, to acknowledge the challenge…'[35] While applying Spivak's call for acknowledgement to the previously discussed works should in no way lead to a dismissal of their validity as politically engaged postcolonial literature, it should lead to an examination of Rushdie, Roy and Swarup's use of molestation in the context of cinema viewing as the products of elite cultural ambassadors (and in the case of Swarup an actual diplomat) to a globalised audience.

Although she shares an elite status with these other writers of postcolonial fiction, Ameena Meer utilises her molestation scene in *Bombay Talkie* to accurately reflect the reality of child sexual abuse and contend with imperial influences via her use of allusions to Hollywood cinema. Despite a lack of critical attention and relative obscurity, *Bombay Talkie* has a much more directly global scope than the other works under consideration here. Adopting a transcultural approach, Meer's novel is centred on a protagonist unburdened by racism against migrants, the destruction of her nuclear family, or slum life in Mumbai. Instead, Sabah Al-Hussain is a second-generation 'Miss America' whose Indian origins give her a certain cache in her New England childhood home and on her California college campus with which she is much more familiar than India.

Yet Sabah is plagued by her inability to reconcile her Indian heritage with her American life, making her feel as if she is 'the paper doll who's had the wrong outfit put over her body' when she encounters Indians and Pakistanis in her California girl attire, and alienated by the commodification of India when her ex-boyfriend Rob takes her to 'this supermarket that's been turned into a temple by this Hindu priest'.[36]

While Meer never directly articulates the sources of Sabah's cultural restlessness, she includes a telling scene detailing an encounter between the teenage virgin Sabah and her Uncle Tony, '...one of India's best known scientists, sent to America to get awards and scholarships', but whose 'English was barely comprehensible in the lectures and seminars he gave'.[37] Uncle Tony's obsession with 'American pop movies' leads him to take an interest in Sabah, including driving her to a party for which she has meticulously dressed in order to look as cool as John Travolta in *Saturday Night Fever*.[38] En route to the party, Uncle Tony molests Sabah:

> His glove moved up under Sabah's chin. He slowed down as they approached the next traffic light. Sabah prayed for it to stay green. It changed to red. He stopped the car and turned toward her. He kissed her, his tongue moving around her mouth, and held her head in his hands, the way they did in movies. Sabah relaxed and let him unbutton her coat while he kissed her. She watched him, tried to decide if she thought he was handsome or not. She thought he could be, in an Indian movie-star way.[39]

Through the sequence, Meer examines the inescapable reach of the confluence of India's postcolonial culture and transnational corporate empire. Uncle Tony's primary purpose for immigrating to the United States is to foster his native country's global presence, touting the value of its scientific institutions and universities through receiving international awards. Beholden to India's need to foster national identity apart from British influence and to secure a place in the globalised economy, Uncle Tony lacks individuality, since he is not an American citizen and is forced into diaspora by international relations. Consequently, his molestation of Sabah is a perverted attempt at connection with another person of Indian descent denied access to her nation of origin as a result of her second-generation status. Lacking common interests or experience with Sabah, Uncle Tony resorts to the conventions ingrained in him through his exposure to globally disseminated Hollywood cinema to 'seduce' her.

Though Meer does not shy away from the pleasure Sabah experiences during her first sexual encounter – 'his mouth on her breasts, on her stomach felt good and disgusting at the same time, like gorging herself on ice cream' – she clearly articulates Sabah's trauma largely through her protagonist's constant allusions

to movies during the act. Uncle Tony clearly learned his seduction technique through his dedication to 'American pop movies', but Sabah psychologically copes with her trauma by using the same conventions as a way to distance herself from the events. What occurs is her characterisation of Uncle Tony not as the family member who molests her, but as an amalgamation of Hollywood leading man and Bollywood actor, too reliant on conventions to be real, but familiar enough to disguise her memories of the molestation. However, the molestation has continuing effects on Sabah, igniting in her a desire to travel to India and visit both her extended family, including Bollywood star Uncle Jimmy, and her childhood friend turned model, Rani. Sabah cannot clearly discern her motivations for the trip, telling those who inquire, 'I don't expect you to understand this', but Meer makes clear that the journey is much more than a romanticised post-collegiate quest to find out one's true self.[40] Rather, the trip is Sabah's attempt to preserve her transcultural identity by discovering that her family and nation of origin are far-removed from the perversions of figures like Uncle Tony who are damaged by a postcolonial nation forced into a globalised economy.

With the advance of corporate empire, postcolonial writers have been placed in the position of developing new methods of resistance that contend with past and present forms of imperial control. In his essay 'On National Culture' Fanon characterises native literature into three phases:

(i) Writing that gives proof that the author has 'assimilated the culture of the occupying power' and mimics its forms.
(ii) Writing that demonstrates the author is immersed in 'past happenings of the bygone days'.
(iii) 'The fighting phase,' in which the author turns himself into an 'awakener of the people', leading to a revolutionary and national literature.[41]

While Fanon's phases serve as a useful method to analyse the development of literature for nations newly liberated from colonial rule, they come into question in an era when authors must deal with a colonising force that has become a transitory empire, globalised and free from boundaries in addition to the lasting impact of their former colonisers. In their representations of cinema to address the interactions of nation and corporate-based imperialism, the authors subject to discussion in this paper have established a framework for resistance and autonomy, creating a complex body of literature founded on hybrid forms capable of reconciling the past and examining the future. With discussions of globalisation and the omnipresence of corporate influence in international affairs increasingly in the public consciousness, such writing is an important first step in transitioning Fanon's phases into a discussion on a politicised, multinational culture.

Notes

1 Robert Stam, 'The Theory and Practice of Adaptation', in *Literature and Film: A Guide to the Theory and Practice of Adaptation*, ed. by Robert Stam and Alessandra Raengo (Malden, MA: Blackwell, 2005), p. 4.

2 Jigna Desai, *Beyond Bollywood: The Cultural Politics of South Asian Diasporic Film* (London: Routledge, 2004), p. 54.

3 Michael Hardt and Antonio Negri, *Empire* (Cambridge, MA: Harvard University Press, 2000), p. 300.

4 Kadiatu Kanneh, 'Feminism and the Colonial Body', in *The Postcolonial Studies Reader*, edited by Bill Ashcroft, Gareth Griffiths and Helen Tiffin (London: Routledge, 1995), 346–48 (p. 346).

5 Bede Scott, 'Partitioning Bodies: Literature, Abduction, and the State,' *Interventions*, 11.1 (2009), 35–49 (p. 36).

6 Pinki Virani, *Bitter Chocolate: Child Sexual Abuse in India* (New Delhi: Penguin Books India, 2000), p. 21.

7 Ibid., p. 23.

8 Mohammad Reza Iravani, 'Child Abuse in India', *Asian Social Science*, 7.3 (2011), 150–53 (p. 153).

9 David Harvey, *Spaces of Global Capitalism: Towards a Theory of Uneven Global Development* (London: Verso, 2006), p. 52.

10 Homi Bhabha, *The Location of Culture* (London: Routledge, 1994), pp. 42–43.

11 Bhabha, p. 239.

12 Ibid., p. 323.

13 Salman Rushdie, *The Satanic Verses* (New York: Viking, 1988), p. 4.

14 Ibid., p. 62.

15 Ibid., p. 157.

16 Bhabha, p. 321.

17 Rushdie, p. 158.

18 Ibid., p. 38.

19 Ibid., p. 344.

20 Ibid., p. 345.

21 Arundhati Roy, *The God of Small Things* (New York: Random House, 1997), p. 90.

22 Ibid., p. 95.

23 Ibid., pp. 98–99.

24 Ibid., p. 94.

25 Ibid., p. 105.

26 The novel is also the source text for Danny Boyle's 2008 Academy Award winning film and global blockbuster *Slumdog Millionaire*.

27 Vikas Swarup, *Q&A* (New York: Scribner, 2005), p. 19.

28 Swarup, pp. 20–21.

29 Hardt and Negri, p. 10.

30 Swarup, p. 30.

31 Ibid., p. 31.

32 Ibid., p. 85.

33 Ibid., p. 232.

34 Virani, p. 49.

35 Gayatri Chakravorty Spivak, 'The Politics of Interpretations', in *In Other Worlds: Essays in Cultural Politics* (London: Routledge, 1987), 161–83 (p. 165).

36 Ameena Meer, *Bombay Talkie* (New York: High Risk Books, 1994), p. 7 and p. 265.
37 Ibid., p. 28.
38 Ibid., pp. 28–29.
39 Ibid., p. 30.
40 Ibid., p. 36.
41 Frantz Fanon, 'On National Culture', in *The Wretched of the Earth*, trans. by Constance Farrington (New York: Grove Press, 1963), 206–48 (p. 223).

Chapter 6

LINGUISTIC IDENTITY IN FRUIT CHAN'S 1997 TRILOGY

Howard Y. F. Choy

Wittenberg University

Chinese cinema scholar Zhang Yingjin 張英進 describes Hong Kong independent filmmaker Fruit Chan's (Chan Gor 陳果) post-1997 films as 'new localism' that 'articulate[s] a feeling of community grounded in Hong Kong's lower social strata'.[1] While film critics have focused on the visual images of class in Chan's productions, few have analysed how such identity is 'articulated' verbally. Familiar to local audiences and yet exotic to foreign viewers are not only the scenes of public housing estates, crowded tenement buildings and red-light districts but also the languages of native Cantonese, national Mandarin, native English and hybrid Chinglish. This paper studies how the lingua franca of Cantonese, with features of English and Mandarin, has constructed a distinct linguistic identity in postcolonial films made in Hong Kong. In a low-key, realistic yet at once nostalgic and hilarious style, Fruit Chan reveals the problematic, marginalised identity of the islanders through the award-winning 1997 trilogy written and directed by himself on the threshold of the new millennium. If one views these films with an attentive ear, one will hear the heteroglossia of Hong Kong beyond the scenes.

The fin de siècle '1997 trilogy' (*jiuqi sanbuqu* 九七三部曲), consisting of *Made in Hong Kong* (*Xianggang zhizao* 香港製造, 1997), *The Longest Summer* (*Qunian yanhua tebie duo* 去年煙花特別多, 1998) and *Little Cheung* (*Xilu Xiang* 細路祥, 1999), presents the postcolonial metropolis as a multilingual society. The linguistic pluralism is not performed by professional players, who are trained for clear enunciation, but basically interpreted by non-professional actors, whose articulations are often twisted in their mixed tongues. It has been pointed out that the trilogy tells about how hapless, helpless and hopeless Hong Kong people feel in the face of the fated end of the flourishing city, but the feelings are told through

the problematics of hybrid linguistic identities. This linguistic hybridity in the postcolonial Hong Kong story is an irony in and of itself. While the citizens lost their right of abode in the United Kingdom as the crown colony was handed over to China in 1997, they maintain English as a colonial legacy; meanwhile, the restructured local government refused to grant mainland Chinese children of non-permanent Hong Kong residents the right of abode in the Special Administrative Region in 1999, even though many of them share Cantonese as a common ancestral language.

If there is a single genre that can represent the contemporary cinema of Hong Kong, it is gangster noir and crime film. In fact, the first two instalments of the '1997 trilogy', *Made in Hong Kong* and *The Longest Summer*, are both classified under this category. It is from the underworld that the subconscious and subculture emerge to supplement or subvert the standard and the official. The official transference of Hong Kong to China is first and foremost presented in *Made in Hong Kong* allegorically as a romantic tragedy of a debt collector, Autumn Moon, and his debtor's daughter, Ping 屏, who needs a kidney transplant in order to survive.[2] Autumn Moon, whose name is reminiscent of the traditional Chinese Mid-Autumn Festival for family reunion, is an abandoned adolescent and a high school dropout recruited by the triads. Moon's beginning voice-over mixes native foul language (for example, *bansat* 笨實 'sheer dumbness') and argots (*pek yau* 劈友 'to kill') with heavily Cantonese-accented English ('free' mis-pronounced as 'fee'), whose flavours are mostly lost in the translations of both Chinese and English subtitles by Jing's production.

In her monograph on *Made in Hong Kong*, Hong Kong cultural studies scholar Esther M. K. Cheung 張美君 concludes that Chan's filmic representations are 'grassrooting cinematic practices',[3] to which I would add the linguistic practices that represent the underrepresented by adopting Cantonese cants and colloquialisms. While colloquial expressions like *baau yi'naai* 包二奶 'keep a mistress' and *gau neui* 溝女 'hang out with girls' reflect everyday life phenomena, popularised gang slang words (e.g., *guwaakjai* 蠱惑仔 'the young and dangerous', *lengjai* 靓仔 'underling', *daailou* 大佬 'head of a triad gang', *baan ma* 班馬 'send the gang', *gwaat liu* 刮料 'get information', and *chyun* 串 'cocky')[4] identify not only the subculture of Hong Kong but also Hong Kong culture as subculture – a subculture that may be looked down on by outsiders and yet is taken pride in as the local identity.

Though despised by their mainland counterparts as 'southern barbarians', Hong Kong Chinese are proud of their Chineseness, which is undeniably maintained in the Cantonese dialect that preserves ancient Chinese expressions and Middle Chinese pronunciations like *poutau* 浮頭 'show up' and *gigi gatgat* 期期吃吃, meaning 'stammer, stutter', hence 'obstruct somebody from doing something' or 'be in the way',[5] as well as heritage from folklore, such as *wuleijing*

狐狸精 'vixen'. Nevertheless, many Hong Kong Chinese are handicapped in writing colloquial Cantonese, because their mother tongue is taught to be a mere spoken language. Moon's handwriting mistakes are abundant as seen in his blood stained suicidal note, whose close-up reduces his tragic death to a vocabulary quiz, as is Little Cheung's note left to his parents in *Little Cheung*. To coin words like *seunye* 筍嘢 'a job with wide margin of profits', *ginye/ lauye* 堅嘢 / 流嘢 'real stuff'/'phony stuff' (*The Longest Summer*) from a dialect into a 'grapholect'[6] is always a triple task of transliteration, transcription and translation.[7] Indeed, the Hong Kong identity can only be identified through multiple translations at the transnational (British English), national (Mandarin Chinese) and regional (mainland Cantonese) levels.

The differences between mainland Cantonese and Hong Kong Cantonese indeed distinguish Hong Kongers from others in Canton province as seen in *The Longest Summer* and *Little Cheung*. The former film shows that Cantonese is not the uniform dialect in Hong Kong. Like many immigrants of their generation, the protagonist Ga Yin's 家賢 parents speak Cantonese with different degrees of Chiu Chow 潮州 accent. In the domestic scene where his mother uses her relatively standard Cantonese to affectionately address Christopher Francis Patten (a.k.a. Pang Ding Hong 彭定康) as A Fei Pang 阿肥彭, or Fat Patten, as if the last Hong Kong governor were a close friend of hers, his father praises the Chinese communists in the Chiu Chow dialect, the dialect from his hometown in eastern Canton province that always reminds him of his origin in the mainland.

Little Cheung, the ending episode of the '1997 trilogy' dedicated to the legendary Cantonese opera singer Tang Wing Cheung 鄧永祥 (alias Sun Ma Sze-tsang 新馬師曾, 1916–97), is set in the midst of the burgeoning migration of mainland children to Hong Kong. The coming-of-age story is told through the childhood innocence of a nine-year-old delivery boy, the title character Little Cheung, and a 'little snake' illegal immigrant girl, Fan 芬, whose three-month visa has expired. Fan's fear of being deported back to the mainland encapsulates Hong Kongers' anxiety of *huigui* 回歸, or 'homecoming' to the motherland. Though also a native Cantonese speaker, Fan writes simplified Chinese characters, instead of the traditional ones used in Hong Kong, and argues with Cheung that 'tips' should not be expressed as *tipsi* 貼士, but *daseung* 打賞 (or *xiaofei* 小費 as in the subtitle). The argument brings forth the problem of a linguistic identity between transliteration from English and translation into Chinese in the era of the transition of sovereignty.

Film reviewer Acquarello has pointed out: 'Fruit Chan illustrates the inherent social dichotomy between Hong Kong residents and mainland Chinese immigrants during the transitional period prior to the handover of Hong Kong.'[8] Does Fan's naive declaration that 'Hong Kong is ours!' signify,

as Acquarello asserts, 'an unattainable dream' of the illegal immigrants or, in my opinion, an unofficial announcement of the Chinese sovereignty? The claim is made in yet another argument between the two little kids on the long pedestrian walkway of the Waterfront Promenade in Tsim Sha Tsui 尖沙咀 East, where they are playing a game to name the landmarks across the Victoria Harbour: the Bank of China that represents the economic takeover of Hong Kong; whether Central Plaza (mistaken as Central Statue Square in the English subtitle) has surpassed the Bank of China to become the tallest building in Hong Kong then; HMS Tamar, the Royal Navy's base that, as Fan proudly points out, 'will belong to the People's Liberation Army'; and the Convention and Exhibition Centre, the site of the handover ceremony that signifies, again in Fan's words: 'Hong Kong will belong to us when President Jian[g] Zemin [江澤民] comes.'[9]

In his introduction to *Linguistic Identity in Postcolonial Multilingual Spaces*, sociolinguist Eric A. Anchimbe proposes: 'The history of colonialism involved the conquest of not only peoples but also of their languages. So the study of postcolonial societies should be accompanied by a study of the history of the languages and their speakers and how these languages moderate the daily lives of these speakers.'[10] Linguistic localism in Hong Kong in fact localises the colonial language in everyday life. English as the imposed official language is to be inherited, indigenised and even insulted. Where colonial legacies such as the early Indian designation *daaiyilung* 大耳窿 'loan shark' (*Made in Hong Kong*) and *gong Yesou* 講耶穌 'preaching' (literally 'talk about Jesus'; *Little Cheung*) have long become part of the daily language practice in Hong Kong Cantonese,[11] individual English words like 'call', 'cancel', 'cancer', 'cash', 'check', 'encore', 'fax', 'feel' and 'shut up' are randomly inserted in the characters' Cantonese conversations or monologues. Moon's misspelling of 'feel' as 'fell' features a not-so-funny failure (or success?) of the colonial system of education that has wittingly or unwittingly produced a second-class linguistic citizenship, whose English-language identity is established only in the margin of the Anglophonic world. It is no less linguistically incorrect than politically incorrect when Ping's use of the English term 'lesbian' is mocked by Moon as *laai sibeng* 賴屎餅 'let's poo', which is loosely rendered into 'What's that?' in the English subtitle. Such a scatological strategy employs a vulgar language to demean the colonial master code.

Also found in *The Longest Summer* are the English words 'expect', 'fair', 'housing', 'over', 'post', 'position' and 'second hand', as well as an English-Cantonese transliteration of 'security' into *sik jiu* 食蕉 (literally 'to eat a banana' with a sexual connotation) and 'sergeant' into *sajin* 沙展. With the song 'Auld Lang Syne' playing in the background, the film starts with an English announcement that officially ended the 140-year service of Chinese soldiers in

the British army. It was on 31 March 1997, three months before the handover, when the Hong Kong Military Service Corps was disbanded. Five ethnic Chinese soldiers of the British garrison are thereafter dismissed and deprived of their benefits overnight. One of them suddenly expresses their lack of a 'normal' identity: 'We wasted two decades as British soldiers on Chinese land. It's not normal. Not Chinese and not British.' Struggling to survive and adjust their identity in the brave new world of national reunification, they resort to joining the underworld and, out of Anglophobia, plan to rob a British bank. Chan showcases a family of gangster and soldier, a society of pro-Britain and pro-China groups in the transition of 'one country, two systems'. We hear both Cantonese and English and see demobilised Chinese and British soldiers selling British military supplies in a flea market, followed by a pier scene with a British naval vessel in the background, where a private arms deal is conducted in English, the global language of trade. As the last deal is closed, the advent of the new era is declared hilariously in Cantonese and English in a disco amidst bloody gang fights.

For the Cantonese population in Hong Kong, until recently Mandarin (a.k.a. Putonghua 普通話 'common speech' in the People's Republic of China) as modern standard Chinese has mainly functioned as a written language; it is much less spoken than English. The separation of the oral and the written makes it awkward to speak such a standard phrase as *waisammo* 為甚麼, instead of the colloquial *dimgaai* 點解, as in the case when Moon teases a nurse 'why' he has to leave the hospital. Perhaps it is not at all surprising that when Big Brother Wing first appears in *Made in Hong Kong* he is speaking Mandarin over the phone for doing business with mainland Chinese, and when it comes to a secret code he resorts to the popular political slogan *poutintunghing ying gauchat* 普天同慶迎九七 'Hallelujah 1997'. In recruiting Ga Yin for the mob, Wing borrows the mainland political terms *rudang* 入黨 'join the Party' and *jiao dangfei* 交黨費 'pay party membership dues' to ridicule the former's British military background. The drug lord also challenges the Hong Kong police officer by alluding to the revolutionary song 'Singing a Folk Song for the Party' ('Chang zhi shan'ge gei dang ting' 唱支山歌給黨聽) when the latter commands the gang to stay home on the days of handover.[12] In the same scene Ga Suen 家璇 defends his older brother by refuting the cop in Mandarin, as if it were a command from the latter's future Chinese boss: 'Ni shuo shenme?' 你說甚麼 'What did you say?' Later on, being mistaken by a school girl as a mainland hick on the upper deck of a tram marked with 'Celebration of Reunification', Ga Suen scolds her, again in Mandarin, before throwing her off to the street.

Acknowledging Mandarin, the official Chinese language based on the dialect of the modern capital Beijing, to be the new metropolitan language for his business, Wing desires to manipulate it. However, his hiring of Moon to

murder the Mandarin-speaking tycoon from Shenzhen 深圳, a major mainland city and special economic zone immediately north of Hong Kong, turns out to be an anticlimax as the young killer sneaks away on the spot. *Made in Hong Kong* ends sarcastically in an imagined people's radio station in Hong Kong (Xianggang renmin guangbo diantai 香港人民廣播電台) broadcasting a quotation from Chairman Mao's celebrated speech to the leaders of the young. The familiar mainland strident tone sounds so strange in Cantonese that one finds release in hearing the final instruction: 'Let's repeat and study the message in Putonghua.'

So Little Cheung has started learning Putonghua at school in spring 1997, when Hong Kong, the poor Mandarin of news reporters and government officials alike was pervasive on local television. Ironically, the former Chinese top leader Jiang Zemin's surname is also misspelled in the film's English subtitle, once again proving Hong Kong people's poor pronunciation of Putonghua and unfamiliarity with the Romanisation system adopted in mainland China. But to describe Hong Kong people's Chinese and English as 'poor' is to acknowledge 'pure' Putonghua Chinese and British English as *the* standards, in other words, to accept linguistic dominance and discrimination, deprive people of their language rights, and eliminate the possibility of linguistic diversity. The linguistic citizenship of Hong Kong is doomed to be second-class under linguistic imperialism, be it British or Chinese. In effect, a split of schizophrenic identities has occurred among the 'two written languages and three spoken languages' (*leung man saam yu* 兩文三語), that is, among the oral, indigenous Cantonese dialect and written, foreign languages of English and Mandarin Chinese. I argue that in terms of its *pinyin* system and simplified characters modern Mandarin is indeed 'foreign' to native Hong Kongers. After 1997, while English is designated to remain an official, ex-colonial language for fifty years, Mandarin has gradually become the new metropolitan language for a reclaimed national identity with the introduction of compulsory Putonghua education in the school system.

Yet an indigenisation of Mandarin, comparable to pidgin English like *keleifei* 茄喱啡 (a loanword from English 'carefree' to refer to 'a side character' in *Little Cheung*), has undergone a long trek through the twentieth century. To take an example from the '1997 trilogy', the Hong Kong neologism *bakgugai* 北菇雞 'mushroom chicken' in Cantonese is coined as a homonym of *beiguji* 北姑妓 'northern whore' in Mandarin. Such invention of Cantonisation is similar to Creolisation in that a particular *patois* appropriates pieces of other languages to make new forms of expression, which would amount to a linguistic hybridism that challenges any linguistic supremacy.

The linguistic hybridism of Hong Kong is also showcased in the docu-drama of *The Longest Summer* dated from 27 June through 1 July 1997 with a

collage of Cantonese and Mandarin newscasts, a battle of languages between Governor Chris Patten's criticism of the People's Liberation Army (PLA) in British English and the PLA's defence in authentic Mandarin, Prince Charles's farewell speech and President Jiang's inauguration address, then a pro-China group's welcome of the PLA in Putonghua, a voice-over interview in Taiwanese Guoyu 國語, and the Special Administrative Region government officials' oaths of allegiance in 'poor' Putonghua. All these end up in the Hong Kong Chinese police officer being reprimanded by his bilingual (Cantonese and English) foreign boss upon wrongly identifying and arresting the retired soldiers. The summer of 1997 indeed witnessed an historical moment of identity confusion and confrontation in the contact zone known as Hong Kong.

The identity confrontation so necessary and inevitable for identity construction in the heterogeneous cultural space of such an immigrant-dominated society as Hong Kong is multilateral. In his discussion of *Little Cheung*, Hong Kong researcher Yau Ka-Fai 邱加輝 observes: 'It is undoubtedly easy to grasp the encounter between Little Cheung and Fan as an encounter between the new generations of mainlanders and Hong Kong people. Taking it as an (national) allegory, as it were, one may well construe their relationship as...one signifying the intermingling nexuses between China and Hong Kong.'[13] Yet Yau calls our attention beyond the national allegory to 'the international allegory that equivocates the China–Hong Kong kinship as a national bond'[14] through the image of the Filipino maid (Banmui 賓妹) Armi.

Armi communicates with Cheung's family daily in a mixture of Philippine English and Hong Kong Cantonese. She comments on her hosts bilingually: 'This family *houdo mantai* 好多問題 (has so many problems)!' She is able to use filthy and dirty Cantonese words and to criticise Hong Kong people as *chisin* 黐線 'crazy' in very accurate tones. The musical dialogue between the deceased star Tang Wing Cheung's Cantonese opera on the television and Armi's live Filipino song is a beautiful and enthralling antiphony of the two Asian cultures, envisioning crossing the ethnic group boundaries. While the nostalgic Cantonese operas reaffirm the Chineseness of the local people, it is the Filipino songs at the open air Sunday concert in the Central Statue Square that reminds them of the ethnic diversity that is an indispensable part of their global citizenship. However, Armi's home nursing is done after grandmother's death. She is dismissed by Little Cheung's parents and mostly missed by Little Cheung. Like many foreigners in Hong Kong, it is time to leave, leaving her space for the new settlers from mainland China. Upon her departure she speaks Tagalog to Little Cheung as if the Austronesian language were his mother tongue, too.

Another minority group that appears in the '1997 trilogy' is the Molocha 摩囉差. According to Lo and Tam,[15] the ethnonym is a portmanteau combining

Molo, the changed sound of the first two syllables of Polomun 婆羅門 (Brahmin), and *chaaiyan* 差人, or 'policeman' in late imperial China. The term refers to the Indian police employed by the British government in the early colonial period (1842–1949). Consequently, Indians are called Molocha or simply Acha 阿差 in Hong Kong. Besides their mother tongues, which are neither translated nor subtitled, they speak English and Cantonese. Interestingly, these Cantonese-speaking members of the South Asian diaspora know such complex popular Chinese concepts as *yihei* 義氣 'loyalty', but get confused between the numbering of the sixth floor in English and the seventh in Chinese (*Little Cheung*). Even the numeric system is not universal in Hong Kong – how could its identity be easily fixed?

Pointing out that 'identity can be a master discourse imposed upon the subject', Yau Ka-Fai considers Chan's '1997 trilogy' as minor discourses with 'a strategy of resisting prevalent identity imposition'.[16] Such discursive strategy, I would like to add, is designed linguistically to achieve a resistance to imposed meanings by producing alternative meanings through a hybridised language which, though untaught in school, speaks for a hybrid identity in a multilingual *Sprachinsel*.

I am deeply grateful to Kwok Ching Ling, Editorial Coordinator of the Hong Kong Film Archive, for her invaluable assistance in the task of tracking down Chinese reviews of Fruit Chan's films. I also want to thank Nicole Elizabeth Barnes for her helpful suggestions. In this article, Mandarin Chinese terms are transcribed using the pinyin system; Cantonese proper names and colloquial expressions are transcribed using the Yale Romanisation.

Notes

1 Zhang Yingjin, *Chinese National Cinema* (New York: Routledge, 2004), pp. 269–70.

2 In an interview Chan remarked that Ping's fatal illness is intended to be a metaphor of Hong Kong's handover deadline. See Yan, Sun, 孫言, '*Xianggang zhizao* ruhe zhizao? Duli dianying shenhua, Chen Guo zhizao' 香港製造》如何製造？獨立電影神話，陳果製造 (How to make *Made in Hong Kong*? A myth of independent film made by Fruit Chan), *Dianying shuangzhoukan* 電影雙周刊 (City Entertainment), 481 (1997), 47–48 (p. 48).

3 Esther M. K. Cheung, *Fruit Chan's Made in Hong Kong* (Hong Kong: Hong Kong University Press, 2009), pp. 125–27.

4 According to Lo and Tam, the Cantonese character *chyun* 串 is a pictograph of a pair of handcuffs used by the police, whose rudeness gradually produced a derogatory meaning of a disgustingly bad, cheeky attitude. Wood Wai Lo and Fee Yin Tam, *Interesting Cantonese Colloquial Expressions* (Hong Kong: Chinese University Press, 1996), p. 70.

5 Lo and Tam fail to recognise that *pou* is actually Middle Chinese pronunciation for 浮 'to float' before it evolved into *fau* in Modern Chinese: Wood Wai Lo and Fee Yin Tam, *Interesting Cantonese Colloquial Expressions*, pp. 62–63. For *gigi gatgat* 期期吃吃, see Lo and

Tam, p. 157; Kit Choi Kwan, *A Dictionary of Cantonese Colloquialisms in English* (Hong Kong: Shangwu yinshuguan, 1990), no. B390, in which the expression is transcribed onomatopoetically as 嘰嘰吃吃 and 嘰嘰趷趷, respectively. For the ancient pronunciation and original meaning of 吃 as 'speak with difficulty, stutter', see Bernhard Karlgren, *Grammata Serica Recensa* (Stockholm: Museum of Far Eastern Antiquities, 1957; repr. Göteborg: Elanders Boktryckeri Aktiebolag, 1972), no. 517g.

6 Wan-kan Chin, 陳雲根, 'From Dialect to Grapholect: Written Cantonese from a Folkloristic Viewpoint', *Hong Kong Journal of Applied Linguistics*, 2.2 (1997), 85–86.

7 For a study of Hong Kong grapholect, see Wan-kan Chin, 'From Dialect to Grapholect: Written Cantonese from a Folkloristic Viewpoint', *Hong Kong Journal of Applied Linguistics*, 2.2 (1997), 77–91 (pp. 85–86).

8 Acquarello, 2001–2003. Reviews of *Made in Hong Kong*, *The Longest Summer*, *Little Cheung*, and *Durian Durian* at Strictly Film School <http://www.filmref.com/directors/dirpages/chan.html> listed under 'Directors & Films' [accessed 24 Jan 2010].

9 The quarrel between Fan and Cheung about whether Hong Kong belongs to mainlanders or Hong Kongers ends with their brief comments on the broken Japanese handheld digital pet Tamagotchi たまごっち: '*waai jo* 壞咗,' which is allegorically translated by Kenneth Bi 畢國智 into 'finished' in the subtitle, as the camera moves above the kids' heads and fixes on the skyline of the island.

10 *Linguistic Identity in Postcolonial Multilingual Spaces*, ed. by Eric A. Anchimbe (Newcastle: Cambridge Scholars Publishing, 2007), p. 4.

11 While *lung* 窿 'aperture' is apparently a transliteration of 'loan', Lo and Tam suggest that *daaiyi* 大耳 'big ear' refers to the big round earrings worn by Indians, the early loan sharks in Hong Kong, who are now replaced by Chinese triad gangs (p. 18).

12 This is smartly translated into 'sing us the new National Anthem' in the English subtitle.

13 Yau Ka-Fai, 'Cinema 3: Towards a 'Minor Hong Kong Cinema', *Cultural Studies*, 15.3/4 (2001), 546–63 (p. 559).

14 Ibid., p. 560.

15 Wood Wai Lo and Fee Yin Tam, *Interesting Cantonese Colloquial Expressions*, pp. 18–19.

16 Yau Ka-Fai, 'Cinema 3: Towards a 'Minor Hong Kong Cinema', p. 549.

Chapter 7

THE POSTNATIONAL AND THE AESTHETICS OF THE SPECTRAL: HOU HSIAO-HSIEN'S *FLIGHT OF THE RED BALLOON*

Je Cheol Park

University of Southern California

In critical discourses on the post–Cold War world cinema, there would be no term that has become more influential than the term transnational. The phrase 'from national to transnational' is now considered one of the best phrases to epitomise the change in the landscape of world cinema over the past two decades. But at this moment when people began to doubt the celebratory attitude toward transnationalism in the wake of global recession, we might need to look at the phrase closely again to find if there is any missing link or any 'vanishing mediator' that we might have neglected between this transition from national to transnational. This paper proposes the buried term 'postnational' as this vanishing mediator in order to theorise how this term enables us to understand the way in which contemporary world cinemas can engage in our imagination of new communities characterised by alterity, openness, and incommensurability rather than by homogeneity, stability and exclusion. To illustrate the potential of cinema for opening up ways to imagine such postnational communities, this paper also closely examines one recent film *Flight of the Red Balloon* (2007) directed by Hou Hsiao-Hsien, focusing on how the aesthetics of the spectral is crucial to such an imagination. It should be noted that the film appears characterised as transnational in terms of both its contexts of production, circulation and reception, and its textual elements. My close reading of the film reveals, however, that the transnational approach to the film risks overlooking its other potentials in relation to our imagination of a postnational community.

Over the past two decades, an increasing number of studies on world cinema have demonstrated how border-crossing movements in terms of production, circulation and reception are crucial to understanding world cinema, especially world cinema in the post–Cold War era. Indeed, this tendency of study complicates the understanding of the nation and national cinema, highlighting how national culture in general and the national cinema in particular can no longer be rigid or pure since they have increasingly been informed by border-crossing cultural flows including multinational co-productions, transnational remakes and transnational stardom. Moreover, as opposed to the emphasis on the national, which has often been critiqued as homogeneous, territorialised or fixed, the emphasis on the transnational draws our attention to new virtues such as mobility, heterogeneity, deterritorialisation and flexibility.

Despite these and other celebratory achievements and possibilities of the transnational perspective, however, I suspect that this perspective does not fully open the way for the potentials overlooked or blocked by the national. Rather, it tends to embrace only the selected potentials that current neoliberal capitalism makes profitable. In other words, it tends to condone the increasing tendency according to which transnational flow is regulated under the global neoliberal governmentality whereby, as Aihwa Ong notes, flexible transnational elites 'claim citizenship-like entitlements and benefits, even at the expense of territorialized citizens' whereas 'low-skill citizens and migrants…are constructed as excludable populations'.[1] Consequently, the transnational perspective tends to ignore a new kind of wasted lives, those who are regarded as worthless and thus excluded from national security, but at the same time also excluded from the border-crossing flow because they appear valueless or even harmful from the perspective of transnational capital. These worthless lives include, but are not limited to, so called 'internally displaced persons' (IDPs), those who 'ha[ve] been forced to leave their homes' as a result of conflict, natural disasters or development projects, but 'remain within the borders of their own countries'[2] unlike exiles or refugees. But they are not simply exceptions to the rest of us who live normal lives, and it should be noted that we are all virtually vulnerable to such abandonment as can be seen in the recent nuclear disaster in Japan. To foreground this limitation inherent to the transnational and to illuminate the excluded potentials, I propose to call attention to the term postnational.

This term, though not as often as the term transnational, has been deployed in academia by critics such as Arjun Appadurai and Jürgen Habermas to designate emerging political or cultural phenomena or horizons that transcend the national boundary or cut across nation-states with the decline of the nation-state in the post–Cold War era.[3] And yet, these previous deployments of the term have some drawbacks, one of which is that as can be seen in

Appadurai's use of it, it is often confused with other similar terms such as global or transnational. Another problem that should be noted concerns Habermas' understanding of the term. He proposes to understand the postnational as a global public sphere in which we can in principle lead to an agreement concerning any global issue through democratising communication beyond particular national interests. What is important to note here is his suggestion that sustaining such a global public sphere requires as a prerequisite constitutional norms or cooperative legislations that are to work at a global level. Hence, the postnational understood this way runs the risk of excluding non-normative phenomena or thoughts from consideration.[4]

To avoid these pitfalls, I would argue, the term postnational not only needs to be re-defined in terms of its temporal rather than spatial character, but also it needs to be redeployed so that it can involve any singular possibilities that cannot be captured either by national or by global norms, rules, or laws. My understanding of the term is greatly indebted to Agamben's discussion of bare life, especially in his book *Homo Sacer: Sovereign Power and Bare Life*. The postnational, I propose, refers to the very dimension of what Agamben terms 'bare life' that emerges in the state of exception or emergency (i.e. state of siege) in which state law is suspended. By the term bare life or *homo sacer* Agamben means 'life that may be killed but not sacrificed'.[5] As this definition indicates, and Agamben also remarks, the quintessential example of bare life is the concentration camp inmate, who resides outside the applicability of state law and thus whose life and death do not have any meaning or value whatsoever. From this perspective, however, bare life seems to be conceived only in negative terms. Indeed, the bare life grasped this way, Agamben notes, is not entirely indifferent to state law, but rather maintains a relation of ban or abandonment with state law whereby bare life is implicated in the sphere of state law through its 'inclusive exclusion'.[6] As the 'Final Solution' or any other cases of sovereign violence illustrate, then, bare life here could not be said to embody the postnational given that it is still understood to be at the mercy of sovereignty.

But there is a different aspect of bare life that we need to highlight in order to illuminate the postnational. This positive potential of bare life, Agamben proposes, is no longer implicated within state law through the relation of ban, but rather emerges in 'non-relation' to state law. To put it another way, unlike the aspect of bare life captured by state law as its exception, this new aspect of bare life, or 'form-of-life' in Agamben's vocabulary emerges as an indeterminate remnant or excess of the process of being captured by state law.[7] In this regard, rather than being deemed meaningless or valueless from state law's perspective, the bare life as form-of-life involves a multiplicity of singularities that exceed state law's as well as any global law's processes of

signification or valorisation. If the term the postnational is to mean 'exceeding all the possibilities allowed by the nation-state including an inclusive exclusion by state law,' it could be best theorised as the bare life as form-of-life.

Although the bare life as form-of-life emerges absolutely outside the nation-state, it does not imply that bare lives have no potential to form a community. Rather, it is possible to imagine a radically different, postnational community that consists of bare lives. Immediately after the collapse of the actually existing socialist regimes, critics have proposed alternative notions of community grounded on alterity, incommensurability, and openness as opposed to the old notions of community such as the nation-state or the Soviet Union founded on a body of shared features or a common ideal. Agamben, among others, proposes an alternative notion of community grounded not on any specific identity, but on unconditional belonging. He proposes a community of whatever singularities, which 'has no identity, [which] is not determinate with respect to a concept, but [which is neither] simply indeterminate, rather [which] is determined only through its relation...to the totality of its possibilities'.[8] In other words, as he paraphrases, the community of whatever singularities is 'mediated not by any condition of belonging, nor by the simple absence of conditions, but by belonging itself'.[9] As far as I understand it, his notion of community requires as the condition of its possibility a medium by means of which beings acquire a sense of belonging without losing their singularities. The first and foremost point about this notion is that a community is less a collective of identical or similar beings than a collective of singularities that have nothing specific in common. This means that a community has potential for involving within itself something radically other or the absolute outside. In this regard, this notion of community is an answer to the question of how singular beings as bare lives can form a postnational community. Another important point about Agamben's notion of community is that he implies the role of media in forming such a community. But it is Derrida's and Stiegler's ideas about spectrality that provide more precise understanding of the relationship between a medium and a community.

Indeed, Derrida's theory of spectrality allows us to understand the precise relationship between mediated perception and the community predicated on alterity or incommensurability. It should also be noted that Derrida and Stiegler highlight the crucial role of photographic/cinematic/electronic media technology in producing the spectral.[10] In fact, that the communicability of the medium is crucial to our imagination of a community is not a new idea. Benedict Anderson has already proposed that media technology such as the newspaper and the novel enables one to develop a sense of national community from other people one has never met. As one comes to know about the lives of others through those media, one becomes acquainted with them and develops

a sense of commonality between one and others.[11] But as Derrida would have put it, one's experience of others through media does not necessarily lead to one imagining a national community grounded on homogeneity and commensurability, but it opens up the possibility that one might envision a postnational community characterised by incommensurability and alterity. To clarify the difference between these two, I want to call attention to Derrida's distinction between the spiritual and the spectral. In deconstructing Karl Marx's *German Ideology*, Derrida writes:

> The production of the ghost, the constitution of the ghost effect is not simply a spiritualization or even an autonomization of spirit, idea, or thought, as happens par excellence in Hegelian idealism. No, once this autonomization is effected, with the corresponding expropriation or alienation, and only then, the ghostly moment comes upon it, adds to it a supplementary dimension, one more simulacrum, alienation, or expropriation…. Once ideas or thoughts (Gedanke) are detached from their substratum, one engenders some ghost by giving them a body. Not by returning to the living body from which ideas and thoughts have been torn loose, but by incarnating the latter in another artifactual body, a prosthetic body, a ghost of spirit, one might say a ghost of the ghost.[12]

To sum up what Derrida states, the spirit is an idea that, sublating (i.e. *Aufhebung* in its Hegelian sense) all the differences or oppositions between bodies, expresses that which is common to all the bodies whereas the spectre is a supplemental dimension of alterity added to the spirit through its reincarnation in an artifactual body. To be more precise, as an excess or supplement added to the spirit, the spectre erodes the unification of bodies the spiritualisation process performs and thereby enables bodies to feel their irreducible differences from one another. This distinction between the two terms clearly reveals how the mediated perception of others also enables one to develop a sense of postnational community distinct from that of the national community that Anderson discusses. Anderson claims that when media allow one to imagine a national community, such a community is created to substitute for religion in transforming 'contingency into meaning',[13] that is, a multiplicity of bodies into a unified collective. Imagining a national community should, then, be understood as a spiritualisation process. In contrast, imagining a postnational community can be understood as a spectralisation process. The reason is because the postnational community, as I discussed, is formed by singular beings and this dimension of singularity is created by the spectralisation process.

 Hou Hsiao-Hsien's films offer us one notable example among contemporary East Asian films that marks the shift from their concern with the national

community to that with the postnational community. While Hou began to make so-called 'national' films financed by Taiwan national film companies including his own called 3H Productions, later beginning with the film *Good Men, Good Women* (1995) he transitioned to 'transnational' filmmaking involving various European and Asian film companies. During the period of his transnational filmmaking, he has often shot at locations outside of Taiwan such as Mainland China and Japan. The film *Flight of the Red Balloon* becomes even more significant given that it is his first film that has ever been financed by European film companies and has ever been shot in the European location that is Paris. What is even more notable is that the film deals with transnational life as its main subject matter although this kind of life has been included sporadically within his earlier 'national' films such as *A City of Sadness* (1989) and *The Puppetmaster* (1993).[14]

As in most of Hou's films, the storyline of *Flight of the Red Balloon* is quite simple if one considers only 'significant' events at the sacrifice of insignificant details. Song, a Chinese film student, begins to live with a Parisian family as a babysitter for the child, Simon. The latter has lived with his single mother, Suzanne (played by Juliette Binoche), who works dubbing Chinese puppet shows. Song, taking care of Simon, is making a remake of Albert Lamorisse's 1956 short film *The Red Balloon*, featuring Simon. Suzanne is having trouble with Marc, her tenant, who does not pay the rent while she waits for the return of her daughter Louise, who lives in Brussels possibly with her father. Last but not least, a strange red balloon floats and sometimes lingers around Simon and Song.

Significantly, the film portrays a Parisian life that is already characterised as transnational in many respects. Indeed, transnational cultural exchanges between China and France appear in the film in a variety of ways: that a Chinese woman works in a French family, that a French woman translates Chinese puppet shows, that a Chinese woman filmmaker makes a remake of a French film (that reflexively refers to Hou's situation), and so forth.

However, from the perspective of what I have discussed so far, the film could not simply be reduced to a multifarious portrayal of transnational life. Indeed, mobilising different types of spectres, the film enables spectators to imagine postnational communities to come. One of the film's notable visual features is that it often creates doubles of people or objects utilising images reflected in mirrors or windows. It seems normal when both the actual source and its reflected image are simultaneously seen within the frame. But when only reflected images are seen within the frame, this cinematic experience begins to communicate a sense of otherness. For instance, in the scene where Song and Simon are walking in a street, what we see for the first few seconds are only their reflections in a cafe window even though after this short period of time their actual images appear within the frame due to the

camera movement. During those few seconds we might get a sense that the reflected images of Song and Simon suddenly look unfamiliar even though these images still resemble their familiar origins supposed to be outside the frame. This antinomic feeling can be described as the feeling of 'uncanniness' (*Unheimlichkeit* in German) Freud once wrote about, given that he defines the uncanny as 'that class of the frightening which leads back to what is known of old and long familiar'.[15] This dimension of unfamiliarity within the familiar is also the first and foremost feature of what Derrida terms spectre since as a supplement added to something, as we discussed, the spectre evokes a sense of alterity. Consequently, during those few seconds we see a spectralisation process emerge because the reflected images add a sense of alterity to the otherwise ordinary perception of Song and Simon. Their spectral doubles enable us to feel as if Song and Simon became endowed with qualities other than what they are, say, qualities other than their national identities. Thus, through this spectral technique, we are given chances to imagine the postnational community of the singularities of Song and Simon over and above chances to see how a transnational relationship between them unfolds.

The film also provides several interesting instances of spectral sound images. Take, for example, the scene in which Suzanne is dubbing a Chinese traditional puppetry into French. During the first few seconds, we hear her vocal dubbing when only the Chinese puppet is within the frame while her visual image is outside the frame. Even though we subsequently see her visual image appear within the frame as a result of camera movement, during this time we do encounter another instance of spectralisation because we might feel as if her voice, temporarily disembodied from her own body, became reincarnated in the puppet's body, an artifactual body. In Michel Chion's vocabulary this vocal spectre is an example of 'acousmêtre'. This term acousmêtre denotes 'a sound that is heard without its cause or source being seen'.[16] When a voice becomes an acousmêtre in a film, Chion highlights, it acquires a sense of otherness that cannot be attributed to its alleged source, as can be seen in many films such as Norman's dead mother's voice in *Psycho* (Hitchcock, 1960) or the unseen Mabuse's voice in *The Testament of Dr. Mabuse* (Lang, 1933). Significantly, in the disjointed joint of the voice and the body in the scene we are discussing, we not only see a spectralisation of Suzan, but we also bear witness to a spectralisation of the puppet in the sense that the alleged voice of the puppet, disembodied from its body, becomes reincarnated into Suzan's spectral voice. In this regard, it would be a mistake to think that the film illustrates a hybrid of Frenchness and Chineseness, or that it exemplifies the cross-national transition from Frenchness to Chineseness. In other words, through this double spectralisation, not only does Suzanne potentially acquire a supplemental dimension irreducible to the alleged French national

character, but also the puppet undergoes a similar metamorphosis. Thus, it is the postnationalisation process rather than the transnationalisation or multinationalisation process that can best describe the change occurring both to Suzanne and the puppet.

Last but not least, we would need to think about the status of the strange red balloon. Here we should also be very careful not to draw a hasty simple conclusion that the red balloon stands for the transnational exchange between Chineseness and Frenchness given that *Flight of the Red Balloon* is a transnational (Chinese or Chinese/French) remake of the French film, *The Red Balloon*. Just as Suzanne's spectral voice does with respect to the puppet, the red balloon during the process of disembodiment acquires an extra dimension of alterity that cannot be ascribed to a cultural feature of Chineseness or a combination of cultural features of Chineseness and Frenchness. Indeed, the balloon in Hou's film cannot be thought to have the quasi-anthropomorphic or magical character Lamorisse's film has, but looks like nothing other than an ordinary balloon.[17] But, even though it does not appear to have a purpose or intention, it nonetheless seems to have an unknown extra dimension that cannot be attributed to any positive nature, as can be seen in the scenes in which it attracts Simon's attention or lingers around him without any explicit reason. Thus, from the Derridian perspective, if Lamorisse's balloon is considered as a spirit, the one in Hou's becomes a spectre, obtaining an extra dimension of otherness that cannot be reduced to any positive national character.

However, not only can we see the spectralisation of the red balloon when we consider the production process of the film. We can also see how it is spectralised within the film text itself in multiple ways. It is reincarnated, for example, in the one in the painting titled *Le ballon* by a Swiss painter named Felix Vallotton, in the one painted on the wall of a building on a street in Paris, and in the one appearing in Song's remake of Lamorisse's, and so forth. For the audience of the film, these multiple spectralisations not only amplify the visibility of the otherwise barely visible balloon, but also strengthen the feeling of postnational alterity about the balloon that otherwise would embody features of Frenchness, of Chineseness, or a hybrid of features of the two, evoking the national or transnational.

To reiterate, it is this aesthetics of the spectral that enables us to develop a sense of postnational community in the process of watching the film *Flight of the Red Balloon*. The imagination of national or transnational communities, then, is accomplished through the aesthetics of the spiritual. Obviously, if we see the film through the lens of this aesthetics of the spiritual, we can be given opportunities to imagine a Chinese or a French national community or a Chinese/French transnational community. For instance, if we treat Suzanne and Song simply as representative of Frenchness and Chineseness respectively,

we will have a chance to imagine a transnational community that can provide a link between Chineseness and Frenchness. But once we call attention to a variety of spectral techniques deployed throughout the film, we will also have a number of chances to imagine postnational communities in the way we can think of other possible relationships or networks between characters without losing their singularities.

In sum, I proposed the term postnational to call our attention to those wasted lives excluded from both the national security and the transnational flow. As I suggested in my definition of the postnational as bare life as form-of-life, those postnational lives are not exceptional but potentially applicable to anyone or 'whatever singularities'. In this way, the term postnational involves a new notion of community characterised by alterity, incommensurability and openness, which is radically different from the old notion of national community based on a shared trait or ideal. The second important point I made is that postnational community can be imagined through the spectrality of media. As I illustrated in a close reading of the film *Flight of the Red Balloon*, the aesthetics of the spectral in cinema enables us to imagine postnational communities in which we can develop a sense of belonging mediated by a sense of otherness inherent in our encounter with others.

Obviously, the transnational approach to world cinema has contributed much to making visible what has been unthinkable from the national perspective on world cinema. But it should be significant to note that the transnational perspective does not fully answer the questions nor fill the voids the national approach to cinema has left behind. The postnational perspective on cinema I propose in this paper is another response to the questions the crisis of the national cinema has opened up.

Notes

1 Aihwa Ong, *Neoliberalism as Exception: Mutations in Citizenship and Sovereignty* (Durham, NC: Duke University Press, 2006), p. 16.
2 <http://www.idpguidingprinciples.org> [accessed 25 June 2011].
3 For Habermas's and Appadurai's understandings of the postnational, see chapter 4 of Jürgen Habermas, *The Postnational Constellation: Political Essays*, trans. by Max Pensky (Cambridge, MA: The MIT Press, 2001) and Arjun Appadurai, *Modernity at Large: Cultural Dimensions of Globalization* (Minneapolis: University of Minnesota Press, 1996), pp. 164–72.
4 Pheng Cheah pertinently draws our attention to the normative and thus exclusive character of Habermas' notion of the postnational. See chapter 2 of Pheng Cheah, *Inhuman Conditions: On Cosmopolitanism and Human Rights* (Cambridge, MA: Harvard University Press, 2006).
5 Giorgio Agamben, *Homo Sacer: Sovereign Power and Bare Life* (Stanford, CA: Stanford University Press, 1998), p. 83.

6 For more details about law's inclusive exclusion of bare life, see Agamben, *Homo Sacer*, pp. 15–29.

7 For the detailed account of the notion of bare life understood as form-of-life, see Agamben, *Homo Sacer*, pp. 54–62.

8 Giorgio Agamben, *The Coming Community* (Minneapolis: University of Minnesota Press, 1993), p. 67.

9 Ibid., p. 85.

10 Jacques Derrida and Bernard Stiegler, *Echographies of Television* (Malden: Polity Press, 2002). Derrida is hesitant to use the term community because for him it presupposes commonality, 'a unity of languages, of cultural, ethnic, or religious horizons' (p. 66). However, my understanding of postnational community, in as much as it is predicated on incommensurability or alterity, does not contradict his vision of the utopian social bond. For the ways in which cinematic technology, among others, produces spectral images, see chapter 6 of Akira Mizuta Lippit, *Electric Animal: Towards a Rhetoric of Wildlife* (Minneapolis: University of Minnesota Press, 2000) and Tom Cohen, *Hitchcock's Cryptonymies, Vol. 1* (Minneapolis: University of Minnesota Press, 2005) and *Hitchcock's Cryptonymies, Vol. 2* (Minneapolis: University of Minnesota Press, 2005).

11 Benedict Anderson, *Imagined Communities: Reflections on the Origin and Spread of Nationalism* (New York: Verso, 1991).

12 Jacques Derrida, *Specters of Marx: the State of the Debt, the Work of Mourning, and the New International*, trans. by Peggy Kamuf (New York: Routledge, 1994), p. 26.

13 Anderson, *Imagined Communities*, p. 11.

14 Even when Hou addresses the colonial period of Taiwan in his earlier 'national' films such as A *City of Sadness* (1989) and *Puppetmaster* (1993), he often portrays an innocuous friendship between Taiwanese and Japanese without recourse to any antagonistic or condescending stance. This signals that Hou's so-called national films had already germs of postnational imaginations that his more recent transnational films are dedicated to.

15 Sigmund Freud, 'The Uncanny', *The Standard Edition of the Complete Psychological Works of Sigmund Freud Vol. XVII*, trans. and ed. by James Strachey (London: The Hogarth Press, 1957), p. 220.

16 Michel Chion, *The Voice in Cinema*, trans. by Claudia Gorbman (New York: Columbia University Press, 1999), p. 18.

17 In comparing Lamorisse's and Hou's film in terms of the nature of the balloon, Sean Metzger and Olivia Khoo point out that the balloon in the former film is 'guided by the exigencies of chance' whereas that in the latter is 'paced by non-events': Sean Metzger and Olivia Khoo, 'Introduction', *Futures of Chinese Cinema*, ed. by Sean Metzger and Olivia Khoo (Chicago: Intellect, 2009), p. 15. While their argument is not without pertinence, it does not precisely reflect the key characteristics of the two balloons. Unlike their assessment, the balloon in Lamorisse's film acts like a human being, thus implying necessity rather than chance whereas the one in Hou's looks ordinary but is also haunted by an extra dimension of alterity.

Chapter 8

THE ART OBJECT AS TEXT IN THE PRACTICE OF COMPARATIVE VISUALITY

Jane Chin Davidson

University of Houston, Clear Lake

'So long as the history of painting is difficult to dissociate in all rigor from the history of the cultural, linguistic, and even literary text, it is enough to ask literature and painting, comparatively, the question of mimesis or of the referent, etc., for the question of the relation between a still-life and a so-called real plant (a vegetable or a game animal) to no longer be simply foreign, a priori exterior, to the domain of comparative literature…. We must understand the structural temptation of this encyclopedic opening…the concept of comparative literature, the essential vocation [is] to be an encyclopedic, encyclopedistic destination.'[1]

—Jacques Derrida

The classificatory order for the visual arts and art history has long been rigorous in its demand for juxtapositions and comparisons – notwithstanding the fact that there is really no such thing as a disciplinary domain called 'comparative visuality' that can parallel comparative literature. In regards to cultural comparisons, there is a vast difference between approaches to visual art and to literature when it comes to analysis of their objects of expression. Historically, the endeavour of comparing the visual arts was an enlightenment practice, established by historian-critics such as Johann Winckelmann who in 1764 made the case for judging the 'highest beauty' achieved by Classical Greek artists in contrast to the 'arrested growth' of the artistic development of Egyptian and Persian art.[2] His politic of comparison simply extended the broader notions about cultures from Kantian 'observations' which were later incorporated with Hegelian philosophies of history. The hierarchies of nationalism remain integral to the practice of comparison in the field – its

ossification simply accepted as natural since European art constitutes the hierarchical frame for aesthetic judgement.

Winckelmann's comparisons instituted the descriptive model for a Western aestheticism that emerged after the seventeenth-century period of colonial conquests, at a time when Portuguese mercantilists conceived of the 'fetish' – talisman, idols and charms – as objects that exemplified the backward, superstitious, obscene, contemptible and primitive, and thereby, non-aesthetic expressions of the West African peoples. As Mitchell suggests, the 'rhetoric of empire and colonization' has a deep connection to the 'division between art objects and mere, unredeemed objecthood, between art and nonart'.[3] These divisions are not juxtapositions or comparisons in any sense of the word, rather, they distinguish the art historical binaries, known best by the opposition between Western and non-Western art. As this essay endeavours to show, the old nationalist distinctions still ascribed to the discipline of art history become apparent when compared to comparative literature, and to this end, a reconceptualisation of 'objects' in a study of the 'regime of objects' can provide an understanding of the intense ways in which they continue to stand in for cultures or nations. In contrast to the analyses of the gaze, an 'object regime' differs from discussions of the 'scopic regime' since the focus is on the potent taxonomic 'thing' that could be interminably classified as either art or non-art.[4] And in looking at the juxtapositions of modern history, this essay reveals how the displays in museums and world's fairs secured the division of culture, not a comparison of them, because it is the 'objects' that are classifiable, not the 'gaze' toward them. Mitchell suggests that visual objects are unified in the 'objecthood of empire', and the modern regime constitutes a structure of knowledge that is implemented through powerful institutional juxtapositions, affinities and comparisons that demarcate the aesthetic boundaries amongst cultures and nations.[5] In this way, the encyclopaedic practice is complicit in the 'philosophical ambition for absolute knowledge,' as Derrida argues, and the goal of this taxonomy is to serve in 'totalizing or finalizing the history of meaning or of culture'.[6] The philosopher goes on to explain that every episteme is self-evidently comparative, which is especially true for the analysis of the modern structure of art history and its objects.

The question of the validity of the ways in which artistic objects represent culture or nation plays a part in the latest characterisation of 'crisis' for both the disciplines of visual art/art history and comparative literature. Artistic globalisation has been viewed as the cause of the major shift in the art history discipline, breaking up the long-held dominance of Euro-American subjects. But even as postcolonialist critiques came late to art historical analyses, division by rubrics for the local, national and international have resurged rather than diminished in the twenty-first century discourses of art. As a case in point,

Rasheed Araeen, the founding editor of the esteemed art history journal *Third Text*, responded disparagingly to the published seminars on the problems of art and globalisation led recently by art historian James Elkins at the School of the Art Institute of Chicago.[7] Araeen asserted that the participating scholars still look patronisingly to 'faraway India, China, Central Asia, or Latin America' as the distant places of the global challenge when post-war European cities have long been 'transformed into multiracial and multicultural metropolises by the new immigrants, among them artists, from Asia, Africa, the Caribbean, and Latin America'.[8] Araeen believes that the real problem is the ignorance of the specialists who are 'unaware of the fact that the Eurocentricity of art history has already been challenged and demolished…by the very people who are not supposed to be within it'. Even in the twenty-first century, the regime of art history perpetuates the Eurocentric status of its subjects and suppresses the post-war scholarship that had 'demolished' its supremacy. Araeen points to the dilemma in which the distinction should be made between the diversity of art historical subjects/objects and the racial diversity of the scholars in the academic institution. But the presumption left unexplained is one that keeps the hierarchy intact, which is the belief that visual art objects represent the individual 'self' of culture or nation. Another aim of this essay is to undertake the ways in which this belief was established through modernist conceptions of subjecthood and thereby revisit some of those challenges that scholars have initiated in more recent forums.

The crisis in comparative literature is vastly different as it is related to an overactive awareness of the post-war challenges to the Eurocentric order (in contrast to art history's underwhelming attention). The outcome included a greater dissemination of global subjects and deconstructionist practices into disciplines other than literature, affecting a range of disciplines from media studies to anthropology and thereby putting into question the need for comparative literature.[9] Historically, Comparative Literature's major contribution to scholarship was in promoting cultural diversity through the study of the literary object. As Rey Chow suggests, 'the term 'comparative' is often used in tandem or interchangeably with words such as 'diverse', 'global', 'international', 'transnational', 'crosscultural', 'planetary' and the like, in ways that once again conjure the signature aspiration of 'more than one', of going beyond restrictive national boundaries'.[10] Since the 1950s, the discipline's radicality is also in crossing boundaries of methodology, relinquishing the requirements for a cohesive literary system.[11] René Etiemble, the French grammarian, articulated the aims for Comparative Literature in his *Litterature comparée* entry in the *Encyclopedia Universalis* (1977), suggesting that, it was not like other ignoble imperialist endeavours 'since it only proposes to combat all the forms of cultural chauvinism and to teach the respect or the admiration

of others'.[12] Etiemble, an expert on Chinese language, had long promoted the belief that 'Europeans should cease to make Europe the centre of their preoccupations'.[13] As simplistically utopian as they sound, comparative literature's ideals and aspirations have only been recently addressed in art history, which are now considered as pressing objectives for confronting its perceived globalist crisis.

In the transformation of university curricula toward globalism, it should come as no surprise that comparative literature ends up usurped by other fields of scholarship since almost any research object can be studied through its corresponding 'literature' in the context of culture and/or nation. As early as 1979, Derrida questioned whether the loss of the 'literariness of literature' inaugurated a crisis, suggesting that '[c]omparative, compared, or comparing literature should, in the final analysis, only have to do with literature or with literatures as its specific object or subject.'[14] In a situation where the term 'literature' becomes an open signifier, the concept of a regime of literary objects under the rubric of 'West' and 'non-West' becomes increasingly questionable in the global order. Why then does art history retain its analysis of heritage objects according to these outdated categories ascribed to particular nations and cultures?

The way in which the visual arts has functioned in a complex system of aesthetics to serve as both objects of culture/nation/heritage and representations of the 'self' is altogether different from comparative literature's cross-cultural discipline. In order to understand the aesthetic logic from which heritage traditions are perpetuated, it becomes important to trace a particular genealogy of subjecthood and objecthood in modern art history. The most apparent example is in the historical comparison of the 'ideal subject' in modernist art as opposed to the 'superstitious object' that was designated as premodern. The impact on present-day contentions that divided the two concepts can be seen in the current model for the dematerialised art object – the viewer of performative and conceptual artworks is engaged with the subjects of the experience rather than material objects. And the conventional premise for the artistic 'subject' that actually represents the 'self' was explained cogently by Whitney Davis as the erroneous assumption that the 'great' work of art is 'subject-constituting' because it is literally 'coterminous' with the artist who becomes absorbed into the artistic subject.[15] Davis was contributing to the 1990s poststructuralist critiques of modernist conventions in challenging the hegemonic white male 'Subject' that was attributed to the writings of Michael Fried and Clement Greenberg. In his famous 1967 essay 'Art and Objecthood', Fried condemned the 'theatricality' of Donald Judd's 'specific objects' because the viewer's engagement of minimalist works that are 'not-painting, not-sculpture' depended on her/his own subjectivity.

The shift of focus to the viewer's interpretative practice destroyed the integrity of the artist's command over his art object and diminished his ordained role as the maker of meaning. Fried was really defending the 'presence' of the artist, expressed through painting as the highest aesthetic achievement of abstract expressionism. And long before Fried, Greenberg had established abstract expressionism as the highest aesthetic achievement that could be ascribed nationalistically to artists of the United States – the only art movement that could be considered as an American invention. In the modernist ideal, the 'presence' of the artist constituted the 'transcendent subject', representing not only the artist but also nation and culture. In the mainstream visual art discourse, the material art object reflected the modernist belief in the heroic individual-as-universal subject. The post-war challenge that Araeen referred to was made primarily by feminists/queer and multiculturalists (especially during the 1980s–90s), and their efforts to displace the supremacy of the hetero, masculine and homogenous subject was through empowering the non-male, non-white heterogeneous subject of art.

However, the notion of the 'presence' of the artist as some kind of haunting of the abstract work of art was a myth that was established to express personhood as a type of subjecthood of art. As Davis argues, the urge to produce or change artistic subjecthood to reflect a non-white-male representation relies on a system of belief that overestimates the autonomy and power of the work of art itself. Davis resists the idea that the 'artistic subject' and the 'artist as subject' are one and the same, and he argues that '[a]rtworks are never subjects, but always objects; only subjects are subjects…. Outside aestheticist ideology, artworks rarely compel personhood'.[16] Davis acknowledges how subjecthood in the visual arts, unlike the literary subject, is susceptible to a misleading aesthetic ideology that denies its objecthood through this idea of personhood.

The problem centres around objecthood as an always-already negative concept based on connotations surrounding objectification. The most obvious example is the 'male gaze' of feminist theory that sexualises the image of the female body and makes woman an object, not a human being – not a 'subject'. Much of feminist art discourse has been dedicated to the politics of the gaze, and yet, as this essay asserts, the politics surrounding the object of the gaze are just as important. Chow explains this concept for comparative literature, suggesting that cultural difference – in language, in form, in aesthetic, for instance – is 'exactly that 'object' which confronts us repeatedly with the limits of the terms of its representation and evaluation'.[17] In terms of visual identification, the object of sexual and racial difference constitutes an oppositional counterpart to the transcendent subject. The writing of the figure of 'race' in literature expresses a visual object in which

Frantz Fanon's familiar description of the 'crushing objecthood' of the white man's gaze toward the black man remains the exemplary model for expressing difference as the object of violence and negative reception.[18] Chow articulates the Kantian practice in which 'aesthetic judgment involves a reflection of the terms of the reflecting activity (or subjectivity) from *within* rather than only a reflection of the external object it judges (my italics)'.[19] In aesthetic terms, visual assessment reveals something more about the subjectivity of the viewer than the object being viewed. In this way, objectification is a visual comparative that denies subjecthood – for instance, the concept of colour-blindness suggests that simply seeing 'race' compels automatic judgement, so much so that one has to be blind to difference before the objecthood of 'race' can be superseded in order to arrive at subjecthood. And in the same vein, Fanon shows how the 'raced' subject can never achieve the ideal modernist subject of the 'self'.

That is why Fanon writes his own 'self' as the object of comparison, one who 'must be black in relation to the white man,' as the ontological figure of difference who is visualised and represented by both the word and the image. The literary writer can subjectively illustrate the external object of her/his imagination, whereas the visual artist must produce an actual external object that supposedly records her/his internal subjectivity. But the racial object is a special case. Fanon distinguishes the special objectivity of the racial subject in his self-reflexive description: 'I subjected myself to an objective examination, I discovered my blackness, my ethnic characteristics; and I was battered down by tom-toms, cannibalism, intellectual deficiency, fetishism, racial defects, slave-ships, and above all else, above all: "sho' good eatin".'[20] This verbal description of difference can be viewed as a literary object that becomes a visual object by which Fanon *sees* how others see him. The usual critical assessment is to blame the 'colonial gaze' for the racist response – Fanon's description 'Mama, see the Negro! I'm frightened!' reveals the way in which 'identification involves not only subject and image, but gaze', as explained by Kaja Silverman.[21] But it is the acknowledgement of the object regime as defined by the history of slavery and the inscription of the 'premodern' that shows how 'difference' itself is represented as an 'object' in the visual arts. Mitchell's comparative for visual culture explains the 'knotting of a double bind that afflicts both the subject and the object of racism in a complex of desire and hatred'.[22] In Mitchell's essay 'What Do Pictures Want', he contextualises Fanon's black man in the 'personification of inanimate objects' which he connects to the judgement against the 'regressive, superstitious attitude toward images' as derived from associations with 'primitive' practices 'like totemism, fetishism, idolatry and animism'.[23] The objecthood of 'race' is one in which the person becomes identified not at all by name but by a presumed associative object.

Figure 18. Metalwork. Installation view of 'Mining the Museum: An Installation by Fred Wilson'. 1992–1993. Courtesy of Maryland Historical Society, MTM 010.

In his use of comparison as artistic practice, contemporary artist Fred Wilson displayed slave manacles next to a colonial silver tea service, removing the ahistorical, timeless signifier of the object of difference and placing it squarely in the history of slavery. Wilson spent a year with administrators of the Maryland Historical Society curating the exhibition 'Mining the Museum' (1992) from the society's collections. For the show, Wilson juxtaposed precious heritage silver, dinnerware sets and fine furniture usually found in historical museums, next to objects from Maryland's racist history, such as slave trade hardware and Klu Klux Klan hoods. Nothing expresses more clearly the regime of objects than the notion that precious silver can exemplify the grandeur of a cultural past. The object of difference in this regime clearly has no place in the aesthetic realm that distinguishes the legacy object.

As the epitome of museum 'interventions', Wilson's performative installation re-introduced the master narratives of cultural comparison to shine a light on the selective memory of the museum's didacticism. The artist reveals how the privileged subjects and objects of history are canonised by collecting and exhibiting. However, very little has changed in museum practices since the groundbreaking 1992 Maryland exhibition. The museum juxtaposition is simply an exhibitionary device, and the solipsism of the institutional self-critique – the self-correction of institutional biases through avant-gardist introspection – is just another way to justify an exclusively 'Western' perspective of art history. The special distinctions of the visual art system defy the logic

of any modern enterprise. No other institution can claim a cultural economy of auction houses, museums, art academies, and art history that serves as the means to create value for its regime of objects.

The exchange of art objects is a multi-million dollar enterprise, and the stakes are much higher for the museological 'institutions of consecration', as phrased by Pierre Bourdieu, who referred to art establishments as being girded by the 'transhistorical norm for every aesthetic perception'.[24] Wilson's objects of slavery can therefore be linked to the premodern object of difference as the contrasting counterpart to the timelessness of the aesthetic norm. But the mythology that the aesthetic subject is ascribable to nations is the belief that undergirds the entire circuit of the cultural economy. For instance, Picasso's *Nude, Green Leaves and Bust* (1932) is a prime example for representing the modernist 'transcendent subject' and it is not coincidental that the painting sold for a record-breaking one hundred and six million dollars in 2010. Neither is it an irony that Picasso helped to develop the modernist terminology for the primitive since he plays a significant role in constructing the premodern 'object of difference'.

The very hallmark of modernist art is abstraction and the artistic shift can be viewed through the style that emerged during the early decades of the twentieth century called Primitivism. Not to be confused with the fetish object of primitivism, the artistic subject of Primitivism was instituted through the process by which the transcendent 'self' of the artist would be established in abstract painting. Curator William S. Rubin explains this process by describing the way in which Picasso experienced a 'revelation' after viewing the display of works by 'primitive' peoples at the Trocadero Museum in Paris. The encounter led to the creation of *Les Demoiselles d'Avignon* (1907), a work that expresses the 'visible symbols of the artist's search within his own psyche', and since Picasso called it his 'first exorcism picture', Rubin surmised that 'he understood the very making of it as analogous to the kind of psycho-spiritual experiences of rites of passage for which he assumed the works in the Trocadero were used'.[25] Tribalism's superstitious power was viewed as the liberating force for Picasso, offering him a personal freedom of a kind that was assumed to be meaningless to tribal man. Rubin concludes that this 'self-analysis, this peeling away of layers of consciousness, became associated with the search into the origins of man's way of picturing himself…for what Picasso recognized in those sculptures was ultimately a part of himself'. And thus, the very origins of modernist expressions of self-recognition as the transcendent 'self' could be traced to the tribal and primitive.

In the modernist intelligibility, an art object functions as a pure expression of the individual artist, and it is not supposed to house the 'life force' of the artist in any superstitious or religious manner. Fetish/idols were thought to have been created as objects of superstition. These would be attributed to

a premodern, primitive and unenlightened form of activity, the basis from which non-Western objects were considered as having nothing to do with art. But this facile distinction is made through the same process by which 'art' functioned to represent the modern European-American 'self'. The distinction was altogether contrived in which the anthropomorphism of the non-Western fetish could show the difference between the premodern object and the modern subject. The superstitious object would eventually stand in for the person of 'race'. Nonetheless, the process for representing 'self' and 'race' would become the comparative model, and the way in which Picasso's artistic 'presence' was attributed to his abstract works can be understood as constructed through its contrivance.

Primitivism as a Western aesthetic could not have continued without its illustration through exhibition. It is important to note that Rubin was not writing in the first decade of the twentieth century but in 1984 as the curator of the '"Primitivism" in 20th Century Art' exhibition at the Museum of Modern Art in New York. The exhibition showcased tribal objects next to modernist abstract paintings – pre-eminently works by Picasso, Klee, Gauguin, Ernst and Weber. The theme 'Affinity of the Tribal and the Modern' would seem promising as a new comparative approach to old concepts from the West/non-West binary. Unfortunately, this was not the case as Rubin explains in his catalogue that the 'ahistorical' juxtapositions of the modern and the premodern 'illustrate *affinities* rather than *influences*',(Rubin's italics) and his primary example was Picasso's 'Girl Before a Mirror' (1932) displayed next to the tribal craftwork of the unauthored, undated Kwakiutl mask.[26] The tribal artist was never considered an 'influence' and therefore her/his personification of the inanimate object, as superstition incarnate, would remain separate from the modernist aesthetic. Rubin makes clear why he opposes the idea of a tribal 'influence' and emphasises instead the way in which artists like Picasso 'discovered' non-Western artefacts, paving the way for the new spiritual abstraction in the modernist representation of the individual 'self'.

Rubin states that not unlike all the aesthetic movements in art, there is a 'history of Primitivism', as he thereby explains his efforts to 'understand the Primitive sculptures in terms of the Western context in which modern artists "discovered" them. The ethnologist's primary concern – the specific function and significance of each of these objects – is irrelevant to my topic, except insofar as these facts might have been known to the modern artists in question'.[27] Rather than distinguishing mutual and shared influences of the African, Oceanic and Native American works he selected, Rubin's comparison was discriminating and divisive as he defines 'affinity' from a conceptual and ideographic perspective. Great pains were taken to transliterate the meaning of the word 'primitive' and therefore transvalue

what was understood before as regressive, superstitious practices. Rubin acknowledges the 'pejorative' meaning of the primitive signifier, hailing back to the fetish, totem, icon or animist object, and also referring to non-Western cultures ranging from the Javanese to the Peruvian. However, he ultimately stakes a claim to the stylistic use of the 'Primitive' for describing Western artistic production from the Byzantine and the medieval epochs.

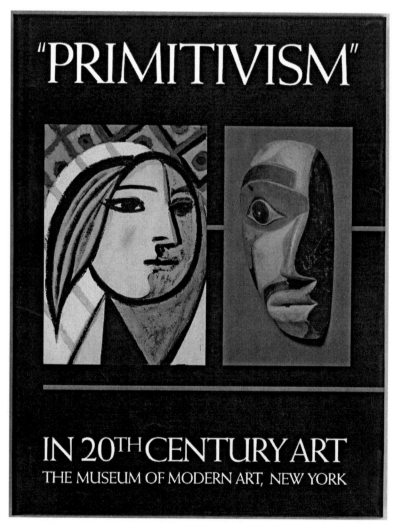

Figure 19. Cover of exhibition catalogue, '"Primitivism" in 20th Century Art: Affinity of the Tribal and the Modern'. New York, The Museum of Modern Art, 1984–1985, courtesy of Digital Image © The Museum of Modern Art / Licensed by SCALA / Art Resource, NY.

By the nineteenth century, the modern Primitivist aesthetic was another innovation of artists such as Van Gogh and Gauguin who 'vaunted the non-Western arts they called 'savage', and as Rubin asserts, 'Primitivism is thus an aspect of the history of modern art, not of tribal art. In this sense, the word is comparable to the French "japonisme", which refers not directly to the art and culture of Japan, but to the European fascination with it.'[28] Modernist Primitivism represents the subject of 'self' of progressive Western culture; whilst the 'primitive' and tribal craftsman represents the premodern, nameless, fetish object of difference.

That is why the paradigmatic shift that came after James Clifford published his important book the *Predicament of Culture* (1988) appears now as something of a hollow restructuring of art history. Clifford's critique of the 1984 '"Primitivism" in 20th Century Art' exhibition functioned to disclose the cultural imperialism that implicated the Museum of Modern art when it conceived of the 'Affinity of the Tribal and the Modern'. The points made by Clifford reveal how cultural meanings were elided and appropriated for the Western art heritage. The contradiction in rewriting the primitive aesthetic to express the modernist 'self' is one in which the comparative terminology functions to perpetuate the language of art and non-art for the regime of objects.

Art historians such as Meyer Schapiro wrote about the nineteenth-century abhorrence of the monstrous primitive in the quest for scientific realism and rationality and the subsequent twentieth-century embrace of the primitive that was due to the 'new valuations of the instinctive, the natural, the mythical as the essentially human… By a remarkable process the arts of subjugated backward peoples, discovered by Europeans in conquering the world, became aesthetic norms to those who renounced it'.[29] This convoluted logic can be reviewed as the neo-colonialist management of cultural/racial difference that Homi K. Bhabha had acknowledged as the 'scene of recognition' in which the unfamiliar is affixed to the familiar, 'a form that is repetitious and vacillates between delight and fear…the play of colonial power as modes of differentiation, defence, fixation, hierarchization'.[30] But to this day, the 'primitive unconscious' is accepted as part of the philosophy of modern abstraction, the style that underlies the primacy of formalist, non-realist tendencies of twentieth-century art. The subjectless painting of abstraction defers to the spiritual aesthetic of the modern 'self' that Wassily Kandinsky articulated so well in 1911.[31] The psychoanalytic terms that Freud conceived for both the valorisation and abhorrence of difference were challenged by Edward Said in 1978 when he finally addressed the European fascination and desire coexisting with anxiety and disavowal toward anything non-European.[32] The ambivalence stemmed from the coloniser's unconscious fear of the animate-power of non-Western objects.

Mitchell argues that this fear of objects emanates from the fear of the person it represents – Fanon's articulation of 'crushing objecthood' extends to Mitchell's assertion that anthropomorphism expresses the 'encounter with the object as Other'.[33] Mitchell moreover suggests that Fried's criticism of anthropomorphism in minimalist art in 'Art and Objecthood' was precisely the defence of the Euro-American aesthetic against the 'influence' of the primitive object of difference: 'We want works of art to have "lives of their own", but we also want to contain and regulate that life, to avoid taking it literally, and to be sure that our own art objects are purified of the taint of superstition, animism, vitalism, anthropomorphism and other premodern attitudes.' Perhaps Mitchell's use of 'we' in his statement reveals further the nature of the problem in the globalist era – what attitudes for the art object can now be considered as 'untainted' when all of the 'West' is diasporic – going back to Araeen's point about art and globalisation?

But the logic for the regime of objects would not have continued into the twenty-first century without the art enterprise and its ability to maintain the money-value of the work of art. Much has been written about the museum's history in establishing the classificatory order that functions in the context of empire, capitalism and knowledge production.[34] But it was the nineteenth-century world's fairs that first introduced the regime of objects according to a hierarchy of nations. The 1851 Great Exhibition of the Works of Industry of All Nations in London instantiated the model for the inventory of empire by juxtaposing objects according to the production of nations – for instance, the showcasing of agriculture would be in one hall while all the fine arts would be shown in the palace. The halls and palaces provided a greater comparative field overall, and as such, the modernist ideals were made tangible by the universal exposition's materialist utopia. Judging by Walter Benjamin's writings on the world's fairs as the 'places of pilgrimage to the commodity fetish', these are the primary displays that affected exhibition value in the nineteenth/early twentieth century.[35] By the turn of the twentieth century, nearly every major city in Europe and the United States had hosted a world exposition, and nearly all of these international shows of progress erected a 'palace' to exhibit the works of fine art.

The way in which art is now defined by cultural aesthetics and practices on the one hand and is classified as a national production on the other was made distinct through the epistemology of modern display. If Winckelmann established a cult ideal for the work of art, Benjamin acknowledged the new terms in which 'exhibition value begins to displace cult value' after the aura of the work of art withers in the age of mechanical reproduction.[36] However, cult value is not so easily relinquished when works of art are juxtaposed next to commodities. The role played by art exhibitions in these spectacles of capitalist production was indeed important in the comparison of commodities

and heritage objects, setting art and industry apart, and creating the binary between art and ethnography as objects are classified by cultures.

The distinctions for subjecthood in which the artist is called upon to represent the 'self' of nation would become very clear under the objectives for exhibiting things as a competitive activity on behalf of the industry of nations. From the beginning, art represented the nation's highest production at the world's fairs, and the ancient Graeco-Judeo-Christian lineages of the Western tradition were simply transcribed into a modernist terminology to function on behalf of the competition. More specifically, the aesthetics inherited from the Classical ideal became a perpetual concept of transcendence for the arts, in which artistic genius connects European origins (Winkelmann's Prussia) to the location, climate, social situation, and habits of the Greeks and the Romans.[37] Whereas Winckelmann actually relocated to Rome from Dresden in order to follow his belief that artistic genius is a national inscription, in the centuries to come, aesthetic affiliation amongst Europe and the United States would enable an uncontested association around the Classical ideal, now defined by the academic category of a 'Western art'. The modern Euro-American subject as 'self' is thereby the inheritor of the Classical subject from antiquity.

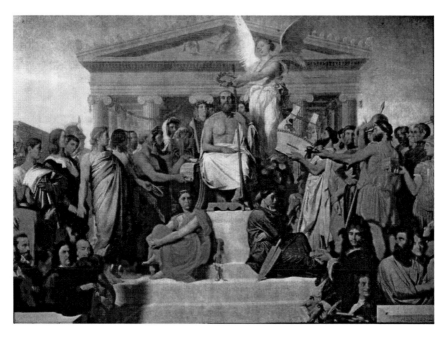

Figure 20. Jean Auguste Dominique Ingres, *Apotheosis of Homer*, 1827. Oil on canvas, 386 × 512 cm. Photo: Thierry Le Mage, courtesy of Réunion des Musées Nationaux / Art Resource, NY.

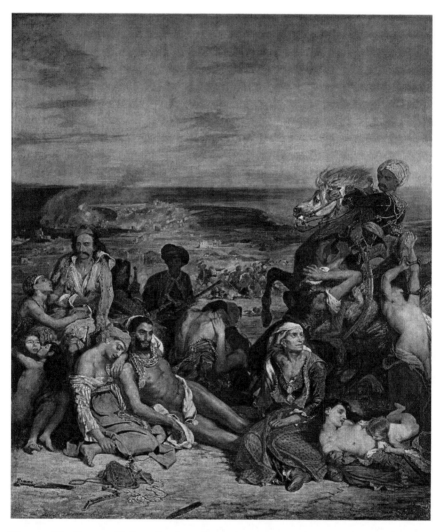

Figure 21. Eugène Delacroix, *Scene from the Massacre at Chios: Greek families awaiting death or slavery,* 1824. Oil on canvas, 419 × 354 cm. Photo: Thierry Le Mage, courtesy of Réunion des Musées Nationaux / Art Resource, NY.

This teleology is still promoted by survey courses in art history as undergraduate curricula.

The prime example of how the aesthetic ideal is transferable occurred as a statement about French national production at the 1855 Paris Exposition Universelle. The French presented a massive fine arts exhibition, including works by the country's 'living' masters Jean Ingres and Eugène Delacroix. Ingres's huge painting, *The Apotheosis of Homer,* was taken down from the

ceiling of the Louvre where it had been housed since its commission in 1827 in order to represent the French artistic tradition at the world exposition.[38] The neoclassical painting tradition served to exalt the French state through the allegory of the painted subject, and in this depiction, Homer is in the process of being crowned like a king whilst sitting atop his pedestal, receiving gifts from his admirers. Invoking the 'apotheosis' of the king was an artistic theme from Hellenistic art, expressly the kind of depiction that heralded the divinity of Alexander the Great, who initiated the cult-god-king iconography of fourth century BCE. Ingres made explicit the analogy of the artist/poet as king when he inscribed on the painting (drawn in the place of the lintel of the temple above the figure of Homer) the saying: 'If Homer is a god, he must be set among the immortals. If he is not a god, he must be made into one'.[39] The narrative is clear: the Classical artistic heritage descends directly from the Greek poet to his mythological enthronement in French painting. The inference of Classical legitimacy in the transference of subjects from one culture to another could not have been missed at the World's Fair. The subject-constituting representation of the 'self' through the 'great' work of art is displayed here for the public at large. And it is the context of the painting in the world's fair inventory of empire that secures the artistic legacy.

But even in 1855, the artist Eugène Delacroix had presented something of a rupture to the neoclassical convention. Citing a symbolic Greek subject, Ingres's painting is confirmation that the artist's technical abilities, the artistic style, the aesthetic sovereignty and the philosophical underpinnings, all culminate to show artistic supremacy. In contrast, Delacroix's contribution to the Universal Exposition, *Scenes from the Massacre at Scios*, depicted a 'real' Greek subject, the 1822 incident in which the Greeks slaughtered thousands of other Greeks and enslaved thousands more because they were resistant to the battle against the Turks in the Greek War of Independence against the Ottoman Empire. For centuries, the Sciotes lived in peace with the neighbouring Turks and did not care to go to war.[40] Delacroix portrayed the *Realpolitik* of the Greek subject that was contemporary to his time period rather than envision the neoclassical Greek past to emulate a glorified French state. The Classical (mythical) Greek subject aligns with Ingres's old school support of the ancient regime in art – borrowing from the apotheosis of the Classical heritage – whilst Delacroix was considered radical, revolutionary and 'realist' in his reflection of the historical Greek against Greek violence that paralleled the 1789 French Revolution. As Derrida points out, 'the question of mimesis or of the referent' marks the critical difference, which is altogether pertinent to the comparison of these two paintings. For in Ingres's painting, the perfect copy is all about development of style, the invocation of aesthetic achievement, and the floating signifier of

the Greek subject of mythology. In Delacroix, the referent is constituted by the subject of those people who really died at Scios in 1822.

Placed together at the 1855 Paris exposition, Ingres's Classical Greek subject was obviously a fantasy in relation to Delacroix's documentary record of the Greek massacre. Nonetheless, the neoclassical heritage triumphs as the 'Western' inheritance of artistic tradition, its construction in art history continues unapologetically to this day. This all-consuming textual production also continues to elide the place of 'modern Greece' in which the comparative paradigm in literature, according to Rey Chow, consigns the 'non-Western' to remain a mere abbreviation of 'Europe and Its Others'. Chow explains that it is not so much a matter of 'taxonomic addition or inclusion', rather, 'it designates a relation of temporality, with Europe being experienced not exactly spatially as a chartable geographical location but much more as a memory, a cluster of lingering ideological and emotional effects whose force takes the form of a lived historical violation, one that preconditions linguistic and cultural consciousness'.[41] The contemporary Greek cultural consciousness is especially elided since it is always already subsumed by the European fantasy of the Classical Greek.

The objective of the 1855 exposition, however, was to present a united front in the global competition of world's fairs. France's greatest industry was French painting, and as such, both Ingres and Delacroix were never at odds since they fulfilled the aims of the State sponsored exhibition. Ultimately, suggests Benjamin, the function of the work of art is in the service of politics when exhibition value supplants cult value, since, as he had perceived in the 1930s: 'by the absolute emphasis on its exhibition value the work of art becomes a creation with entirely new functions, among which the one we are conscious of, the artistic function, later may be recognized as incidental'.[42] In hindsight, both exhibition and cult value enabled the nationalist formation of a powerful Western art category during the nineteenth century. In this way, the classificatory display of visual objects – through their comparisons as representatives of nations – secured a long-lasting knowledge production in which 'seeing is believing' gives credence to the 'scopic regimes' that art historians have studied to great lengths as the critical influence of nineteenth-century visual culture.

The objecthood of empire, however, makes visible and tangible the artistic subject as 'self' who is ultimately subsumed into the 'Western art subject'. The overarching subjecthood of 'self' and nation continues in such a way that resists acknowledgment of the globalist subject existing in present-day Europe or the United States. Instead, the transhistorical norm of the Western aesthetic is a condition of necessity for supporting the art industry within the capitalist system. As introduced earlier in this essay, the circuit of cultural capital has no

comparisons since cultural heritage obfuscates the exchange among collectors, auction houses and museums through investments and endowments that actually consist of money-profit for someone other than the artist. The scale of the enterprise can be viewed by the record year for sales in the 2011 art market in which Picasso prevails as the model representative since his painting, 'La Lecture' (1932), sold for forty million at auction, ten million over the pre-sale estimate.[43] The auction houses Christies and Sothesby flourished in 2011 at a time when austerity measures proliferated in governments around the world as the threat of debt-defaults further extended the global financial crisis. In the aftermath of the 2008 inception of the crisis, the irony of Lehman Brothers selling off their art collection (for 12.3 million) to pay off their creditors in bankruptcy is in the perception that the banking industry not the art industry was considered 'too big to fail'.[44] The stakes are enormous for maintaining the interconnections of museology which are now associated to globalisation's 'massively effective organization of views', as described by art historian Donald Preziosi, and these conceptions correspond to the 'auxiliary discursive practice, art history'.[45] The cult value and exhibition value of Western art continue to depend on art history's timeless aesthetic concepts, organising principles and exhibitionary practices.

The impending crisis felt by those who fear the crumbling of a monolithic art history, however, is never overtly connected to the art industry that is 'too big to fail'. Etiemble reminds us that what we understand about art history is dependent on the body of literature in such a way that 'Panofsky's *Iconology* confirms that literature very often sheds light on paintings or statues that, in the absence of any reference to the texts that found them remain unintelligible.'[46] In this way, Preziosi has long contributed to the critique of a discipline that is in need of radical re-invention. Still, under the intransigent system of art history, there can never be a comparative visuality that compares to comparative literature because of the inextricable connection between cultural capital and money capital in the institutions of art. By contrast, if comparative literature has succeeded to render obsolete the nationalist boundaries for the literary object, does that not mean that literariness is expanded by cultural influences rather than suffering a loss, as Derrida suggests? In his essay entitled 'Who or What is Compared? The Concept of Comparative Literature and the Theoretical Problems of Translation' (1979), Derrida was making his point about the 'paranoiac structure' of comparative literature's 'encyclopedic rationality', describing comparative literature as a 'wandering discipline, as delirious as it is bulimic in an unbridled encyclopedism'.[47] Derrida argues that the encyclopaedic logic for the comparativist as the generalist, in which 'the entire world would become an immense department of comparative literature', should really be understood as the definition of the 'Universitas itself, the

unified, centralized, state-controlled organization on the global level'.[48] The totalising logic aligns with old modernist ambitions for a philosophy of absolute knowledge, and historically, the danger of centralised knowledge was in its co-optation for fascist objectives. But the encyclopaedia was originally conceived as a literary compilation of objects for which Etiemble argues the merits of the universal bibliography that supports the broadest literary relations among music, architecture and poetry, 'since the history of literature and of the arts are inseparable from the evolution of the sciences, technology, religion'.[49] To Etiemble, the expansion of knowledge can only come from relinquishing the borders for art.

As for visual art comparisons and juxtapositions, the question is, if comparative literature succeeds as the shared scholarly space for reading across cultures, supporting readers of literary objects that express on multiple planes, no one ever questions what might work for the viewers of artistic objects that function outside of the Western/non-Western binary. At the end of a dialectic for cultural juxtapositions, the need is to find a new kind of vocabulary that can serve to interpret multiple aesthetics without recourse to comparison. Or, at least, provide a comparison that does not resort to hierarchical dispositions.

Notes

1 Jacques Derrida, 'Who or What Is Compared? The Concept of Comparative Literature and the Theoretical Problems of Translation', *Discourse*, 30.1/2, (2008), 22–50 (p. 30).
2 Johann Joachim Winckelmann, 'History of Ancient Art' in Eric Fernie, *Art History and its Methods* (London: Phaidon, 1995), p. 74.
3 W. J. T. Mitchell, *What Do Pictures Want?: The Lives and Loves of Images* (Chicago: University of Chicago Press, 2005), p. 147.
4 Laura Mulvey established the Lacanian terminology for feminist analysis in her landmark essay 'Visual Pleasure and Narrative Cinema,' *Screen*, 16.3 (1975), 6–18. Also, Martin Jay surveys the perspectives in art history that distinguishes the 'scopic regime' in 'Scopic Regimes of Modernity', in *Vision and Visuality*, ed. by Hal Foster (Seattle: Bay Press, 1988), 3–28.
5 Mitchell, *What Do Pictures Want?*, p. 155.
6 Derrida, 'Who or What Is Compared?', p. 33.
7 *Art and Globalization*, ed. by James Elkins, Zhivka Valiavicharska and Alice Kim (University Park, PA: Pennsylvania State University Press, 2010).
8 Ibid., p. 138.
9 See for instance Emily Apter, 'Afterlife of a Discipline', *Comparative Literature*, 57.3 (2005), 201–6 (p. 203).
10 Rey Chow, 'The Old/New Question of Comparison in Literary Studies: A Post-European Perspective', *ELH*, 71 (2004), 289–311 (p. 290).
11 Susan Bassnett, *Comparative Literature: A Critical Introduction* (Oxford: Blackwell), p. 5.
12 Cited in Derrida, 'Who or What Is Compared?', p. 32.

13 Douglas Johnson, 'René Etiemble, Leading the fight against the threat of Franglais', *The Guardian*, 31 January 2002. The professor who believed in the advancement of comparative literature supported the Islamic scholar Taha Hussein in developing French studies in Alexandria, and he was also known for his research on pre-Columbian civilisation in Mexico.

14 Derrida, 'Who or What Is Compared?', p. 35.

15 Whitney Davis, 'The Subject in the Scene of Representation', *Art Bulletin*, 76.4 (1994), 570–75 (p. 574).

16 Ibid., p. 571.

17 Chow, 'The Old/New Question of Comparison in Literary Studies', p. 304.

18 Frantz Fanon, *Black Skin White Masks*, trans. by Charles Lam Markmann (London: Pluto Press, 1993), p. 109.

19 Chow, 'The Old/New Question of Comparison in Literary Studies', p. 304.

20 Frantz Fanon, *Black Skin White Masks*, p. 112.

21 Kaja Silverman, *The Threshold of the Visible World* (New York and London: Routledge, 1995), p. 29.

22 Mitchell, *What Do Pictures Want?*, p. 34.

23 Ibid., p. 29.

24 Pierre Bourdieu, 'The Historical Genesis of a Pure Aesthetic', *The Journal of Aesthetics and Art Criticism*, 46 (1987), 201–10 (p. 202).

25 *Primitivism and Twentieth-Century Art: a Documentary History*, ed. by Jack Flam (Berkeley: University of California Press, 2003), p. 329.

26 Ibid., p. 326.

27 Ibid., p. 316.

28 Ibid., p. 319.

29 Meyer Schapiro, *Modern Art, 19th & 20th Centuries* (New York: Braziller, 1978), p. 200 and p. 201. Schapiro's study acknowledges the diversity of modern artists who in their adoption of primitivism were indifferent to the 'material conditions which were brutally destroying the primitive peoples or converting them into submissive, cultureless slaves' in contrast to those who justified their 'ethical and metaphysical standpoints' by making complicit the 'preceding style as the counterpart of a detested social or moral position': Schapiro, *Modern Art*, p. 202.

30 Homi K. Bhabha, *Location of Culture* (New York and London: Routledge, 1994), p. 105.

31 Wassily Kandinsky, *Concerning the Spiritual in Art* (1914) (Boston: MFA Publications, 2006).

32 Edward W. Said, *Orientalism* (New York: Pantheon Books, 1978).

33 Mitchell, *What Do Pictures Want?*, p. 149.

34 See for instance Tony Bennett, *The Birth of the Museum: History, Theory, Politics* (London: Routledge, 1995). Also, Donald Preziosi and Claire Farago, *Grasping the World: The Idea of the Museum* (London: Ashgate, 2004).

35 Walter Benjamin, 'Paris, Capital of the Nineteenth Century: Exposé (of 1939)', in *The Arcades Project*, ed. by Rolf Tiedemann (Cambridge, MA: Harvard University Press, 1999), p. 17.

36 Walter Benjamin, 'The Work of Art in the Age of Mechanical Reproduction' (1935), *Illuminations*, ed. by Hannah Arendt and trans. by Harry Zohn (New York: Schocken Books, 1969), p. 227.

37 See Fernie, *Art History and its Methods*, p. 68.

38 Patricia Mainardi, *Art and Politics of the Second Empire: The Universal Expositions of 1855 and 1867* (New Haven: Yale University Press, 1987), p. 152.

39 Hans Belting, *The Invisible Masterpiece* (Chicago: University of Chicago Press, 2001), p. 96.

40 See Albert Boime, *Art in an Age of Counterrevolution 1815–1848* (Chicago: University of Chicago Press, 2004), pp. 204–5.

41 Chow, 'The Old/New Question of Comparison in Literary Studies', p. 305.
 Benjamin, 'The Work of Art in the Age of Mechanical Reproduction', p. 227.

42 See Jim Boulden and Laura Allsop, 'Picasso Sells for $40 Million in Austerity-Proof Art Market,' *CNN International Edition*, 9 February 2011.

43 <http://edition.cnn.com/2011/BUSINESS/02/08/auction.sales.london/index.html> [accessed 9 September 2011].

44 See Lindsay Pollock, 'Lehman $12.3 Million Art Sale Picks 'Long Way Home' Over Hirst,' *Bloomberg Businessweek*, 27 September 2010. <http://www.businessweek.com/news/2010-09-27/lehman-12-3-million-art-sale-picks-long-way-home-over-hirst.html> [accessed 9 September 2011].

45 Donald Preziosi, *The Art of Art History: a Critical Anthology* (Oxford: Oxford University Press, 2009), p. 488.

46 Cited in Derrida, 'Who or What Is Compared?', p. 32.

47 Ibid., p. 30.

48 Ibid., p. 31 and p. 33.

49 Ibid., p. 32.

Chapter 9

EXPLORING IN-HUMANITY: GERTRUDE STEIN'S *TENDER BUTTONS* AND STILL-LIFE PAINTING

Nandini Ramesh Sankar

Cornell University

Gertrude Stein (1874–1946) composed her 'verbal still lifes'[1] in *Tender Buttons*[2] in explicit dialogue with the Post-Impressionist – particularly Cubist – uses of the still life. The utter obviousness and universal givenness of its referents have made it the genre least requiring exegesis or special attention. This leanness best explains the fascination it exerted upon the Modernists: devoid of subjective intrusions and emptied of traditional symbolic associations, it was best suited to express the 'pure' and fundamental components of visual composition. But even in its most abstract and formalist moments, the still life continues to harbour the disruptive plenitude of the non-human as that which provides the ground for the appearance of the human. I argue that Stein's *Tender Buttons* designates the still life as a space for alternative and possible forms of being human. Rather than being deliberately nonsensical or opposed to subjectivity as such, *Tender Buttons* remains cognizant of the inevitability of a subject whose every act of interpretation and inscription also constitutes self-interpretation and self-inscription. At the same time, it explores the possibility that the realm of things – rendered objects by the positing of the subject – might in fact offer the most congenial space for the recuperation of what is not yet or no longer human.

Still lifes tend to accommodate both strangeness and familiarity in equal measure. The objects depicted are types rather than unique individuals, and their commonness makes them easy to replicate and possess. While still lifes often represent rare and expensive objects – the opulence of seventeenth-century Dutch still lifes comes to mind – the painting remains concerned with types rather than particulars, with the common rather than the proper. Since the metaphysical categories that house these generic objects ensure against

their loss, still life paintings affirm the world of middle class possessions.[3] On the other hand, the erasure of the subject from the picture plane can suggest the possibility of a world of objects that are independent of the subject. In spite of the reassuring fact that objects represented usually bear the imprint of human manufacture or at least capture, the sinister moment of the still life – eloquently described by Norman Bryson in *Looking at the Overlooked*[4] – persists as the threat of a self-sufficient object that has in effect become the subject. Hence the terror of alienation and the comfort of familiar presences constitute the affective poles between which the experience of viewing a still life oscillates. Individual still lifes have frequently flaunted their strangeness long before the twentieth century: one only has to compare Juan Sanchez Cotan's still life presently housed in the San Diego Museum of Art, entitled *Quince, Cabbage Melon and Cucumber* (1602) – whose shallow spaces contain suspended vegetables etched with surrealistic precision against a black background – with Jean Baptiste Simeon Chardin's still life, *The Silver Goblet* (c. 1728) from the Musée du Louvre, Paris, softened as they are by the gentle mystique of the bourgeois interior, to experience this strangeness.

By lavishing minute attention on the everyday object, the still life painting effectively transforms it, since the everyday object is, by definition, that from which attention is withheld.[5] On the other hand, art invites the exercise of attention, and is to that extent the very opposite of the common object: the art of still life thus has an oxymoronic quality to it. The strangeness of the still life as a genre arises from the incommensurability of the common object and the privileged context of its appearance as art: still life painting thus constitutes a challenge to both artistic and metaphysical hierarchies. Still life painters of the seventeenth century had already recognised that the subject matter of the still life is closest to the object of the painting itself since a painting of a painting would be a still life. Cornelis Gijbrechts's *Reverse Side of a Painting* (1670) presently exhibited in the State Museum of Art, Copenhagen, for example, acknowledges the material reality of the painting as a thing on par with other things. But its playful hyperrealism also advertises its nature as an artefact, so that its ironic and canny presence almost – but not quite – compensates for the absence of the human figure.[6] The eclipsing of the human figure without erasing the possibility of agency and affect thus makes the still life ideal for Cubist experiments in forms of artistic agency grounded in the materialities of canvas and paint.

In *The Autobiography of Alice B. Toklas*, Stein describes her attempt to represent the visible, 'outside' world in painterly terms: 'She always was, she always is, tormented by the problem of the external and the internal. One of the things that always worries her about painting is the difficulty that the artist feels and which sends him to painting still lifes, that after

all the human being essentially is not paintable.'[7] Stein imagines the still life here as a refuge for the painter from the rigours of – and possible taboo against – representing the human figure. The essence of the human being, Stein implies, is its resistance to representation: this view certainly modifies the confident taxonomy of humanity that Stein undertakes in *The Making of Americans*, the book that immediately preceded *Tender Buttons*.[8] In the same paragraph in *Autobiography*, she adds: 'if you do not solve your painting problem in painting human beings you do not solve it at all'.[9] As that which cannot be represented, the human being both describes the limits of representation and invites the transgression of those limits. Stein's turn towards objects in *Tender Buttons* can be interpreted as a moment of necessary distraction in her pursuit of the human portrait:

> No, she stayed with her task [of making portraits], although after the return to Paris she described objects, she described rooms and objects, which joined with her first experiments done in Spain, made the volume *Tender Buttons* [sic]. She always however made her chief study people and therefore the never ending series of portraits.[10]

This account of the writing of *Tender Buttons* is thus flanked on both sides by an affirmation of Stein's commitment to producing verbal representations of human individuality.

Yet there is also evidence that the distinction between portraiture and still life is somewhat complicated by the artistic technique of abstraction. Cézanne's famous injunction to reduce figures to simple geometrical shapes suggests the possibility, often discreetly but also sometimes stridently declared by still lifes, that both animate and inanimate objects can be constructed from the same basic shapes. Hence formal simplification and abstraction negate to a certain extent the distinction between subject and object. This tendency is clearly visible in the so-called analytic period of Cubism, where still lifes and portraits look very much the same, and the portraits seem to have none of the advantages that realistic portraits, with their interest in crystallising the drama of an individual life into a single physical materialisation, have traditionally had over still lifes (See the distinction between Georges Braque's *Violin and Pitcher* (1910) (Kunstmuseum Basel) and his *Man with a Guitar* (1911) (The Museum of Modern Art, New York.). But one can see this even earlier, in Stein's account of Picasso's portrait of herself in *The Autobiography of Alice B. Toklas*.[11] The painting began as a continuation of the realism of Picasso's blue and pink periods. After about ninety sittings, Picasso painted out Stein's head, complaining that he could not see Stein any longer when he looked. Picasso later painted

the head and face in Stein's absence, and both Stein and Picasso declared themselves pleased with the results. Picasso had, famously, painted a mask-like face upon the more traditionally executed torso, reducing (or perhaps distilling) the face into an immobile object, as can be seen in his *Portrait of Gertrude Stein* (1906), exhibited presently at the Metropolitan Museum of Art in New York. This form of abstraction, which masks and obscures traditional personhood, can arguably endow the unique but evanescent human individual with the fungibility, and the resulting transhistorical endurance, of the inanimate object.[12]

Stein herself, it seems, could interpret/misinterpret human figures as still lifes. Picasso relates the following story about Stein's response to *Three Musicians* painted in 1921 as a warning to those who try to understand paintings intellectually: 'People who try to explain pictures are usually barking up the wrong tree. Gertrude Stein joyfully announced to me the other day that she had at last understood what my picture of the three musicians was meant to be. It was a still life!'[13] Clearly, Picasso was unimpressed by Stein's epiphany. The eponymous three musicians, while painted in the flat collage style of synthetic cubism, have been generally identified as Picasso, Apollinaire and Max Jacob, and the pair of very similar paintings,[14] both called *Three Musicians*, was completed soon after Apollinaire's death and Max Jacob's entering a monastery. The harlequin represents Picasso, with Apollinaire as the white-clad Pierrot, and Jacob as the monk. But when one compares this painting to the realistic human figures of Picasso's so-called 'classical phase' that is about to commence, the figures of the musicians mimic the flatness of the canvas rather than the three-dimensionality of the human figure. What the painting achieves, among other things, is a representation of the human figure purely in terms of types: not only the swathes of flat colour, but the costumes and masks under which the faces of the figures are concealed present human individuals as types. In the face of the transience of human lives and relationships, Picasso presents himself and his friends as enduring stereotypes from the Italian *commedia dell'arte* tradition. If this painting is a still life, as Stein claimed, then still life enacts a simultaneous erasure and immortalisation of identity by dislocating it within the order of the common. Stein's own verbal still lifes in *Tender Buttons* point to a form of abstraction and strangeness that resist interpretation; yet human presences gleam through the dense thickets of its language. The book is divided into three sections: 'Objects', 'Food' and 'Rooms', and the first two sections consist of short, individually titled pieces that one might, following Stein's own nomenclature, call poems. Though the level of linguistic opacity in the poems has often been exaggerated by those who claim Stein for postmodernism,[15] there is no doubt that *Tender Buttons* makes palpable

the concreteness of language by being inhospitable to conventional ways of making meaning. I will discuss here a small poem titled 'A Dog', which appears in the section 'Objects':

> A little monkey goes like a donkey that means to say that means to say that more sighs last goes. Leave with it. A little monkey goes like a donkey.[16]

The presence of a dog among still lifes is not particularly anomalous; dogs often appeared among more traditional still life motifs as another prized object of the owner, as in the case of Juan van der Hamen's *Still Life with Flowers and a Dog*, or as an animate but non-human complement to the array of dead animals and birds in still lifes depicting kitchens or butchers' shops.[17] It is also significant that the version of Picasso's *Three Musicians* in the New York Museum of Modern Art contains a half hidden image of a dog: another reason, perhaps, for Stein's conclusion that the painting was a turning away from, rather than the confrontation of, the human figure.

In 'A Transatlantic Interview' (1946), she explains the poem to her interviewer thus: 'That was an effort to illustrate the movement of a donkey going up a hill, you can see it plainly'.[18] This explanation might indicate that we should perhaps search for the uphill movement of the donkey in the cadences of the poem, or visualise the three sentences of the poem as a hill with long slopes on either side of a narrow apex. Naturally, Stein might say, the climb uphill is slower and more laborious than the descent downhill, so the first sentence has to be longer than the third. 'Donkey' and its near-homophone 'monkey' traverse the sentences, inaccurately echoing each other through the similitude afforded by rhyme. Here we have a fine example of modernism's formalist hermeticism, and a mode of representation that is faithful to the materiality and logic of language rather than of the world of objects. This purity of form – to follow what might well be Stein's logic here – makes the poem essentially a still life: it has eliminated the temporal certainties of syntax to create a playful moment of heightened insignificance.

In the essay 'Portraits and Repetition' however, Stein cites this poem as an instance of her attempt to write without remembering.[19] What, one might wonder, was Stein trying not to remember while writing this poem, which she claims is about an upwardly mobile donkey? The 'story' behind this poem, I argue, can be found in a passage in *The Autobiography of Alice B. Toklas* (1936), which describes a particular incident that occurred while Stein visited Granada for the first time:

> [Gertrude and Leo Stein] had a delightful time and she always tells of sitting in the dining room talking to a bostonian [sic] and his daughter when suddenly

there was a terrific noise, the hee-haw of a donkey. What is it, said the young bostonian trembling. Ah, said the father, it is the last sigh of the Moor.[20]

While revisiting Granada with Toklas – this visit coincided with the composition of *Tender Buttons* – it is likely that Stein was reminded of her first visit to Granada in the company of her brother, and particularly of the incident that became one of her favourite anecdotes: the story of the donkey's bray, which she also repeats in *Everybody's Autobiography*.[21] Many of the words in the story – donkey, Moor, last, sigh – are repeated in the poem, and the punch line of the anecdote is particularly well preserved: 'more sighs last goes'. The only proper noun in the anecdote – 'Moor' – is transformed in the poem into the adverb 'more'.

The source of many of the other words in the poem lies in the much more public domain of historical fact. Since Stein's earliest reading included a vast quantity of history, it is highly probable that she may have come across Washington Irving's version of 'The last sigh of the Moor' in *A Chronicle of the Conquest of Granada* (1897).[22] Boabdil, (in Arabic, Abu-Abdullah) nicknamed *el chico*, or 'the little one', was the last Moorish king to rule Granada. In the spring of 1491, King Ferdinand V of Castile besieged Granada, and after a spirited resistance, Granada fell on 2 January 1492. 'The last sigh of the Moor' is both an act and a place: the term refers to the name of the hill from which Boabdil looked at Granada for the last time before he went into exile, as well as his last gesture before leaving.[23] The 'little' in 'A little monkey goes like a donkey' suggests Boabdil, who is introduced by Irving as 'Boabdil el Chico' or 'Boabdil the Little One',[24] and the phrase 'leave with it' remembers his exit from Granada. The reduction of the proper name to the nickname – 'Boabdil' to 'little' – inverts the transformation of 'Moor' into 'more'. Thus the donkey whose bray is the last sigh of the Moor goes up the hill like Boabdil leaving Granada. The title of the poem – 'A Dog' – also gains significance in this context, since it is an anagram for 'dago', a common American term used to refer to darker-skinned Europeans, particularly Spaniards, Italians and the Portuguese.

Stein's deliberate forgetting of these details parallels the general Modernist tendency to evacuate art of subjectivity in order to attain monumentality. I have tried to show, however, that the common-noun format of her poem is not entirely devoid of the memory of the proper for the determined and assiduous reader. To the extent that Stein's work focuses upon its own linguistic materiality rather than its translatability into other orders of experience or being, it accedes to Picasso's own notion of art as obdurately resistant to explanation. The work of art then becomes an object that discourages further acts of representation, and therefore becomes analogous

to the unrepresentable human subject. Yet Stein's modernism requires that the impossibility be confronted and overcome: her poem succeeds in making the accidents of biography both present and absent at the same time. *Tender Buttons* experiments with the possibility of a mode of being human that is not dependent on any form of special pleading; private experience, public knowledge, animals and everyday objects produce an inversion that struggles against its own rectification.

Forgetting, thus, could be a species of remembering, and the still life a species of portraiture. While Stein's verbal portraits set off from the particularity of the named human individual, her still lifes explore the essence of particularity within the order of the generic. Stein's thing-poem, which attempts to forget one of her stronger memories, releases personal significance into the realm of public and de-particularised meanings, only to reassert the claim of particularity in the singular enigma of the poem itself. Her curious misreading of Picasso's *Three Musicians* as a still life suggests that for her, the still life is not the absence of the human figure, but the simplification of the human realm of memory and anecdote into the order of anonymous, common objects that foreground the stark particularity of the work of art, which can in turn constitute an oblique expression of the human subject. The mute significance of things offers a refuge from the limitations of known selfhood, so that the still life can constitute a form of self-knowledge that is predicated upon an utter estrangement from the self. If the experience of otherness is the affective indicator of the truly proper, the still life – as Stein's contemporary Frances Hodgkins realised – constitutes the most authentic self-portrait, since it suggests human presence without capitulating to the lure of naming and description.

Notes

1 Several critics have freely used the term 'verbal still lifes' (see, for instance, Jane P. Bowers, *Gertrude Stein*, Women Writers (New York: St. Martins, 1993), p. 2) to describe the textual curiosities that compose *Tender Buttons*. This particular phrase, which is absent in Stein's own writings, grants precedence to the painterly art by identifying the verbal still life as a subset of still life proper, which is non-verbal. Though Stein acknowledges the influence of Cézanne upon her work, she never concedes any superiority or priority to painting as an art. In fact, she often refers to Picasso's painting as a version of writing. See Gertrude Stein, *Picasso* (Beacon Hill: Beacon, 1938; repr. 1959), p. 46.

2 Gertrude Stein, *Tender Buttons*, in *Selected Writings of Gertrude Stein*, ed. by Carl van Vechten (New York: Random House, 1962), pp. 459–509.

3 This is true even of those paintings placed under the category of 'vanitas': the inclusion of traditional symbols of mortality, such as skulls, clocks, insects and decaying fruit simultaneously delivers to the viewer a solemn warning of his/her own dissolution, the faceless generality of the skull indicates the commonness of the experience of death, as well as the real source of particularity, which is the immortal soul.

4 See Norman Bryson, *Looking at the Overlooked: Four Essays on Still Life Painting* (Cambridge, MA: Harvard University Press, 1990), which is the only extended theoretical treatment of the genre. He argues that in still life we never see the human form at all. Still life negates the whole process of constructing and asserting human beings as the primary focus of depiction. Opposing the anthropocentrism of the 'higher' genres, it assaults the centrality, value and prestige of the human subject. Physical exclusion is only the first in a series of negations of the kinds of human-centred dignity we are used to finding in the other genres. Removal of the human body is the founding move of still life, but this foundation would be precarious if all that was needed to destroy it were the body's physical return: the disappearance of the human subject might represent only a provisional state of affairs if the body is just around the corner, and likely to re-enter the field of vision at any moment. Human presence is not only expelled physically: still life also expels the values which human presence imposes on the world (p. 60).

5 Hence Heidegger's emphasis on van Gogh's painting of boots derives from the fact that the painting, rather than the object itself, makes available to consciousness the world that congeals around the shoes. See Martin Heidegger, 'The Origin of the Work of Art', in *The Continental Aesthetics Reader*, ed. by Clive Cazeaux (London: Routledge, 2000), pp. 80–101.

6 It also recognises the commodification of art in an increasingly bourgeois context: the piece of paper tacked on to the back of the canvas displays its price. The painting, incidentally, refers to the fact that some of the earliest still lifes, like Hans Memling's late fifteenth-century painting of flowers, were executed on the reverse sides of canvases.

7 Stein, *The Autobiography of Alice B. Toklas* in *Selected Writings of Gertrude Stein*, p. 112.

8 Gertrude Stein, *The Making of Americans* (New York: Something Else, 1966).

9 Stein, *The Autobiography of Alice B. Toklas*, p. 112.

10 Ibid., p. 112.

11 Ibid., pp. 42–53.

12 Bryson describes the ordinary object as essentially timeless and indestructible: 'Everything that is presently made is only a replica or variant of a previous object, and so on back into the abyss of time and the rubble of archaeology. The objects themselves dictate to matter the forms of their replication; the individual user only repeats the gestures it encodes. And the objects go on existing outside the field of human consciousness, yet with no diminution of the powers stored within them' (Bryson, *Looking at the Overlooked*, p. 144).

13 *Picasso on Art: A Selection of Views*, ed. by Dore Ashton (New York: Viking, 1972), p. 23.

14 One is housed in the Museum of Modern Art and the other in the Philadelphia Museum of Art.

15 See, for instance, Harriet Scott Chessman, *The Public Is Invited to Dance: Representation, the Body and Dialogue in Gertrude Stein* (Stanford, CA: Stanford University Press, 1989), Ellen E. Berry, *Curved Thought and Textual Wandering: Gertrude Stein's Postmodernism* (Ann Arbor: University of Michigan Press, 1992), and readings of Stein by poets belonging to the L=A=N=G=U=A=G=E group.

16 Stein, *Tender Buttons*, p. 474.

17 Charles Sterling notes that live animals were included along with still lifes in ancient Greece: 'Objects are often accompanied by live animals. Birds, barnyard fowl, rabbits, dogs and cats were shown nibbling at food, as if 'to suggest their savor.' Sometimes the animals introduced an amusing note of anecdote by contending against each other, just as they appeared later in Flemish still lifes of the seventeenth century, those of Snyders

and Fyt, for example. Charles Sterling, *Still Life Painting from Antiquity to the Present Time*, trans. by James Emmons (New York: Universe, 1959), p. 12.

18 Gertude Stein, *A Primer for the Gradual Understanding of Gertrude Stein*, ed. by Robert Bartlett Haas (Los Angeles: Black Sparrow, 1971), p. 24.

19 Gertrude Stein, *Writings and Lectures 1909–1945*, ed. by Patricia Meyerowitz (Baltimore: Penguin, 1971), p. 112.

20 Stein, *The Autobiography of Alice B. Toklas*, p. 111.

21 Gertrude Stein, *Everybody's Autobiography*, (New York: Random House, 1937). This version replaces 'bostonian' with 'American': "'I can always remember'", Stein says, 'when we were the first time in Granada my brother and I and there was an American there and his daughter and there was a fearful sound and she said what is it and he said it is the last sigh of the Moor. It was a bray of a donkey of course and if one has never heard it it is a fearful thing': *Everybody's Autobiography*, p. 108.

22 Washington Irving, *A Chronicle of the Conquest of Granada* in *The Works of Washington Irving*, 40 vols (New York: Collier, 1897), III.

23 In Irving's words: 'Having rejoined his family, Boabdil set forward with a heavy heart for his allotted residence in the valley of Purchena. At two leagues' distance the cavalcade, winding into the skirts of the Alpuxarras, ascended an eminence commanding the last view of Granada. As they arrived at this spot, the Moors paused involuntarily, to take a farewell gaze at their beloved city, which a few steps more would shut from their sight forever…. The unhappy monarch. . .was not to be consoled; his tears continued to flow. 'Allah Achbar!' exclaimed he; 'when did misfortunes ever equal mine?' From this circumstance, the hill, which is not far from the Padul, took the name of Feg Allah Achbar: but the point of view commanding the last prospect of Granada is known among Spaniards by the name of *El ultimo suspiro del Moro*; or, 'The last sigh of the Moor': Irving, *A Chronicle of the Conquest of Granada*, p. 415.

24 Ibid., p. 79.

Chapter 10

RE-DEFINING ART: MANUEL RIVAS' *MUJER EN EL BAÑO*

Ana-María Medina

Metropolitan State College of Denver

'A la manera de Camus, no es la lucha lo que nos obliga a ser artistas, sino el arte que nos invita a ser luchadores. Caravaggio definía a los verdaderos artistas como *valenthuomi*. Y así han de ser. No bravucones, pero si valientes… Los ojos reconocen de inmediato la luz extra de la valentía. Los ojos son cleptómanos. Carece de importancia que el cuadro tenga propietario si pueden acceder a él… Cuando se injerta en el espino de la vida, el cuadro renace y pide hablar. Los colores, las líneas, las formas, se descomponen en palabras que llevan memoria en los hombros del lenguaje'.

—Rivas, *Mujer en el baño*[1]

In the twenty-first century Manuel Rivas becomes the most promising Galician author at the commercial level not only in Spain but worldwide. His position in the Galician literary panorama is consolidated as the result of the well merited awards received for his work, his cultural and political participation in Galicia, as well as his efforts in educating citizens abroad from countries all around the world. Through his works he has known how to take Galician culture to the world by-passing the boundaries of language/culture without forfeiting his assessment of Galicia as a culturally indigenous country that deserves a position and recognition within the Spanish literary canon. If in fact, his major works present the traditional history of life in Galicia during the Civil War; one not only encounters the intellectual figure but also the marginalised: the mother, the guerrillas or *maquis*, the prostitute, the poor, the defeated and the homosexuals. In the same manner, his characters inhabit spaces where fable and the world that we know intertwine providing the union between the ancestral Galician mythical space and the modernity that now surrounds it.

In general, literary production for the mass public in the twentieth century and the introduction of other discursive media – television, radio and internet – influence what is popularised in the civic sector. Technological innovations reshape the dynamics of social organization the economy and urban spaces where interpersonal relationships are forged. These processes occur as part of worldwide globalisation where social, economic and political relationships between people are unrestricted by territorial barriers and span the entire planet.[2] This causes invalidation of the artistic frameworks set by modernity and hence the emergence of a process of rediscovery that leads to postmodernism. On a global level, social processes change drastically resulting in a lack of self-existence provoking a cultural awakening known as 'Glocalization' and defined as:

> The coming together of local cultures whose content has to be redefined when local cultures encounter the forces of globalization. It is the process of a world-wide re-stratification, in the course of which a new social-cultural hierarchy, on a world-wide scale is put together.

The events of glocalization are highlighted in the essence of the numerous postmodernisms (post-history, post-novel, post-rhetoric, post-isms, etc):[3] 'all seem to transcend what they see as the self-imposed limitations of modernism, which in its search for autonomy and purity or for timeless, representational, truth has subjected experience to unacceptable intellectualisations and reductions'.[4] Upon transcending the limitations of modernism there is a new direction towards different aesthetic dimensions and narrative themes that had been previously unexplored or forgotten. Similarly, there is a rebirth in which the peripheral and the factual are placed in the centre where they are fused with the past to update/rediscover/recreate. In the current era, authors, as well as readers, suffer a crisis of representation and identity. As responses to the state of insignificance they make use of the text to tread into the new essences of identities which serve as archetypes to the new social imaginaries:

> Postmodernist writers, faced with a crisis of representation, in which the text becomes more important than the reality to which it alludes, find ways to make this productive. A key element to this new emphasis on textuality is the impulse to blur the distinction between 'high' and 'low' art through the process of quoting from, or alluding to, popular cultural forms. It is the 'postmodernist novel's abundant use of popular cultural discourse' that produces its 'demonic orientation'.[5]

The authors re-vindicate their position within the postmodernist chaos by means of the cultural global capital. They expose the realities previously dismissed

that proportion new symbolic imaginaries and offer alternate identities to the readers. Rivas uses the cosmopolitan experience through which, via narrations, he provides a means of connecting with new imaginaries that make one reflect on our individual positions within spaces beyond the mundane that move toward global emotions, thus learning, from the experiences of the characters, preciously disregarded facets of one's self and of the whole of humanity.[6] It is worth mentioning that beyond the narrative, cosmopolitanism is 'an effect of economic migration as much as metropolitan elitism, and so a sign of new and complex global identities'.[7] These two vertices of the cosmopolitan experience, the literary and the economic/social/cultural, are bound in that the cultural is reflected in the arts and the arts function within the global market. In this manner as the global identities become more complex, the authors should respond to these interpretative needs and proportion symbolic spaces where the readers can connect.

Rivas is reared in a space where globalisation is not felt directly, in that its effects are first felt following Franco's death in 1975. Nonetheless, he witnesses the liberalisation of Spain following the dictator's death and the great economic, social and technological changes that transform the outlook of Spanish identity. At first Rivas begins his career by utilising the textual hybrid to recreate pertinent realities for contemporary society. In spite of his great success in the field of fiction, he does not leave his journalism by the wayside and in this area one sees an evolution strongly influenced by regional, national and global changes. As such, he has regularly collaborated in diverse media: *El País*, *Diario de Galicia*, *A Nosa Terra*, *El Ideal Gallego*, *El integral*, *World Today*, *BBC World Service* and *La voz de Galicia*. From these media text has been collected for the following publications: *Galicia, El bonsái atlántico* (1994), *El periodismo es un cuento* (1997), *Toxos e flores* (1999), *Galicia, Galicia* (2001), *Muller no baño* (2003), *Unha espía no reino de Galicia* (*Una espía en el Reino de Galicia*) (2005) and *A cuerpo abierto* (2008). Initially the themes of these works provide a re-definition of the Galicia that is not based in popular folklore but rather in the history that formerly lied in the shadow of Spain, nevertheless, with the evolution of the author within the literary panorama it has had a debut toward the global public by way of the discussion of topics that cross cultural and social barriers.

Changes occurring in rural Galicia in the twentieth century are especially outstanding due to the influence of large urban areas and the need to immigrate within a system controlled by city capital. One of the sources of inspiration for Rivaserian texts are the stories heard during his youth, sitting on a hidden step, after being sent to bed by the adults:

> …contaban historias de crímenes, lujuria de amores, de aventuras y de viajes, porque casi todo el mundo había emigrado o se había ido en un barco o trabajado

como marinero. Estaban todos los géneros literarios modernos contadas en esa conversación al calor del fuego, ...el artificio literario en su esplendor y cómo todo el mundo aceptaba que aquello era como el fuego: algo que salía de la madera para crear una nueva realidad.[8]

One of the freedoms that an author has, male or female, is to weave new realities based on a multiplicity of genres. Nonetheless, theorists and critics search to characterise and set parameters to distinguish the artistic endeavours of each. These categorisations become analogous to a Russian doll, each more restrictive, and the beauty of the art object fades upon being defined in fast and unwavering parameters. This article analyses the manner in which globalisation and postmodernism affect, or re-define, the artistic genre in general, specifically the texts of Manuel Rivas. Beyond this, it seeks to propose how Rivas uses the artistic genre to create an essence in his work that serves as a cure for the social schizophrenia that exists in the postmodern period.

It is necessary to mention how the aesthetic currents and literary themes are influenced by the globalisation of the literary market and the internationalisation of the news media. It is via televised media and the information highway that authors, formerly limited to an autonomous audience, have access to a global audience:

> Literary culture is now clearly wedded to commerce, with the literary price as 'the most overt form of that validated procedure'. The process of reconciling 'good taste and commercial success' in the awarding of literary prizes produces something distinctive, a form or 'serious' commercial fiction aimed at middle to highbrow readers', which is 'a literary genre in its own right'.[9]

This new vision of commercial literature continues offering works that are 'serious' for the general reading public, but also attracts one that is more academically developed. Through commercial literature and the use of translations, as Head points out, a new literary genre, initially propelled by literary accolades, is developed. I use 'initially' because once the author, be it male or female, is known, his/her work finds an audience and the process of critiques, blogs and commentaries on a global stage via the internet which are viewed as a chain of events with a life of their own which will take him/her to greater fame or a demise in notoriety. Notwithstanding, in order for the author not to become obsolete, it is indispensible that his/her body of work constantly addresses the needs of a universal audience and be self-resurrecting for a society that seeks aesthetics and themes which promote 'ideas' suggesting a resolution to the crisis of essence from which they suffer within postmodernism.[10]

Contemporary authors, among them Rivas, present new spaces and imaginaries to understand a globalised, cosmopolitan world through textures that transcend, and annul the barriers between literary genres:

> Genres are responsible, as Lyotard argues, for giving finality: they produce the conditions for a coming to rest; they cause a state of quiescence; they suppress and exclude. This is made possible by virtue of the fact that 'genres of discourse impose onto phrases the finality of a concatenation able to procure a success proper to each.[11]

At the moment that one attempts to categorise the literary genres, the texts and consequently the authors are responsible for adhering to factors that limit and codify them. Rivas admits the historical specificity of the narrative genres, however, he stresses, 'Me apasiona el contrabando de géneros, ¡otra vez la frontera!, y este encuentro es la mejor respuesta que se me ocurre a la cuestión recurrente sobre el lugar de lo real y la 'verdad' en el periodismo y la literatura'.[12] Hence, Rivas places himself in an intermediate space, where Cuellar points out that 'our most crucial and tantalizing experiences of literature' by being 'at the interstices of genres, in this region of non-genre literature' occur.[13] By the use of postmodern artistic objects new elements are created: generic hybrids that are positioned as signs with the text/object and they converse with the readers such that:

> a sign, or representamen, is something which stands to somebody for something in some respect or capacity. It addresses somebody, that is, creates in the mind of that person an equivalent sign, or perhaps a more developed sign. That sign which it creates I call the interpretant of the first sign. The sign stands for something, its object. It stands for that object, not in all respects, but in reference to a sort of idea.[14]

This is to say that the reader becomes interpreter of the idea fomented by the diverse signs. For example, a novel is first represented by way of a diverse group of signs within the literary market such as critics, publicity, reviews and so on. However, once the text is read and given value it becomes an object: it becomes independent. This independence occurs within the postmodern dynamic, that is to say one in which thematic and stylistic barriers are non-existent and in which generic hybrids stand out for appealing in their aesthetics and themes and because they function as 'ideas' that are created independently in the reading of each individual. In this manner each 'idea' functions as a cultural organiser within postmodern society because it serves to re-establish a representation of what is and is not.

Manuel Rivas, as noted previously, is a novelist, journalist, poet and essayist, but he describes himself as a writer. The literary postmodernism evoked within the cosmopolitan experience in Rivas' work congeals between a local past and a vanguard global present. The possibility of weaving a new reality, without limiting oneself to certain parameters of a certain literary genre, presents a thematic and stylistic liberation seen in Rivaserian work. This further affords new forms to view a world that break with all pre-established schemes between narrative and artistic genres. Via the dialogue that is established with the readers, temporal and cultural barriers are crossed. It is necessary to highlight that journalism, as a genre, in its finality consists of a multiplicity of sub-genres that coincide and forge the evolution, albeit slightly ignored what is today known as the journalist essay. The toponym represents a pluri-genre namely, it is constantly renewing its aesthetic and themes in such a way that one single definition that synthesizes its function cannot be found. Alberto Hernando points out that the essay in Spain during the transition flourishes but then declines with the access to other genres that provide the reader with more proximate identifiers during a period of uncertainty:

> The ideological famine resulted in these being vertiginously devoured, passed through the intellectual digestive system of the social body, and eliminated with hardly any evidence of nutrients. The euphoria for the essay dissipated due to saturation, as the result of boredom, and above all from the transformation in social logic. The general ideological crises in the West favored that process: the skepticism, the 'disenchantment', the immunodeficiency to critique, and the comfortable investiture of the new mechanism of the State, such as 'organic intellectuals,' from an important sector of intelligence, opposition from yesteryear, eroded the precarious ground on which the essay stood. The detective novel, the esoteric, and evasion occupied the essay void.[15]

The present essay void is revealed by the generic hybrids to facilitate the polyphony of voices and themes that are instrumental to reflecting on the social present and themes that go beyond the quotidian events. The body of Rivas' works gives to the 'murmured voices', that is to say those voices 'que leva facendo a humanidade perseguida dende sempre cando transmite a información esencial'.[16] If in fact Rivas is representative of the whispers of the marginalised within the journalistic arena he must retain, as a rule of thumb, the most ineludible facet of journalism: veracity. Nonetheless, Rivas notes, with a certain irony, that in contradistinction to the history of the narrative, 'the history of journalism is full of lies that sometimes last forty years'.[17] He accentuated that following the dictatorship in Spain journalism had to be, for all practical purposes, re-invented seeing that censorship had limited the genre

and the concept of accuracy and legitimacy to such an extent that the legacy was characterised by unilateralism and restrictions.

The journalist hybrids in Rivas' work are found in *Galicia, bonsái atlántico* (1989) written for *El País*, *No mellor país do mundo*, *Toxos e flores* (1992), *El periodismo es un cuento* (1997), *Galicia, Galicia* (2001), *Muller no baño* (2002), *Unha espía no reino de Galicia* (2004) and *A cuerpo abierto* (2008). These are true stories although they do not focus on the country's elite but on the accounts of those who have, for the most part, been forgotten or ignored. By means of his work, a glocalization occurs where there is an approximation to the discernment of what happens at a social and personal level surrounding each character, and consequently within the social spaces of each reader when the act of reading takes place. This transpires by virtue of the union of literary cosmopolitanism and the recreation of the past to ensure a dialogue that promotes awareness by way of Rivaserian aesthetics and themes. These stories:

> were born on newsprint, but have the calling to be told as timeless fireside stories. They are in defiance of a schizoprenia… Chronicles of a life, fragments of the human novel. Like a couple of street-sweepers on a freezing night, the journalist and the writer share the traces and the remains of an intimate and chilling odyssey.[18]

An analysis of each of the aforementioned collections would be exhausting and repetitive, consequently this paper focuses on 'La triste historia de Eva'[19] in *El periodismo*, which is a story to provide an example of the reflections that make the generic hybrid created by Rivas possible.

Generic hybrids stand out in his work among them the collection of *cuentos periodísticos*: spaces where literature and journalism meet and engage in order to present: 'el descubrimiento de otra verdad, del lado oculto, a partir del hilo de un suceso'.[20] As a representation of the generic hybrids *Mujer en el baño* (2004) is analysed: a text that goes beyond the fusion of the literary and artistic genres towards the creation of an object that promotes the vindication of the feminine space with society and the arts. Making use of the works in the Thyssen Museum, Rivas reconstructs the feminine space and articulates a new perception of each of the paintings that affords the beholder a glimpse from the position of women within patriarchy.[21]

Mujer en el baño is a collection of articles that form what Rivas highlights as 'un libro de porqués, de las cuestiones límites, de subjetiva vanguardia, que se dirimen, ocultos o visibles en nuestro tiempo' (MB 11).[22] Amongst these he finds 'Mujer en el baño', inspired by the pop art painting of the same name by Roy Lichtenstein. The text was initially presented at a conference and is described as 'amarrado a las paredes de la realidad' between the nexus

of what Virginia Woolf denoted as 'una tela araña...la relación entre la literatura y lo real' (MB 11).[23] The position of the newspaper text is reiterated by the necessity of identifying its purpose within the press, nonetheless as with all of Rivas' journalism it accentuates the convergence of narrative genres. In order to analyse the piece we will make use of Benjamin's concepts of montage and dialectical image for its analysis. The use of montage is stressed for being 'neither liberated from genres nor necessarily disruptive of them'.[24] This is to say; in *Mujer en el baño* there is a relation between visual and narrative genres that enables us to discern the author and the intention of a position of vindication towards the place of subjectivity of women specifically in the paintings described by Rivas, and more so to understand how this dichotomy works within contemporary society. Through the use of art Rivas develops a text with the purpose of humanising the intimate: in this case both the text and the painting. Rivas becomes an interpretative guide that raises the readers' awareness and facilitates new possibilities within the spaces of reality and fiction.

The use of image and the mixing of visual and literary genres lend themselves to reflection on one important theme: According to Jan Mukarovsky, the artistic object can have or lose its aesthetic function depending on when and where it is observed:

> The active role of the aesthetic function is not a real quality of the object although it may have been of intentional construction; it manifests itself only in particular circumstances – that is, in certain social contexts: the phenomenon that was privileged by the aesthetic function during a certain time or in a certain country can lose this function at another time or in another country.[25]

How does this hypothesis function when the works of art become textualised? As Benjamin reiterates 'the place where one encounters [the dialectical image] is language' and as such it is through both seeing and reading the image that the image itself emerges.[26] By converting the visual works to text, Rivas provides a new dimension for the reader that goes beyond that which is derived face to face with the artistic work, viewed during a distinct period and combined with a direct critique by the author towards the subordinate position of women in world history:

> A mediados de siglo con el desarrollo de capitalismo hay cambios sindicales que afectan la entrada de un nuevo sistema social: la demanda de la mujer en mercado laboral, los avances de la ciencia (anticonceptivos), el acceso a la educación para mujeres, son fenómenos que facilitan cierta autonomía femenina pero que en práctica reproducirán, en gran medida, las viejas estructuras de dominación

con un reajuste tutelado[27] y dirigido por los grandes intereses económicos nuevos, dando lugar a la crisis de la familia como unidad de producción y su conversión en unidad de consumo manipulada por el fetichismo publicitario de la mercancía.[28]

Rivas uses *Mujer en el baño* as the instigator of thoughts that move away from the initial function given by Lichtenstein to the piece, which is one without any purpose other than ornamental. In order to accomplish this in the first lines Rivas provides information of his knowledge of Lichtenstein's painting and the change in his reception of it by asking the reader and himself, '¿Qué había cambiado en la mujer en el baño?' (MB 13).[29]

> ¿Por qué sentía ahora como intensa melancolía lo que antes me había parecido una esplendida sonrisa? En un abrir y cerrar de ojos, se había convertido en mi *doe-doe*. Esa locución tan gallega, eres la que me duele, para nombrar a la mujer amada, adquiría pleno sentido. La quise. Me dolía. Hechizado, ¿por qué tenía miedo? Miedo por ella. ¿Por qué interpretaba su sonrisa como un SOS? En la bañera, como un ultrasonido, sus labios murmuraban el código de auxilio en el mar, la llamada que estremece: *¡Mayday, mayday, mayday!* (MB 15).[30]

Within Rivas' imaginary, the painting becomes the agent of the collective feminine. That is to say, the woman in the bath is the display of what he needs to enunciate in order to feel in control of what occurs in his surroundings. Through the nexus of the artistic and literary genres, Rivas compromises the painting. This is an easier task because, as noted earlier, for Roy Lichtenstein the painting does not lend itself to sentimentalism or social function. The creation is born within the pop-art movement that in the moment of its conception implied an artistic representation of technological goods and the style during a period in which capitalism and consumerism flourish.[31] Being superficially representative of real intimate objects allows the symbol to be void of social implications or major significance beyond what is directly exhibited. However, in the case of 'the woman in the bath' it is that state of insignificance that enables Rivas complete freedom of interpretation:

> Si el autor decía que no pretendía trasladarnos ninguna emoción al pintarla, ella sí quiere. Una vez que nos quedamos con ella a solas, que olvidamos la teoría plástica en la que surge, y que los años la van pintando con su pátina de melancolía, o que ella misma ha limpiado el vaho desde dentro, empieza a hablar, a contarnos una emocionante historia... Ella es ahora todo. Ella era evidentemente el reclamo, estaba 'cosificada', era un vehículo para llamarnos la

atención a nosotros, el partido de los consumidores, sobre esa cosa. Ahora no nos quiere vender nada. La mujer se ha salido del anuncio. Ha huido. (MB 33)[32]

The change of perception of the painting, the attraction that he feels towards her and the call of the woman submerged in bubbles, is the result of the chilling known facts, about the gender violence in Spain, prior to the museum visit. The news report 'donde se hablaba de sesenta asesinatos de mujeres a manos de sus maridos durante este año en España …mil casos de agresiones graves y de un total de veinticinco mil denuncias por malos tratos' (MB 17).[33] This data presents an awakening for the author before entering the tranquil space of the museum and causing the painting to melt into the reality resulting in its rebirth. This reappearance is internalised by the reader when Rivas refers to a 'we' and not to a first person or second person singular. The public, both the reader and the author, relive their positions given the narrated information; they become participants in the anecdote:

> Imaginemos un extraterrestre inteligente que llegase con el encargo de describir vida en el planeta. Tierra sin ningún perjuicio y que se encontrase, en la India, con los rostros desfigurados por el ácido sulfúrico de las novias abandonadas y para que no pudiesen jamás tener otra relación, con las ablaciones y las amputaciones sexuales en África para negarle a la mujer la dimensión del placer... Un mapa de horror que nos sitúa todavía en la prehistoria brutal de la humanidad. (MB 18)[34]

Rivas underlines the feminine experience in societies where women are considered subordinate, marginal or simply objects for the benefit of man. For this elucidation, Rivas makes use of other works of art to provide a chronology of the feminine presence forged in the paintings that surround Lichtenstein's work. Again, by way of the textualisation, an alternative view is given to the history that the art represents. The understanding and the connection that the painting creates with the life of the readers becomes tri-dimensional. On the one hand the paintings plastered on the paper, on the other Rivas' response and interpretation give way to ours assuming new contingencies that rouse not only our personal, distorted memories but also the creation of new symbolic imaginaries of the feminine space. Rivas re-defines and adds realities to the companions of the woman in the bath: Kiki de Montparnasse in Kees van Dongen's *Portret van een Vrouw met sigaret*, Toulouse Lautrec's *Femme rousse en blouse blanche*, two paintings by John Singer Sargent, *The Duchess of Sutherland* and *The Onion Seller*, and finally Edward Hopper's *Hotel Room*. Each of these paintings stands out by depicting a different but real woman: Kiki represents the 'femme fatale;' the red head is the woman 'of skin and bones'. Singers

paintings – two women – one an aristocrat 'dominating the scene with absolute security' (MB 30) and the other poor wretch 'doubts about the opportunity (so to say) of being immortalised (MB 30–31) and finally, the woman sitting on the bed in an hotel room, the woman that 'begins to emerge out, to flee!' from her subordinate condition (MB 33). It is also these portrayed women that encourage the appearance of the real proposal, the reality of what or who, the woman in the bath represents: when the voice in the story states that 'las cosas no son lo que aparentan. La mujer en el baño ya no es el cuadro de un rostro feliz. Lleguemos a un acuerdo. Es un cuadro de encrucijada' (MB 40).[35] The painting is relocated at the crossroads and we find the theme of 'montage' proposed by Benjamin in the XIX century as a mechanism for criticising the capitalist culture via the dialectic image that contributes:

> a dialectical reading of history – history defined not as a continuum projected out of the past and propelled by progress into the future, but history apprehended from our vantage-point in the present as ruptured moments that take on significance because of their relationship to the present.[36]

This is the birth of Rivas' discussion, at the artistic as well as historic crossroads. Thus the text forms a recollection of events, not linearly, but in a manner that the reading becomes directly related to the present, from a present in constant stress and a future that forces one not to forget:

> John F. Kennedy es asesinado…. Muere James Dean, muere Marilyn, muere Buddy Holly, muere el Dios social-cristiano, ¡Dios mío!, muere o se mata todo el mundo…. Porque este cuadro nuestro, en el principio, cuando se inspira en la publicidad, nace como algo inocente. Y resurge el conflicto, porque existía antes. Se recrudece la xenofobia, el ku-klux-klan. Ante la evidencia de desigualdades y las marginaciones racistas, nacen los movimientos por derechos civiles…. Nacen los primeros movimientos feministas…en 1963 hay otro acontecimiento crucial, hablando de cambios decisivos en la vida de las personas, y es el descubrimiento de algunos de los más conocidos fármacos antidepresivos y tranquilizantes. (MB 40)[37]

The rescued moments of the past provide a filter for the present. How does this transport the reader from the painting of the woman in the bath to pharmaceuticals? And why? The pharmaceuticals enable the smile of the woman in the bath; she reclaims the mask of the 'social producers of harmony', so qualified by means of pharmaceuticals needed for the social imposition of having to 'sostener las vigas de la casa…ofreciéndose como productora y emisora de un efecto emotivo, de orden mental, sin él que no se sostendría la sociedad' (MB 44).[38] Rivas' text supplies the words reflected in

the mirror, the textual gaze of an observer that seeks the explanation of the social injustices towards the woman in the painting of *Mujer en el baño*, reading the text to see her, 'hace[r]r visible lo invisible' (MB 46).[39]

Notes

1 'In the manner of Camus, is it not the fight that makes us become artists, but the art that invites us to be fighters. Caravaggio defined the true artists as *valenthuomi*. And that I show they must be. Not boastful, but brave…. The eyes immediately recognize the extra light of bravery. Eyes are kleptomaniacs. It lacks importance that the painting has an owner if one's eyes can access it…. When the thornbush of life is grafted, the painting is reborn and asks to speak. The colors, the lines, the forms they decompose in words that carry on their shoulders the memory of language': Manuel Rivas, *Mujer en el baño*, trans. by Dolores Vilavedra (Madrid: Santillana Ediciones Generales, S. L., 2004), pp. 19–20.

2 Zygmunt Bauman, *Work, Consumerism and the New Poor* (Buckingham: Open University Press, 1998), p. 1.

3 I am making references to the postmodernisms because of all the different versions which are found in *Beyond Postmodernism: Reassessments in Literature, Theory, and Culture*, ed. by Klaus Stierstorfer (Berlin and New York: de Gruyter, 2003).

4 Hans Bertens, *The Idea of the Postmodern: A History* (New York and London: Routledge, 1995), p. 5.

5 Ibid., p. 32.

6 Kwame Anthony Appiah, *The Ethics of Identity* (Princeton: Princeton University Press, 2005), p. 258.

7 Dominic Head, *The state of the novel: Britain and beyond* (Oxford: Wiley-Blackwell, 2008), p. 75.

8 '…they told stories of crimes, lustful romances, adventures and travels, because nearly everyone had immigrated or had been on a boat or worked as a seaman. There were all the modern literary genres in that conversation in the warmth of the fire… the entire world agreed that was the source of the fire: something that would emerge from the wood to create a new reality': Armando G. Tejeda, 'Manuel Rivas: "mi primer libro fue la memoria de mi madre"', September 2006 <http://www.babab.com/no19/rivas. php> [accessed 21 July 2011]. Tejeda, s.p. personal emphasis.

9 Head, *The state of the novel*, p. 56.

10 I am drawing a distinction between postmodernism as a literary epoch and postmodernity as the economic, social and historic events that occur after modernity.

11 Garin Dowd 'Introduction: Genre Matters in Theory and Criticism' *Genre Matters*, in *Essays in Theory and Criticism*, ed. by Garin Dowd, Lesley Stevenson and Jeremy Strong (Bristol: Intellect, 2006), p. 61.

12 'I'm passionate about genre contraband. Again the border! And this meeting point is the best answer that I can find to the recurring question about the place of the 'real' in journalism and the literary': Manuel Rivas, *La mano del emigrante*, trans. by Dolores Vilavedra (Madrid: Santillana Ediciones Generales, S. L., 2002), p. 6.

13 Rivas, *La mano del emigrante*, p. 258.

14 Cited by Paul Cobley, *The Routledge Companion to Semiotics and Linguistics* (New York and London, 2001), p. 282.

15 Alberto Hernando, 'Una necesidad de orientarse', *La Esfera* supplement in *El Mundo*, Madrid, 4 June 1994, p. 2.

16 In Galician 'voces baixas', defined as: 'voices that prosecuted humanity has always made when they are transmitting essential information' (Rivas 'O galego 4049 de Mauthausen'). Manuel Rivas, 'O galego 4049 de Mauthausen', *El País*, Madrid, 21 November 2008. <http://www.elpais.com/articulo/Galicia/galego/4049/Mauthausen/elpepiautgal/20081121elpgal_19/Tes> [accessed 8 September 2011].

17 Manuel Rivas, *El periodismo es un cuento* (Madrid: Alfaguara, 1997), p. 23.

18 Ibid., p. 24. Translation by author of the article.

19 For the article in *El Mundo* on the subject please see: http://documenta.elmundo.orbyt.es/ [accessed 6 September 2011].

20 '...collection of journalistic stories: spaces where literature and journalism meet and engage in order to present: 'the discovery of the other truth, from the dark side, setting out from the thread of one event': *El periodismo es un cuento*, p. 23.

21 Manuel Rivas, *Mujer en el baño*, trans. by Dolores Vilavedra (Madrid: Santillana Ediciones Generales, S. L., 2004). All further references to the work will be marked by the abbreviation MB followed by the page number in Arabic script in parentheses in the text.

22 '...a book of reasons, of off-limit questions, of subjective avant-garde, that void themselves, occult or visible in our time' (MB 11).

23 'tied to the walls of the reality' between the nexus of what Virginia Woolf denoted as 'a spider web...the relationship between the literature and the reality' (MB 11).

24 Jeff Collins, 'The Genericity of Montage: Derrida and Genre Theory', in *Genre Matters*, in *Essays in Theory and Criticism*, ed. by Garin Dowd, Lesley Stevenson and Jeremy Strong (Bristol: Intellect, 2006), p. 61.

25 Jan Mukarovsky, *Función y norma y valor estético como hechos sociales: escrito de estética y semiótica en arte* (Barcelona: Gustavo Gilli, 1975), p. 48.

26 Walter Benjamin, *The Arcades Project*, ed. by Rolf Tiedemann and trans. by Howard Eiland and Kevin McLaughlin (New York: Belknap Press, 2002), pp. 462–63.

27 Since the inclusion of Spain in CIME (Intergovernmental Committee for European Migrations) in 1965, a plan of Family Reuniting is established that contributes to female migration with the help and supervision of the Catholic Commission of Spanish Migration.

28 'With the advent of the mid-century and the spread of capitalism there are changes in the syndicates that affect the coming into effect of the new social system: the demand for women in the labour market, the scientific advancements (contraceptives), the accession of education to women, are phenomena that facilitate a degree of female autonomy. These gains, albeit superficial, will only serve to reproduce the old structures of dominance in the patriarchal system. However, a readjustment occurs and the role of women is directed by new economic interests. The family as the unit of reproduction no longer exists and it becomes an entity of consumerism manipulated by the advertising fetish of merchandise': Carmen Blanco, 'Literatura gallega de las mujeres: fundación y refundación', *Actas XII: AIH*. (1995), 30–38 (p. 30).

29 'What had changed in the woman in the bath?' (MB 13).

30 'Why did what before seemed such a splendid smile now feel so intensely melancholic? In the blink of an eye, she had become my doe-doe. Such a Galician phrase, you are the one for whom I ache, to name the woman loved, it made perfect sense. I loved her. I ached for her. Bewitched, why did I interpret her smile as an SOS? In the bath, like an ultrasound, her lips murmured the call for help at sea, the call that makes one shudder: Mayday! Mayday! Mayday!' (MB 15)

31 The movement emerges in the fifties in England and in the USA utilising objects identified by mass media and a consumerism driven society.

32 'If the author said that he did not seek to transmit any emotion when painting her, she does. Once that we are alone with her, we forget the plastic theory in which she appears, and the years paint her with a patina of melancholy, or that she herself has cleaned the steam from within, begins to talk, to tell us an emotional story…. Now, she is everything. Evidently she was the inducement, she was 'confiscated,' she was a vehicle to call our attention to ourselves, the party of the consumers, about that thing. Now, she does not want to sell anything to us. The woman has emerged from the advertisement. She has escaped' (MB 33).

33 '…that denotes that sixty murders of women by their husbands have taken place this year [2002] in Spain …a thousand cases or serious aggressions and a total of twenty five thousand cases filed for domestic abuse' (MB 17).

34 'Let us imagine an extra-terrestrial intelligence should arrive with the assignment to describe life on the planet. Earth with no prejudice and that it find itself, in India, with the faces of abandoned brides disfigured by sulphuric acid and so that they might never have another relationship, the ablations and sexual amputations in Africa to deny women the dimension of pleasure…. A map of horror that places us in the brutal prehistory of humanity' (MB 17).

35 '…things are not as they appear. The *Woman in the Bath* is no longer the portrait of a happy countenance. We arrive at an agreement. The painting is a crossroads' (MB 40).

36 Susan Willis, *A Primer for Daily Life* (London: Routledge, 1991), p. 34.

37 'John F. Kennedy is assassinated…. James Dean dies, Marilyn dies, and Buddy Holly dies, the socio-Christian God dies. My God! Everyone dies or kills themselves, because this painting of ours, in the beginning, when it is inspired by publicity, is born as something innocent. And the conflict re-emerges, because it existed before. Xenophobia resurfaces, the Ku Klux Klan. Before the evidence of racial inequalities and marginalisation, the civil rights movements are born…the first feminist movements…in 1963 there is another crucial event, speaking of decisive changes in the lives of people, and it is the discovery of some of the most familiar pharmacological anti-depressants and tranquilizers' (MB 40).

38 'social producers of harmony,' so qualified by means of pharmaceuticals needed for the social imposition 'to have to hold up the beams of the house…offering one's self as producer and transmitter of an emotional image, of intellectual calm, without which society would not be sustained' (MB 44).

39 'make visible the invisible' (MB 46).

Chapter 11

RE-ENVISIONING THE HAUNTING PAST: KARA WALKER'S ART AND THE RE-APPROPRIATION OF THE VISUAL CODES OF THE ANTEBELLUM SOUTH

Minna Niemi

Lebanon Valley College

Kara Walker (born in 1969) is a prominent figure in the field of contemporary African American visual arts. She is a distinguished artist who has won several prizes and held exhibitions in different countries all over the world.[1] In her art Walker re-imagines pictorially the past of slavery over and over again, as she represents the horrors of the American South of that period in very specific ways. Walker is best known for her black cut-paper silhouettes displayed on white walls. This choice of colours already underlines the racial division in the antebellum South. Walker's art is generally prized by white art critics, but reviewed more critically by African American audiences.

This essay examines the ways in which Walker's silhouettes have been experienced as threatening. Her art seems to confuse our understanding of the past and the present, by bringing something from the past into the present. This is perceived as a threat, as we tend to understand the past as departed and finalised, and do not expect any of its spectres to haunt the present moment. Walker's art, in its use of a particular pictography, has been condemned as offensive by the African American art community because it brings painful images from the past into the present.[2] Here I read such forms of art, perceived as threatening, in relation to Sigmund Freud's theory of the uncanny, which emphasises the importance of understanding a dreadful element of the present in relation to something old and familiar that has been repressed. The return of such a repressed element is featured in Walker's art, which brings the old imagery from the past to the present in an unspeakable manner, and compels the spectator to re-fashion himself/herself in relation to a particular past.

Roderick A. Ferguson, in his essay 'A Special Place within the Order of Knowledge', argues that Walker's art is interpreted by some of her critics as an attack against the conventions of African American history writing. He further analyses official African American history writing as an arbitrary invention and maintains that 'much of the storm around Walker's work takes place because she dares to target that invention and its machinery'.[3] Critics who have protested against her work interpret 'Walker's art as politically unviable and historically illegible'. These critics are 'implicitly invoking the proscriptions of history itself, chastising Walker for not working according to those proscriptions'.[4] As Ferguson's analysis illustrates, official history works as narrative, which enables us to distance ourselves from the painful, chaotic past, which after all contains ruptures and incomprehensible elements. It creates a protective narrative layer or a defensive shelter between us and the past. In other words, Walker's notion of history resists conventional understanding of history and it goes further, as it shocks and disturbs its audience by examining painful, chaotic and unorganised material from the past. Such a style, naturally, is uncomfortable and questions our official views of history: The historical taboo on this material reminds us of aspects of the past we would rather not deal with, or as Ferguson claims, 'African American history, like history in general, is constituted out of a poetics of evasion-avoiding'.

Nevertheless, at the other end of the spectrum, there are many scholars – art and cultural critics – who fiercely defend Walker's art. Walker's work – which challenges our readings of the past in the present – has emerged at the same time with the recent theoretical focus on the unresolved past, and this may partially explain the great interest in her work in academic circles. In other words, the challenge to history writing made by Walker's art, which creates as it sees the past as a haunting spectre of the present, has historically coincided with contemporary theoretical approaches to the examination of the past. Freud's and Walter Benjamin's theoretical readings of the past have been revived and re-interpreted by many contemporary thinkers, including Jacques Derrida, who in his book *Specters of Marx* creates a new term, 'hauntology'. Derrida uses hauntology to illustrate how our notion of history cannot be finalised as the spectres of the past can always re-emerge in the future.[5] In other words, Walker's art and its reflections on the past should be seen in this larger cultural and philosophical context which has influenced academic discourses recently. When we analyse her work in this broader perspective, we can conclude that there is a wider persistent cultural call to re-examine the notions of history writing and the gaps that this conventional writing produces simultaneously.

I would like to take this theoretical discussion further and claim that it is in the form of art that painful historical material often haunts us most effectively, and this is partially the reason why reactions to Walker's art have been so

strong. It is after all in relation to literature and art that Freud analyses the haunting aspects of the past as well, as he theorises the notion of the 'uncanny' as a theoretical concept arising from his reading of E. T. A. Hoffmann's short story 'Der Sandmann' (1816, 'The Sandman'). Similarly to this, Freud's reading of Michelangelo's Moses sculpture also represents Freud's attempt to understand the ways in which painful history is captured in the form of art. Walker's art captures in its form a particularly painful historical legacy: the imagery of antebellum American racism. Her art is considered illegible precisely because it does not avoid mimicking the racist pictography from that era.

But what exactly is this historical and pictorial material in Walker's work that so deeply disturbs some of its viewers? The unsettling aspect of her work is its refusal to do away with the pictography of the painful history of slavery and the Jim Crow era. Her work does not allow people to forget but rather forces them to confront painful images from the past as they intersect with our present moment and threaten our notion of the present. This happens through the use of a certain type of pictography. Namely, Walker's silhouettes uncannily represent or mimic those very stereotypical images characteristic of the racist pictography of the antebellum South.[6] She highlights the past by using historical stereotypes such as 'mammies, pickaninnies, the old slave, the young buck, the lusty wench, Uncle Tom, the master and young master, even Br'er Rabbit and Uncle Remus' through her use of the historical pictography attached to these stereotypes.[7] In Walker's work these stereotypes, which were invented in order to justify a racist culture, and which emphasised a certain kind of hyper-visibility attached to African American people, seem to come back.[8] The spectator is not allowed to forget certain images, but is rather compelled to witness violent spasms of history disrupting present-day life.

Furthermore, her work creates a carnivalesque situation of racist relations in its representation of images of black-and-white people that are overtly sexualised, as her sometimes chaotic sceneries are full of brutalities, orgies, violence and pain.[9] Such images painfully remind the spectator of the violence of slavery. Thus not only is Walker evoking the racist pictography of the past, but she also re-images the racist and sexist violence attached to such a past. Therefore, her work does not produce a coherent picture of the past but rather shows the chaos of it, the violence of the slave regime that is hardly understandable. And this naturally is painful for the spectator. Such a process of recycling historical images and painfully violent themes attached to the notion of slavery fails to keep the past and the present separate, but instead brings them together. In Walker's work the past and the present are linked, or, as Anne Wagner writes: 'They [Walker's silhouettes] are too active to seem moribund, and too recognizable to be dismissed as safely part of the past. Instead they cross-breed past with present.'[10]

Moreover, it remains important that Walker does use such images and themes in her work, as she forces us to re-examine our relations to the past, re-awakened by these images in the present. The fact that these images are so instantly recognizable is precisely what makes them unsettling. The image itself captures pain from the past, but it is not a pain that can be overcome but is rather a pain re-awakened by the image in the present. The past is still circulating in a social unconscious and these images, like Freud's idea of the 'uncanny', evoke horror precisely because they bring up memories of the past and suggest a return of the repressed. Thus, according to Freud, 'dies Unheimliche ...ist wirklich nichts Neues oder Fremdes, sondern etwas dem Seelenleben von alters her Vertrautes, das ihm nur durch den Prozeß der Verdrängung entfremdet worden ist'.[11] What is dreadful or horrific about the uncanny experience is the fact that with the return of the repressed, something that should have remained secret and hidden has come to light.

It could be said that there is something uncanny in Walker's work, particularly in the return of the repressed notions that it implies, as the past starts to haunt the present. Certain narratives of history should remain secret, or at least we should not be reminded of them, but Walker's work brings such narratives from the past to the present. Against this backdrop it is easier to understand why many viewers have found her work disturbing and have wanted to boycott her work: the criticism of her work becomes more understandable when we remember that blackness is still often associated with those above-mentioned stereotypes, and as Shaw notes, '[c]ultural constructions of the African American imago as hypersexual, lazy, and brutal subhuman creatures still permeate racial discourse in the United States'.[12] The fact that these derogatory notions still circulate in our contemporary culture has nevertheless led to a situation in which some offended spectators have drawn hasty conclusions of Walker's art. Rather than seeing the artist as working on her own cultural past and trying to understand the gaps and pain of African American past, they have interpreted her work as an attempt to continue racist ideologies.

One of the most vocal critics of Walker's work is African American artist Betye Saar who in 1997 'launched an extensive letter writing campaign to protest...display of Walker's work'.[13] As Anne Wagner writes, the campaign called 'for a boycott of the work' because of 'its "negative images" – by which was meant the derogatory and regressive version of blackness they believed it displayed'.[14] In this context, Walker's work was seen to offer 'a kind of pandering, a minstrel performance dishing out unmediated stereotype to whites to lap it up'.[15] According to Saar, Walker's images of black people continue to emphasise those cruelly formed narratives of hyper-visual blackness, as throughout the history of the US, blackness has been visually

fixed through a series of tropes and images. In such readings, nevertheless, Walker's work is examined as an unmediated performance of old stereotypes coming back. According to her critics, just by using those racist images from the past, which were part and parcel of the creation and the reproduction of white supremacist discourses, Walker seems to accept such a racist history as if she could not reclaim such material for subversive purposes.

However Walker, rather than catering to the white eye, has expressed many times the need to examine the painful past as it haunts the present. Walker is using this pictography but re-signifying it. It is precisely because it is such painful (taboo) material that Walker wants to work with it, as it is a spectre from the past that cannot be finalised but continues to inform us in the present. Not only is her work not racist but it also shows us that remaining silent about the painful past does not make this past go away. The past repeats itself in the present. It is precisely for this reason that we have to examine it, and Walker has many times throughout her career made similar claims. The importance of remembering and remaining attentive to such painful aspects of the past is implied by the artist when she says: '[i]t took me quite some time before I realized what I assume other Southerners already knew: That the shadows (oh, here we go) of the past, the deriding names and titles, in fiction and in fact, are continually informing, no, more like de-forming and re-forming, who we think we are – who I think I am'.[16] What Walker is saying is that we can pretend that the past is not haunting us, but it will still re-form and de-form us. Walker's point is therefore that we have to live with the past and its residues. Her art reminds us that only through the remembrance of past violence can the past be processed and re-evaluated in the present.

Thus, rather than reproducing any degrading narratives of blackness in her art, what remains painful and haunting about it is rather the fact that Walker's art forces us to remember that such narratives have existed and that they continue to haunt us. This is the reason her work has been seen as threatening, or as Gwendolyn Shaw puts it, it is precisely '[b]ecause of her ability to speak the unspeakable, [that] her work has been the subject of debate nearly everywhere it has been shown'.[17] In an interview conducted in 2002 Walker stated in response to the criticism she has received that '[t]he audience has to deal with their own prejudices or fear or desires when they look at these images. So if anything, my work attempts to take those 'pickaninny' images and put them up there and eradicate them'.[18] In other words, Walker is consciously acknowledging the need to discuss the violent and painful past.

Similarly to this, in a public conversation on Walker's art at California College of Arts and Crafts in 2000, the artist talked about the stereotypes of African American people that we can identify in her own work and maintained

that 'I think they're stereotypes that exist today. I think my work sort of mimics the past, but it's all about the present. Oh, some great artist in the past, Courbet or somebody, said that there's no historical art that isn't about the present, or something like that'.[19] Thus Walker acknowledges that past is a painful and haunting problem, but at the same time, that such a past has a hold on us; we are inheriting it. Therefore, rather than trying to finalise such a past, we are called on to remember it. It is important to remember, even if remembering means confronting pain. Thus I would argue that like Walter Benjamin's angel of history, Walker's works bear witness to the chaos and pain of history in a way that tears apart any teleological attempt to explain such a history.[20] And this is the most painful aspect of her work.

Even if such a history of slavery is chaotic and means pain, it still makes a claim on us, as we are inheriting it. Such a history keeps re-forming and de-forming us, because the past remains a part of the present, and makes a claim on the present. Thus to follow Benjamin's notion of weak Messianic power,[21] we could say that Walker, in her work, responds to the claim the past makes on the present. Walker inherits a problematic past, and her response is not to forget or finalise the past but rather to let it haunt us through her art. This is important cultural work, as she does not let the history escape; instead, she captures some residues of that past in her work. It is important to allow such a past to haunt us, as it re-forms us in the present. Benjamin's notion of weak Messianic power is useful in examination of Walker's art and her approach to history. Somewhat similarly to this, a Freudian notion of the past as something that has formed us and will form us remains important in regard to her work as well. In the works of both of these theorists the past is identified as a problem that a present moment has difficulty in facing, as it defensively protects itself from the past. At the same time, such a past rewrites the present in its negation.

Therefore Walker's conscious decision to work with the problematic past can be defined as Freudian and Benjaminian in a broad sense, namely, to use Freudian terminology, we could say – as a gross generalisation – that the past is always a problem.[22] To further discuss these ideas in relation to Freud's work, I would like to maintain that this form of art is fundamentally related to questions of the past, and the mediation of it. Referring to Freud's essay entitled 'Der Moses des Michelangelo' (The Moses of Michelangelo), Gregg Horowitz elaborates on Freud's ideas of art forms, and further describes what 'we might treat as the Freudian "definition" of artistic form: the failure to make comprehensible a violent gust of suffering from the past'.[23] It is therefore exactly the failure or the incapacity of the form to smooth the pain that becomes important here; thus, suffering remains to haunt us, and it is captured in the form of the work itself. Horowitz goes on to state that '[w]hen Freud

treats artistic form as threatening, then, it is not because it rears up as another living thing, but because in it the dead, the violent gusts of suffering from the past, continue to call on us'.[24]

I maintain that Walker's decision to work on racist pictography from the antebellum South is a conscious move designed to evoke forms of suffering from the past that continue to call on us. Her art captures the feeling and memorialises it in its very form, in its usages of painful historical images. And I would insist that by doing so, these images wake up the ghosts from a painful past, which destroy our illusion of a past situated securely behind us. The very specific form of her art threatens us, as her art manages to connect past and present in an unspeakable manner.[25] Therefore, to quote Reinhardt, I maintain that: '[u]ncanniness is not an incidental or peripheral by-product of Walker's art, but is integral to the way she confronts the viewer'.[26]

This exploration of Kara Walker's art and its critical responses demonstrates that the racial past remains a problematic issue in many ways. As Ferguson has argued, the conventions of African American history, like any history writing, contain strict rules regarding what is included and what is excluded from this discourse. According to Walker's critics, she is not following those proscriptions of African American history and is chastised for it. Her work, as it questions the conventional understanding between the past and the present, should be read in a wider contemporary cultural context in which the interest in examining and confronting the unresolved past has emerged. At the same time, it is important to bear in mind that the pictographic material she works with is particularly traumatic and painful for many African American viewers to be confronted with, as she uses stereotypical images and such themes as sexualised and racial violence to deliberately conjure up painful historical formations. Her pictography fuses past and present, and it disturbs the viewer. I have maintained that it is a conscious move on the artist's part to work on the history that will de-form and re-form us, and through her art she compels her audiences to re-examine their views of the past as well. Her work creates an important challenge to the black art community, and, as Gwendolyn Shaw correctly maintains – while examining the criticism Walker and other African American artists have received – 'confrontation with, rather than censorship of, the art's unspeakable content is a difficult choice that the American art world must soon find the courage to make'.[27]

The most effective aspect of Walker's art is the fact that this fusing of past and present does not occur just on the level of the 'content' but it is the way in which the art itself can function. In case of Walker's art, it is the work of art rather than any written account of the past that most efficiently keeps the past alive by capturing the pain in its form, and thus disturbing our perception of the present. Walker's art proves once again the powers of art, which can work

as a repository of the confused pain from the past. The analysis of Walker's art and its haunting character bears witness to the ways in which Freud examined the haunting character of art, whether it was E. T. A. Hoffman's short story 'Der Sandmann' or Michelangelo's 'Moses'. By capturing the unspeakable spectres of the past in its visual form, Walker's art keeps haunting our defensive formations of the present.

Notes

1 Walker was born in Stockton, California in 1969, but the family moved to Atlanta, Georgia when Walker was thirteen, as her father accepted a teaching position at Georgia State University. She graduated from the Atlanta College of Art in 1991 and received her MFA from the Rhode Island School of Design in 1994. Her first exhibition to gain wider popular attention was her silhouette wall installation *Gone: An Historical Romance of a Civil War as It Occurred Between the Dusky Thighs of One Young Negress* which was exhibited at the Drawing Center in New York in 'Selections 1994'. Gwendolyn DuBois Shaw, *Seeing the Unspeakable: The Art of Kara Walker* (Durham, NC: Duke University Press, 2004), pp. 12–14. Since then Walker's work has been exhibited in various museums and galleries across the world. Some of her most widely known exhibitions include the two exhibitions at the Walker Art Center in Minneapolis: *Slavery! Slavery!* (1997) and *Kara Walker: My Complement, My Oppressor, My Enemy, My Love* (2007). Walker has also published art books based on her exhibitions including *The Emancipation Approximation* in 1999, and in 2004 she made a film entitled *Testimony: Narrative of a Negress Burdened by Good Intentions*.

2 Gwendolyn DuBois Shaw well illustrates the controversial reception of Walker's work. In 1999, the Detroit Institute of Art (DIA) had 'to pull a work by Walker from display [as] [t]he print *A Means to an End: A Shadow Drama in Five Acts* was deemed too controversial by the administration of the museum': Shaw, *Seeing the Unspeakable*, p. 103. The DIA was pushed to this decision by the strong conservative voices prevailing in the circles of the African American art world. This criticism was most clearly enunciated by a group named 'Friends of African and African American Art', which concluded that this would be an inappropriate time to display Walker's work. Walker's work has been particularly criticised by the African American art community whereas the white mainstream art community celebrates her art: Shaw, *Seeing the Unspeakable*, p. 105.

3 Roderick A. Ferguson, 'A Special Place within the Order of Knowledge: The Art of Kara Walker and the Conventions of African American History', *American Quarterly*, 61.1 (2009), 185–92 (p. 186).

4 Ferguson, p. 187.

5 Jacques Derrida, *Specters of Marx: The State of the Debt, the Work of Mourning and the New International*, trans. by Peggy Kamuf (New York: Routledge, 1994), p. 48.

6 Walker's decision to use silhouettes, which were popular among women artists in the nineteenth century, is a conscious reference to art history and to the time of slavery. Gwendolyn Shaw writes that '[a]s such, her silhouettes create a space in which she can combine her personal interest in exploring her own role as a raced and gendered artist through a vast array of nineteenth- and twentieth-century literature and imagery': Shaw, *Seeing the Unspeakable*, p. 20.

7 Jo Anna Isaak, 'Looking Forward Looking Black', in *Looking Forward Looking Black*, ed. by Jo Anna Isaak (Geneva: Hobart and William Smith Colleges Press, 1999), p. 6.

8 Walker's art draws our attention to the racist pictography of the antebellum South that also constructed or further emphasised a certain kind of hyper-visibility which has been attached to African American people in a highly problematic manner in the history of the United States. Such racialised hyper-visibility, connected to corporeality and sexuality, has been theorised by Sander Gilman, for instance, who discusses the embodiment and sexualisation of black womanhood in the European context. Gilman's example of the ways in which the intersections of racial and sexual knowledge were painfully demonstrated in black women's bodies and more specifically in their genitals is Sarah Bartman, who was forced to exhibit her black, exotic and denigrated body to curious white audiences in the capitals of Europe in the late nineteenth century. Sander L. Gilman, *Difference and Pathology: Stereotypes of Sexuality, Race, and Madness* (Ithaca, NY: Cornell University Press, 1985), p. 85. Similarly to this, the over-signification of black sexuality was typical to the antebellum South, as black sexuality was demonised and stereotypically loaded in the southern slave regime. According to those stereotypes black women were hypersexual and formed a contrast to pure white womanhood. Similarly, black men were seen as sexually aggressive and therefore a danger to the pious white women.

9 Gwendolyn Shaw writes about the carnivalesque racial relations in Walker's art: Shaw, *Seeing the Unspeakable*, p. 122.

10 Anne M. Wagner, 'Kara Walker: 'The Black-White Relation'', in *Kara Walker: Narratives of a Negress*, ed. by Ian Berry, Darby English, Vivian Patterson and Mark Reinhardt (Cambridge, MA: The MIT Press, 2003), p. 95.

11 Sigmund Freud, 'Das Unheimliche' in *Gesammelte Werke*, 18 vols, ed. by Anna Freud et alia (Frankfurt am Main, Fischer, 1999), XII, p. 254. Translated by Strachey as 'The uncanny is in reality nothing new or alien, but something which is familiar and old – established in the mind and which has become alienated from it only through the process of repression': Sigmund Freud, 'The 'Uncanny' (1919)', in *The Standard Edition of the Complete Psychological Works of Sigmund Freud*, ed. by James Strachey, 24 vols (London: Hogarth Press, 1953–74), XVII, 217–56 (p. 241).

12 Shaw, *Seeing the Unspeakable*, p. 105.

13 Ibid., p. 115. Call for censorship is not the only form of criticism Walker has faced from this community; she was also attacked by members of the African American art community after receiving MacArthur Foundation's 'genius' grant, as the older members of the art community felt that a young artist like Walker would not deserve such a prestigious prize. This criticism was taken even further by certain individual artists like Betye Saar, who organised a letter-writing campaign against Walker's art

14 Anne M. Wagner, 'Kara Walker: 'The Black-White Relation'', in *Kara Walker: Narratives of a Negress*, p. 92.

15 Ibid., p. 92.

16 Jo Anna Isaak quotes the artist. See *Looking Forward Looking Black*, p. 6.

17 Shaw, *Seeing the Unspeakable*, p. 123.

18 Hilarie M. Sheets, 'Cut it Out!', *ArtNews*, 1 April 2002, 1–4 (p. 2).

19 Tommy Lott, 'Kara Walker Speaks: A Public Conversation on Racism, Art, and Politics', *Black Renaissance*, 3.1 (2000), 69–91.

20 I am here referring to Benjamin's 'Theses of the Philosophy of History'. In thesis IX, he writes about Paul Klee's painting 'Angelus Novus', in which the angel of history

has turned its face toward the past: 'Where we perceive a chain of events, he sees one single catastrophe which keeps piling wreckage upon wreckage and hurls it in front of his feet. The angel would like to stay, awaken the dead, and make whole what has been smashed. But a storm is blowing from Paradise; it has got caught in his wings with such violence that the angel can no longer close them': Walter Benjamin, *Illuminations*, ed. by Hannah Arendt, trans. by Harry Zohn (New York: Schocken Books, 1968), pp. 257–58.

21　He refers to the term 'weak Messianic power' in his 'Theses on the Philosophy of History'. In thesis II he writes: 'the past carries with it a temporal index by which it is referred to redemption. There is a secret agreement between past generations and the present one. Our coming was expected on earth. Like every generation that preceded us, we have been endowed with a weak Messianic power, a power to which the past has a claim. That claim cannot to be settled cheaply': Benjamin, p. 254.

22　In the Freudian logic, 'the present is a system of forms and institutions that draw their energy from the past they defensively reproduce': Gregg M. Horowitz, *Sustaining Loss: Art and Mournful Life* (Stanford, CA: Stanford University Press, 2001), p. 122.

23　Horowitz writes that according to Freud '[i]n his creations Michelangelo has often enough gone to the utmost limit of what is expressible in art' (119). Similarly to this, Walker, in her art, often touches the limits of expression.

24　Horowitz, p. 121.

25　As Horowitz writes, art threatens 'not despite being a work of art, but just because it is a work of art', p. 117.

26　Mark Reinhardt, 'The Art of Racial Profiling', in *Kara Walker: Narratives of a Negress*, p. 118.

27　Shaw, *Seeing the Unspeakable*, p. 108. Other African American authors and their works have also been strongly criticised in a way that bears comparison with the criticism launched against Walker. One of these artists is Robert Colescott, who took the liberty to re-represent Jan Van Eyck's classical masterpiece *The Wedding of Arnolfini* (1434). Colescott's *Natural Rhythm: Thank You Jan Van Eyck* (1976) is almost a replica of Van Eyck's work except in Colescott's work the artist changed the pregnant bride's skin colour from white to black. This piece of art has reminded some people of the slave regime in a way that – according to them – the work signifies the master's sexual power over black female slaves. Colescott's work evoked strong criticism too, and he aptly summarizes the farce that usually takes place in a situation like this: 'I get this all the time…what happens is this: some African Americans see my painting and get upset. Then the curators get nervous. We don't want to upset black folks, because then we'd be racist, and we're not racist even though we belong to a white club and live in a white neighbourhood. So if a black person complains, we must take it down because we are good liberals. But it's still censorship.' Quoted in Shaw, *Seeing the Unspeakable*, p. 109.

BIBLIOGRAPHY

Archive Sources

Dictionaries and lexicons

Pearsall, Judy, ed., *Concise Oxford English Dictionary*, 10th edn (Oxford: Oxford University Press, 2002)

Recordings, television, films

A City of Sadness, dir. by Hou Hsiao-Hsien (Artificial Eye, Era Communications, 1989)

A Modern Woman, dir. by Pingqian Li (Lianhua Film Company, 1933)

Angel, dir. by Neil Jordan (Film Four, 1982)

Anne Devlin, dir. by Pat Murphy (British Film Institute, 1984)

Asphalt, dir. by Joe May (Universum Film, UFA, 1929)

Banlieue 13, dir. by Pierre Morel (EuropaCorp, 2004)

Batman Begins, dir. by Christopher Nolan (Warner Bros, 2005)

Bend it Like Beckham, dir. by Gurinder Chadha (British Screen, Helkon Media, 2002)

Berlin Symphony of the Big City, dir. by Walter Ruttmann (Deutsche Vereins-Film, 1927)

Casino Royale, dir. by Martin Campbell (Columbia Pictures, Metro-Goldwyn-Mayer, 2006)

Contact, dir. by Alan Clarke (BBC, 1985)

Daybreak, dir. by Yu Sun (Lianhua Film Company, 1933)

Diamonds Are Forever, dir. by Guy Hamilton (United Artists, Eon Productions, 1971)

Diary of a Lost Girl (*Tagebuch einer Verlorenen*), dir. by Georg Wilhelm Pabst

Die Another Day, dir. by Lee Tamahori (Metro-Goldwyn-Mayer, 2002)

Dr. No, dir. by Terence Young (United Artists, Eon Productions, 1962)

Elephant, dir. by Alan Clarke (BBC Northern Ireland, 1989)

Flight of the Red Balloon, dir. by Hou Hsiao-hsien (3H Productions, Margo Films, 2007)

For Your Eyes Only, dir. by John Glen (United Artists, Eon Productions, 1981)

From Russia with Love, dir. by Terence Young (United Artists, Eon Productions, 1963)

GoldenEye, dir. by Martin Campbell (United Artists, 1995)

Goldfinger, dir. by Guy Hamilton (United Artists, Eon Productions, 1964)

Good Men, Good Women, dir. by Hou Hsiao-Hsien (3H Productions, 1995)

Hennessy, dir. by Don Sharp (American International Pictures, 1975)

Hunger, dir. by Steve McQueen (Blast! Films, 2008)

Joyless Street, dir. by Georg Wilhelm Pabst (*Die freudlose Gasse*, Sofar-Film, 1925)

Lament for Art O' Leary, dir. by Bob Quinn (Cinegael, 1975)

Live and Let Die, dir. by Guy Hamilton (United Artists, Eon Productions, 1973)

Lost, dir. by Jack Bender, Stephen Williams et alia (Bad Robot Productions, ABC Studios as Touchstone Television, 2004–2007)

M, dir. by Fritz Lang (Nero-Film AG, 1931)

Maeve, dir. by Pat Murphy and John Davies (British Film Institute, 2011)

Metropolis, dir. by Fritz Lang (Universum Film, UFA, 1927)

Monsoon Wedding, dir. by Mira Nair (Mirabai Films, Inc., 2001)

Moonraker, dir. by Lewis Gilbert (United Artists, 1979)

On Her Majesty's Secret Service, dir. by Peter R. Hunt (United Artists, Eon Productions, 1969)

Persona, dir. by Ingmar Bergman (AB Svensk Filmindustri, 1966)

Peter Pan, dir. by Herbert Brenon (Famous Players-Lasky for Paramount Pictures, 1924)

Piccadilly, dir. by E. A. Dupont (BIP Wardour, 1929)

Psycho, dir. by Alfred Hitchcock (Shamley Productions, 1960)

Quantum of Solace, dir. by Marc Forster (Eon Productions, Columbia Pictures, Metro-Goldwyn-Mayer, 2008)

Shanghai Express, dir. by Josef von Sternberg (Paramount, 1932)

Slumdog Millionaire, dir. by Danny Boyle and Loveleen Tandan (Pathe Pictures (UK), Fox Searchlight Pictures, Warner Bros. Pictures, 2008)

Spider-Man, dir. by Sam Raimi (Columbia, 2002)

Spies (Spione), dir. by Fritz Lang (Universum Film, UFA, 1928)

Star Wars, dir. by George Lucas (Twentieth Century Fox, Lucasfilm, 1977)

The Andromeda Strain, dir. by Robert Wise (Universal Pictures, 1971)

The Blue Angel (Der blaue Engel), dir. by Josef von Sternberg (Universum Film, UFA, 1930)

The Bourne Supremacy, dir. by Paul Greengrass (Universal Studios, 2004)

The Goddess, dir. by Younggang Wu (Guangzhou: Beauty Culture Communication Co. Ltd, 2006)

The Living Daylights, dir. by John Glen (United Artists, Eon Productions, 1987)

The Long Good Friday, dir. by John Mackenzie (Black Lion Films, 1979)

The Love of Jeanne Ney (Die Liebe der Jeanne Ney), dir. by Georg Wilhelm Pabst (Universum Film, UFA, 1927)

The Man with the Golden Gun, dir. by Guy Hamilton (United Artists, Eon Productions, 1974)

The New Women, dir. by Chusheng Cai (Lianhua Film Company, 1935)

The Puppetmaster, dir. by Hou Hsiao-hsien (3H Productions, 1993)

The Red Balloon, dir. by Albert Lamorisse (Lopert Pictures Corporation Janus Films, 1956)

The Sound of Music, dir. by Robert Wise (Twentieth Century Fox, 1965)

The Street (Die Straße), dir. by Karl Grune (Stern-Film, 1923)

The Testament of Dr. Mabuse (Das Testament des Dr. Mabuse), dir. by Fritz Lang (Nero-Film AG, 1933)

Thief of Bagdad, dir. by Raoul Walsh (Douglas Fairbanks Pictures for United Artists, 1924)

Toll of the Sea, dir. by Chester M. Franklin (Technicolor Motion Picture Company for Metro Pictures, 1922)

Three Modern Women, dir. by Wancang Bu (Lianhua Film Company, 1933)

Varieté (1925), dir. by Ewald André Dupont (Universum Film, UFA, 1925)

Westworld, dir. by Michael Crichton (MGM, 1973)

CDs, DVDs and digital media

Chan, Fruit 陳果. 1997. *Xianggang zhizao* 香港製造 (Made in Hong Kong). 2 VCDs. [Hong Kong]: Nicetop Independent

_____· 1998. *Qunian yanhua tebie duo* 去年煙花特別多 (The longest summer). 2 VCDs. [Hong Kong]: Team Work Production House

_____· 1999. *Xilu Xiang* 細路祥 (Little Cheung). 2 VCDs. [Hong Kong]: Nicetop Independent; [Tokyo]: NHK

Larson, Jane Leung, 'The 1905 Anti-American Boycott as a Transnational Chinese Movement' (Thomson Gale, 2007)

Exhibitions

Susan L. Siegfried, 'The Self-Production of the Artist: Ingres' Apotheosis of Homer', Ingres exhibition, Musée du Louvre, Paris, February 2006

Newspapers and magazines

Bennett, Ronan, 'Hidden Agenda', *Independent*, 31 October 1996

Diangying Zazhi, November 1925

Diangying Huabao, May 1925

Fraser, Nick, 'A Kind of Life Sentence', *Guardian*, 28 October 1996, p. 9

Gilbert, Gerard, 'Five Minutes of Heaven', *Independent*, 3 April 2009

Hernando, Alberto, 'Una necesidad de orientarse', La Esfera supplement in *El Mundo*, Madrid, June 4 1994, p. 2

Johnson, Douglas, 'René Etiemble, Leading the fight against the threat of Franglais', *The Guardian*, 31 January 2002

McKittrick, David, 'Why are all the Troubles' films about republicans?', *Belfast Telegraph*, 31 October 2008

Macnab, Geoffrey, 'Classic films with the Troubles in mind', *Independent*, 14 March 2008

Mon Ciné, July 1924

New York Times, Film Review, 30 June 1926

O'Hagan, Sean, 'McQueen and Country', *Observer*, 12 October 2008

'Paramount Uses Anna May Wong to Embarrass China Again', *Pei-Yang Pictorial News*, 5 December 1931

Picturegoer, 29 November 1924

Radio Movie Daily News, June 1932

Sheets, Hilarie M., 'Cut it Out!', *ArtNews*, 1 April 2002, pp. 1–4

Svetkey, Benjamin, 'He's Bond. He's Blond. Get Used to It!', *Entertainment Weekly*, 31 March 2006, pp. 11–13

'The Toll of the Sea,' *New York Times*, 27 November 1922, p. 18

Wong, Anna May, 'The Chinese Are Misunderstood', *Hua Tzu Jih Pao* (Hong Kong) 22 February 1936

Websites

Acquarello, 2001–2003. Reviews of *Made in Hong Kong*, *The Longest Summer*, *Little Cheung*, and *Durian Durian* at Strictly Film School. <http://www.filmref.com/directors/dirpages/chan. html>, listed under 'Directors & Films' [accessed 24 January 2010]

Boulden, Jim and Laura Allsop, 'Picasso Sells for $40 Million in Austerity-Proof Art Market,' CNN International Edition, 9 February 2011. <http://edition.cnn.

com/2011/BUSINESS/02/08/auction.sales.london/index.html> [accessed 9 September 2011]

El Mundo: http://documenta.elmundo.orbyt.es/> [accessed 6 September 2011]

El País: <http://www.elpais.com/articulo/Galicia/galego/4049/Mauthausen/elpepiautgal/20081121elpgal_19/Tes> [accessed 8 September 2011]

Guiding Principles on Internal Displacement: <http://www.idpguidingprinciples.org> [accessed 25 June 2011]

Independent: 'Classic films with the Troubles in mind' <http://www.independent.co.uk/arts-entertainment/films/features/classic-films-with-the-troubles-in-mind-795354.html> [accessed 16 July 2011]

Marxists Internet Archive: <http://www.marxists.org/> [accessed 21 July 2011]

Northern Ireland Screen: <http://www.northernirelandscreen.co.uk/newspage.asp?id=100&storyID=2184> [accessed 7 August 2009]

'On Her Majesty's Secret Service (1969)', The Internet Movie Database, 12 March 2009. <http://www.imdb.com/title/tt0064757/> [accessed 25 August 2011]

'Plot summary for Casino Royale (2006)', The Internet Movie Database, 19 March 2008. <http://imdb.com/title/tt0381061/plotsummary> [accessed 25 August 2011]

Pollock, Lindsay, 'Lehman $12.3 Million Art Sale Picks "Long Way Home" Over Hirst,' Bloomberg Businessweek, 27 September 2010. <http://www.businessweek.com/news/2010-09-27/lehman-12-3-million-art-sale-picks-long-way-home-over-hirst.html> [accessed 9 September 2011]

Tejeda, Armando G., 'Manuel Rivas: "mi primer libro fue la memoria de mi madre"', September 2006. <http://www.babab.com/no19/rivas.php> [accessed 21 July 2011]

Printed Sources

Primary sources

Adorno, Theodor, *Aesthetic Theory*, trans. by C. Lenhardt (London and New York: Routledge and Kegan Paul, 1984)

Agamben, Giorgio, *Homo Sacer: Sovereign Power and Bare Life* (Stanford, CA: Stanford University Press, 1998)

———, *The Coming Community* (Minneapolis: University of Minnesota Press, 1993)

Appiah, Kwame Anthony, *The Ethics of Identity* (Princeton: Princeton University Press: 2005)

Benjamin, Walter, *Illuminations*, ed. by Hannah Arendt, trans. by Harry Zohn (New York: Schocken Books, 1968)

———, *Reflections: Essays, Aphorisms, Autobiographical Writings*, ed. by Peter Demetz, trans. by Edmund Jephcott (New York: Harcourt Brace Jovanovich, 1978)

———, 'Das Kunstwerk im Zeitalter seiner technischen Reproduzierbarkeit', Zeitschrift für Sozialforschung (1935) (Frankfurt on Main, Suhrkamp Verlag, 1955). Translated by Harry Zohn, 'The Work of Art in the Age of Mechanical Reproduction', in *Illuminations. Essays and Reflections*, ed. with an introduction by Hannah Arendt (New York: Harcourt Brace, 1968; repr. New York: Schocken Books, 1969), 217–52

———, *The Arcades Project*, ed. by Rolf Tiedemann, trans. by Howard Eiland and Kevin McLaughlin (New York: Belknap Press, 2002)

———, *The Arcades Project*, ed. by Rolf Tiedemann (Cambridge, MA: Harvard University Press, 1999)

Chion, Michel, *The Voice in Cinema*, trans. by Claudia Gorbman (New York: Columbia University Press, 1999)

Derrida, Jacques, 'Who or What Is Compared? The Concept of Comparative Literature and the Theoretical Problems of Translation', *Discourse*, 30.1/2, (2008), 22–53

——, *Specters of Marx: The State of the Debt, the Work of Mourning, and the New International*, trans. by Peggy Kamuf (New York: Routledge, 1994)

Derrida, Jacques and Bernard Stiegler, *Echographies of Television* (Malden, MA: Polity Press, 2002)

Fanon, Frantz, *The Wretched of the Earth*, trans. by Constance Farrington (New York: Grove Press, 1963)

——, *Black Skin White Masks*, trans. by Charles Lam Markmann (London: Pluto Press, 1993)

Freud, Sigmund, *The Standard Edition of the Complete Psychological Works of Sigmund Freud*, James Strachey (ed.), 24 vols (London: Hogarth Press, 1953–74)

——, 'Das Unheimliche' in *Gesammelte Werke*, 18 vols, ed. by Anna Freud et alia (Frankfurt on Main, Fischer, 1999), XII, 227–68

Habermas, Jürgen, *The Postnational Constellation: Political Essays*, trans. by Max Pensky (Cambridge, MA: The MIT Press, 2001)

Heaney, Seamus, *North* (London: Faber & Faber, 1975)

Irving, Washington, *The Works of Washington Irving*, 40 vols (New York: Collier, 1897)

Jordan, Neil, *Michael Collins: Screenplay & Film Diary* (London: Vintage, 1996)

Kandinsky, Wassily, *Concerning the Spiritual in Art* (1914) (Boston: MFA Publications, 2006)

Meer, Ameena, *Bombay Talkie* (New York: High Risk Books, 1994)

Rivas, Manuel, *Mujer en el baño*, trans. by Dolores Vilavedra (Madrid: Santillana Ediciones Generales, S. L., 2004)

——, *El periodismo es un cuento* (Madrid: Alfaguara, 1997)

——, *La mano del emigrante*, trans. by Dolores Vilavedra (Madrid: Santillana Ediciones Generales, S. L., 2002)

Roy, Arundhati, *The God of Small Things* (New York: Random House, 1997)

Rushdie, Salman, *The Satanic Verses* (New York: Viking, 1988)

Stein, Gertrude, *Picasso* (Beacon Hill: Beacon, 1938; repr. 1959)

——, *Selected Writings of Gertrude Stein*, ed. by Carl van Vechten (New York: Random House, 1962)

——, *The Autobiography of Alice B. Toklas* in *Selected Writings of Gertrude Stein*, ed. by Carl van Vechten (New York: Random House, 1962)

——, *The Making of Americans* (New York: Something Else, 1966)

——, *Writings and Lectures 1909–1945*, ed. by Patricia Meyerowitz (Baltimore: Penguin, 1971)

——, *Everybody's Autobiography* (New York: Random House, 1937)

Swarup, Vikas, *Q&A* (New York: Scribner, 2005)

Secondary literature

Amis, Kingsley, *The James Bond Dossier* (New York: The New American Library, 1965)

Anderson, Benedict, *Imagined Communities: Reflections on the Origin and Spread of Nationalism* (New York: Verso, 1991)

Anchimbe, Eric A., ed., *Linguistic Identity in Postcolonial Multilingual Spaces* (Newcastle: Cambridge Scholars Publishing, 2007)

Apter, Emily, 'Afterlife of a Discipline', *Comparative Literature*, 57.3 (2005), 201–6

Appadurai, Arjun, *Modernity at Large: Cultural Dimensions of Globalization* (Minneapolis: University of Minnesota Press, 1996)

Ashcroft, Bill, Gareth Griffiths, and Helen Tiffin, eds, *The Postcolonial Studies Reader* (London: Routledge, 1995)

Ashton, Dore, ed., *Picasso on Art: A Selection of Views* (New York: Viking, 1972)

Barton, Ruth, Irish *National Cinema* (London: Routledge, 2004)

Bassnett, Susan, *Comparative Literature: A Critical Introduction* (Oxford: Blackwell)

Bauman, Zygmunt, *Work, Consumerism and the New Poor* (Buckingham: Open University Press, 1998)

Beiner, Ronald, 'Walter Benjamin's Philosophy of History', *Political Theory*, 12.3 (1984), 423–34

Belting, Hans, *The Invisible Masterpiece* (Chicago: University of Chicago Press, 2001)

Bennett, Ronan, 'Telling the Truth about Ireland', *Vertigo*, 1.4 (1994), 24–29

Bennett, Tony, *The Birth of the Museum: History, Theory, Politics* (London: Routledge, 1995)

Benson, Timothy O., ed., *Expressionist Utopias: Paradise, Metropolis, Architectual Fantasy* (Los Angeles: Los Angeles County Museum of Art, 1993)

Berry, Ellen E., *Curved Thought and Textual Wandering: Gertrude Stein's Postmodernism* (Ann Arbor: University of Michigan Press, 1992)

Berry, Ian, Darby English, Vivian Patterson and Mark Reinhardt, eds, *Kara Walker: Narratives of a Negress* (Cambridge, MA: The MIT Press, 2003)

Bertens, Hans, *The Idea of the Postmodern: A History* (New York and London: Routledge, 1995)

Bhabha, Homi, *The Location of Culture* (New York and London: Routledge, 1994)

Blanco, Carmen, 'Literatura gallega de las mujeres: fundación y refundación', *Actas XII: AIH*. (1995), 30–38

Bock, Hans-Michael and Michael Töteberg, eds, *Das Ufa Buch: Kunst und Krisen, Stars und Regisseure, Wirtschaft und Politik* (Frankfurt on Main: Zweitausendeins, 1992)

Bourdieu, Pierre, 'The Historical Genesis of a Pure Aesthetic', *The Journal of Aesthetics and Art Criticism*, 46 (1987), 201–10

Boime, Albert, *Art in an Age of Counterrevolution 1815–1848* (Chicago: University of Chicago Press, 2004)

Bowers, Jane P., *Gertrude Stein*, Women Writers (New York: St. Martins, 1993)

Broccoli, Albert R. and Donald Zec, *When the Snow Melts: The Autobiography of Cubby Broccoli* (London: Boxtree, 1998)

Bryson, Norman, *Looking at the Overlooked: Four Essays on Still Life Painting* (Cambridge, MA: Harvard University Press, 1990)

Cazeaux, Clive, *The Continental Aesthetics Reader* (London: Routledge, 2000)

Certeau, Michel de, *The Practice of Everyday Life*, trans. by Steven Rendall (Berkeley: University of California Press, 1984)

Chan, Anthony B., *Perpetually Cool: The Many Lives of Anna May Wong (1905–1961)* (Maryland: The Scarecrow Press, 2007)

Cheah, Pheng, *Inhuman Conditions: On Cosmopolitanism and Human Rights* (Cambridge, MA: Harvard University Press, 2006)

Chen, Yong, *Chinese San Francisco, 1850–1943: A Trans-Pacific Community* (Stanford, CA: Stanford University Press, 2000)

Chessman, Harriet Scott, *The Public Is Invited to Dance: Representation, the Body and Dialogue in Gertrude Stein* (Stanford, CA: Stanford University Press, 1989)

Cheung, Esther M. K., *Fruit Chan's Made in Hong Kong* (Hong Kong: Hong Kong University Press, 2009)

Chiesa, Lorenzo and Alberto Toscano, eds, *The Italian Difference: Between Nihilism and Biopolitics* (Melbourne: re.press, 2009)

Chin, Wan-kan, 陳雲根, 'From Dialect to Grapholect: Written Cantonese from a Folkloristic Viewpoint', *Hong Kong Journal of Applied Linguistics*, 2.2 (1997), 77–91

Chow, Rey, 'The Old/New Question of Comparison in Literary Studies: A Post-European Perspective', *ELH*, 71.2 (2004), 289–311

Cobley, Paul, *The Routledge Companion to Semiotics and Linguistics* (New York and London, 2001)

Cohen, Tom, *Hitchcock's Cryptonymies, Vols 1 and 2* (Minneapolis: University of Minnesota Press, 2005)

———, *Hitchcock's Cryptonymies, Vol. 2* (Minneapolis: University of Minnesota Press, 2005)

Cork, John and Bruce Scivally, *James Bond: The Legacy* (New York: Henry N. Abrams, 2002)

Cui, Shuqin, *Women through the Lens: Gender and Nation in a Century of Chinese Cinema* (Honolulu, HI: University of Hawai'i Press, 2003)

Davis, Whitney, 'The Subject in the Scene of Representation', *Art Bulletin*, 76.4 (1994), 570–75

Desai, Jigna, *Beyond Bollywood: The Cultural Politics of South Asian Diasporic Film* (London: Routledge, 2004)

Dimendberg, Edward, 'From Berlin to Bunker Hill: Urban Space, Late Modernity and Film Noir in Fritz Lang's and Joseph Losey's *M*', *Wide Angle*, 19.4 (1997), 62–93

Dissanayake, Wimal, ed., *Melodrama and Asian Cinema* (Cambridge and New York: Cambridge University Press, 1993)

Dowd, Garin, Lesley Stevenson and Jeremy Strong, eds, *Essays in Theory and Criticism* (Bristol: Intellect, 2006)

Elkins, James, Zhivka Valiavicharska and Alice Kim, eds, *Art and Globalization* (University Park, PA: Pennsylvania State University Press, 2010)

Ferguson, Roderick A., 'A Special Place within the Order of Knowledge: The Art of Kara Walker and the Conventions of African American History', *American Quarterly*, 61.1 (2009), 185–92

Fernie, Eric, *Art History and its Methods* (London: Phaidon, 1995)

Flam, Jack, ed., *Primitivism and Twentieth-Century Art: a Documentary History* (Berkeley: University of California Press, 2003)

Foster, Hal, ed., *Vision and Visuality* (Seattle: Bay Press, 1988)

Freeman, Elizabeth, 'Time Binds, or, Erotohistoriography', *Social Text*, 23 (2005), 57–68

Gardner, Martha, *The Qualities of a Citizen: Women, Immigration, and Citizenship, 1870–1965* (Princeton and Oxford: Princeton University Press, 2005)

Gilman, Sander L., *Difference and Pathology: Stereotypes of Sexuality, Race, and Madness* (Ithaca, NY: Cornell University Press, 1985)

Grant, Barry Keith, ed., *Film Genre Reader II* (Austin, TX: University of Texas Press)

Günther, Ernst, *Geschichte des Varietés* (Berlin: Henschelverlag, 1981)

Gunning, Tom, *The Films of Fritz Lang: Allegories of Vision and Modernity* (London: BFI Publishing, 2000)

Guerin, Frances, 'Dazzled by the Light: Technological Entertainment and Its Social Impact in *Varieté*', *Cinema Journal*, 42.4 (2003), 98–115

Haas, Robert Bartlett, ed., *Gertude Stein: a Primer for the Gradual Understanding of Gertrude Stein* (Los Angeles: Black Sparrow, 1971)

Hamamoto, Darrell Y. and Sandra Liu, eds, *Counter Visions: Asian American Film Criticism* (Philadelphia: Temple University Press, 2000)

Hansen, Miriam, 'Fallen Women, Rising Stars, New Horizons: Shanghai Silent Film As Vernacular Modernism', *Film Quarterly*, 54.1 (2000), 10–22

_____, 'Early Silent Cinema: Whose Public Sphere?', *New German Critique*, 29 (1983), 147–84

Hardt, Michael and Antonio Negri, *Empire* (Cambridge, MA: Harvard University Press, 2000)

Harvey, David, *Spaces of Global Capitalism: Towards a Theory of Uneven Global Development* (London: Verso, 2006)

_____, *The Condition of Postmodernity: An Enquiry into the Origins of Cultural Change* (Cambridge, MA: Blackwell, 1990)

Hayot, Eric, *The Hypothetical Mandarin: Sympathy, Modernity, and Chinese Pain* (Oxford and New York: Oxford University Press, 2009)

Head, Dominic, *The State of the Novel: Britain and Beyond* (Oxford: Wiley-Blackwell, 2008)

Heath, Stephen, *Questions of Cinema* (Bloomington: Indiana University Press, 1981)

Hershatter, Gail, *Dangerous Pleasures: Prostitution and Modernity in Twentieth-Century Shanghai* (Berkeley and London: University of California Press, 1997)

Hill, John, *Cinema and Northern Ireland* (London: BFI, 2006)

Horowitz, Gregg M., *Sustaining Loss: Art and Mournful Life* (Stanford, CA: Stanford University Press, 2001)

Iravani, Mohammad Reza, 'Child Abuse in India', *Asian Social Science*, 7.3 (2011), 150–53

Isaak, Jo Anna, ed., *Looking Forward Looking Black* (Geneva: Hobart and William Smith Colleges Press, 1999)

Isenberg, Noah, ed., *An Essential Guide to Films of the Era* (New York: Columbia University Press, 2009)

Jonge, Alex de, *The Weimar Chronicle: Prelude to Hitler* (New York: A Meridian Book, 1978)

Ka-Fai, Yau, 'Cinema 3: Towards a 'Minor Hong Kong Cinema', *Cultural Studies*, 15.3/4 (2001), 543–63

Kaes, Anton, *M* (London: BFI Publishing, 1999)

_____, 'The Debate about Cinema: Charting a Controversy (1909–1929)', *New German Critique*, No. 40, Special Issue on Weimar Film Theory (1987), 7–33

_____, 'The Cold Gaze: Notes on Mobilization and Modernity', *New German Critique*, 59, Special Issue on Ernst Junger (1993), 105–17

Karlgren, Bernhard, *Grammata Serica Recensa* (Stockholm: Museum of Far Eastern Antiquities, 1957; repr. Göteborg: Elanders Boktryckeri Aktiebolag, 1972)

Kwan, Kit Choi, 關傑才, *A Dictionary of Cantonese Colloquialisms in English* (Hong Kong: Shangwu yinshuguan, 1990)

Kniesche, Thomas W. and Stephen Brockmann, eds, *Dancing on the Volcano: Essays on the Culture of the Weimar Republic* (Columbia, SC: Camden House, 1994)

Kracauer, Siegfried, *From Caligari to Hitler. A Psychological History of the German Film*, ed. by Leonardo Quaresima (Princeton: Princeton University Press, 1947; repr. 2004)

Larson, Jane Leung, 'The 1905 Anti-American Boycott as a Transnational Chinese Movement', *Chinese America: History and Perspectives* (Chinese Historical Society, 2007)

Lash, Scott and Jonathan Friedmann, eds, *Modernity and Identity* (Cambridge, MA: Blackwell, 1992)

Leong, Karen J. *The China Mystique: Pearl S. Buck, Anna May Wong, Mayling Soong, and the Transformation of American Orientalism* (Berkeley and Los Angeles: University of California Press)

Leyda, Jay, *Dianying Electric Shadows: An Account of Films and Film Audience in China* (Cambridge, MA: The MIT Press, 1972)

Linder, Christoph, ed., *The James Bond Phenomenon: A Critical Reader* (New York: Manchester University Press, 2003)

Lippit, Akira Mizuta, *Electric Animal: Towards a Rhetoric of Wildlife* (Minneapolis: University of Minnesota Press, 2000)

Lo, Wood Wai and Fee Yin Tam, *Interesting Cantonese Colloquial Expressions* (Hong Kong: Chinese University Press, 1996)

Lott, Tommy, 'Kara Walker Speaks: A Public Conversation on Racism, Art, and Politics', *Black Renaissance*, 3.1 (2000), 69–91

Lu, Sheldon, *Transnational Chinese Cinemas: Identity, Nationhood, Gender* (Honolulu, HI: University of Hawai'i Press, 1997)

McCormick, Richard, *Gender and Sexuality in Weimar Modernity* (New York: Palgrave, 2001)

McIlroy, Brian, *'Shooting to Kill': Filmmaking and the Troubles in Northern Ireland* (Trowbridge: Flicks Books, 2000)

McLoone, Martin, *Film, Media and Popular Culture in Ireland* (Dublin: Irish Academic Press 2008)

Mainardi, Patricia, *Art and Politics of the Second Empire: The Universal Expositions of 1855 and 1867* (New Haven: Yale University Press, 1987)

Metzger, Sean and Olivia Khoo, eds, *Futures of Chinese Cinema* (Chicago: Intellect, 2009)

Meyer, Richard J., *Ruan Ling-yu: The Goddess of Shanghai* (Hong Kong: Hong Kong University Press, 2005)

Mitchell, W. J. T., *What Do Pictures Want?: The Lives and Loves of Images* (Chicago: University of Chicago Press, 2005)

Mukarovsky, Jan, *Función y norma y valor estético como hechos sociales: escrito de estética y semiótica en arte* (Barcelona: Gustavo Gilli, 1975)

Mulvey, Laura, 'Visual Pleasure and Narrative Cinema', *Screen*, 16.3 (1975), 6–18

Nancy, Jean-Luc, *The Inoperative Community*, trans. by Peter Connor et alia (Minneapolis: University of Minnesota Press, 1991)

Oksiloff, Assenka, *Picturing the Primitive: Visual Culture, Ethnography and Early German Cinema* (New York: Palgrave, 2001)

Ong, Aihwa, *Neoliberalism as Exception: Mutations in Citizenship and Sovereignty* (Durham, NC: Duke University Press, 2006)

Pang, Laikwan, *Building a New Cinema in China: the Chinese Left-Wing Cinema Movement, 1932–1937* (Lanham: Rowman & Littlefield Publishers, 2002)

Pan, Ling, *In Search of Old Shanghai* (Hong Kong: Joint Publishing Company, 1983)

Peffer, George, *If They Don't Bring Their Women Here: Chinese Female Immigration Before Exclusion* (Urbana: University of Illinois Press, 1999)

Pettitt, Lance, *Screening Ireland* (Manchester: Manchester University Press, 2000)

Petro, Patrice, *Joyless Streets: Women and Melodramatic Representations in Weimar Germany* (Princeton: Princeton University Press, 1989)

Peucker, Brigitte, *Incorporating Images* (Princeton: Princeton University Press, 1995)

Peukert, Detlev J. K., *The Weimar Republic*, trans. by Richard Deveson (New York: Hill and Wang, 1989)

Pike, Burton, *The Image of the City in Literature* (Princeton: Princeton University Press, 1981)

Pine, Emilie, *The Politics of Irish Memory* (Basingstoke: Palgrave Macmillan, 2011)

Preziosi, Donald, *The Art of Art History: A Critical Anthology* (Oxford: Oxford University Press, 2009)

Preziosi, Donald and Claire Farago, *Grasping the World: The Idea of the Museum* (London: Ashgate, 2004)

Rambuss, Richard, 'After Male Sex', *South Atlantic Quarterly*, 106.3 (2007), 577–88

Richie, Alexandra, *Faust's Metropolis: A History of Berlin* (New York: Carroll & Graf Publishers, Inc., 1998)

Rocket, Kevin, Luke Gibbons and John Hill, *Cinema and Ireland* (London: Routledge, 1988)

Said, Edward W., *Orientalism* (New York: Pantheon Books, 1978)

Sandmeyer, Elmer Clarence, *The Anti-Chinese Movement in California* (Urbana: University of Illinois Press, 1939)

Schapiro, Meyer, *Modern Art, 19th & 20th Centuries* (New York: Braziller, 1978)

Scott, Bede, 'Partitioning Bodies: Literature, Abduction, and the State', *Interventions*, 11. 1 (2009), 35–49

Shaw, Gwendolyn DuBois, *Seeing the Unspeakable: The Art of Kara Walker* (Durham, NC: Duke University Press, 2004)

Shen, Ji, *Ruan Ling-yu: Yi Dai Ying Xing* (Shanghai: Shanghai Bookstore Publishing House, 1999)

Shimizu, Celine, *The Hypersexuality of Race: Performing Asian / American Women on Screen and Scene* (Durham, NC: Duke University Press, 2007)

Silverman, Kaja, *The Threshold of the Visible World* (New York and London: Routledge, 1995)

Spence, Jonathan D., *The Search for Modern China* (New York: Norton, 1999)

Spivak, Gayatri Chakravorty, *In Other Worlds: Essays in Cultural Politics* (London: Routledge, 1987)

Stam, Robert, *Literature and Film: A Guide to the Theory and Practice of Adaptation*, ed. by Robert Stam and Alessandra Raengo (Malden, MA: Blackwell, 2005)

Sterling, Charles, *Still Life Painting from Antiquity to the Present Time*, trans. by James Emmons (New York: Universe, 1959)

Stevens, Sarah, 'Figuring Modernity: The New Women and The Modern Girl in Republican China', *NWSA Journal*, 15.3, Gender and Modernism Between the Wars, 1918–1939 (2003), 82–103

Stierstorfer, Klaus, ed., *Beyond Postmodernism: Reassessments in Literature, Theory, and Culture* (Berlin and New York: de Gruyter, 2003)

Sun, Yan, 孫言, '*Xianggang zhizao* ruhe zhizao? Duli dianying shenhua, Chen Guo zhizao' 香港製造》如何製造？獨立電影神話，陳果製造 (How to make *Made in Hong Kong*? A myth of independent film made by Fruit Chan). *Dianying shuangzhoukan* 電影雙周刊 (City Entertainment), 481 (1997), 47–48

Tiedemann, Rolf, ed., *The Arcades Project* (Cambridge, MA: Harvard University Press, 1999)

Vasey, Ruth, *The World According to Hollywood* (Madison: University of Wisconsin Press, 1997)

Vidler, Anthony, *The Architectural Uncanny* (Cambridge, MA and London: The MIT Press, 1992)

Virani, Pinki, *Bitter Chocolate: Child Sexual Abuse in India* (New Delhi: Penguin Books India, 2000)

Volk, Andreas, ed., *Frankfurter Turmhäuser Ausgewählte Feullitetons 1906–1930* (Zurich: Edition Epoca, 1997)

Willis, Susan, *A Primer for Daily Life* (London: Routledge, 1991)

――――, 'Learning from the Banana', *American Quarterly*, 39. 4 (1987), 586–600

Winder, Simon, *The Man Who Saved Britain: A Personal Journey into the Disturbing World of James Bond* (New York: Farrar, Straus, and Giroux, 2006)

Yingjin, Zhang, *Chinese National Cinema* (New York: Routledge, 2004)

――――, 'Prostitution and Urban Imagination: Negotiating the Public and Private in Chinese Films of the 1930s.' in *Cinema and Urban Culture in Shanghai, 1922–1943*, ed. by Yinjing Zhang (Stanford, CA: Stanford University Press, 1999)

Zhen, Zhang, *An Amorous History of the Silver Screen: Shanghai Cinema, 1896–1937* (Chicago: University of Chicago Press, 2005)

INDEX

Lightning Source UK Ltd.
Milton Keynes UK
UKOW052310030212

186633UK00001B/3/P